AUG

A

ART CENTER COLLEGE OF DESIGN

751.426 B636 1989

ACTYLIC Painting Book

Art Center College of Design Library 1700 Lida Street Pasadena, Calif. 91103

By Wendon Blake

Paintings by Rudy de Reyna

Cincinnati, Ohio

The Complete Acrylic Painting Book. Published by North Light Books, an imprint of F&W Publications, 1507 Dana Avenue, Cincinnati, Ohio 45207 (800) 289-0963.

Copyright © 1989 by Don Holden, all rights reserved.

No part of this publication may be reproduced or used in any form or by any means—graphic, electronic, or mechanical, including photocopying, recording, taping, or information storage and retrieval systems—without written permission of the publisher.

Manufactured in China.

Other fine North Light Books are available at your local bookstore, art supply store or direct from the publisher.

00 99 98 97 96 10 9 8 7 6

Library of Congress Cataloging-in-Publication Data

Blake, Wendon.

The complete acrylic painting book/by Wendon Blake; paintings by Rudy de Reyna.

p. cm.

Rev. ed. of: The acrylic painting book. © 1978.

Bibliography: p.

Includes index.

ISBN 0-89134-306-7

 Acrylic painting—Technique. 2. Painting—Technique. I. De Reyna, Rudy, 1914. II. Blake, Wendon. Acrylic painting book. III. Title.

ND1535.B548 1989

89-30381 CIP

751.42'6-dc19

Paintings on pages 5-8, 15-18, and 26-150 are by Rudy de Reyna. All other illustrations are by the author.

Editor: Mary Cropper

A complete catalog of North Light Books is available FREE by writing to the address shown below, or by calling toll-free 1-800-289-0963. To order additional copies of this book, send in retail price of the book plus \$3.00 postage and handling for one book, and \$1.00 for each additional book. Ohio residents add 5½% sales tax. Allow 30 days for delivery.

North Light Books 1507 Dana Avenue Cincinnati, Ohio 45207

Stock is limited on some titles: prices subject to change without notice. Write to the above address for information on North Light Book Club, Graphic Artist's Book Club, The Artist Magazine, Decorative Artist's Workbook, HOW magazine, and North Light Art School.

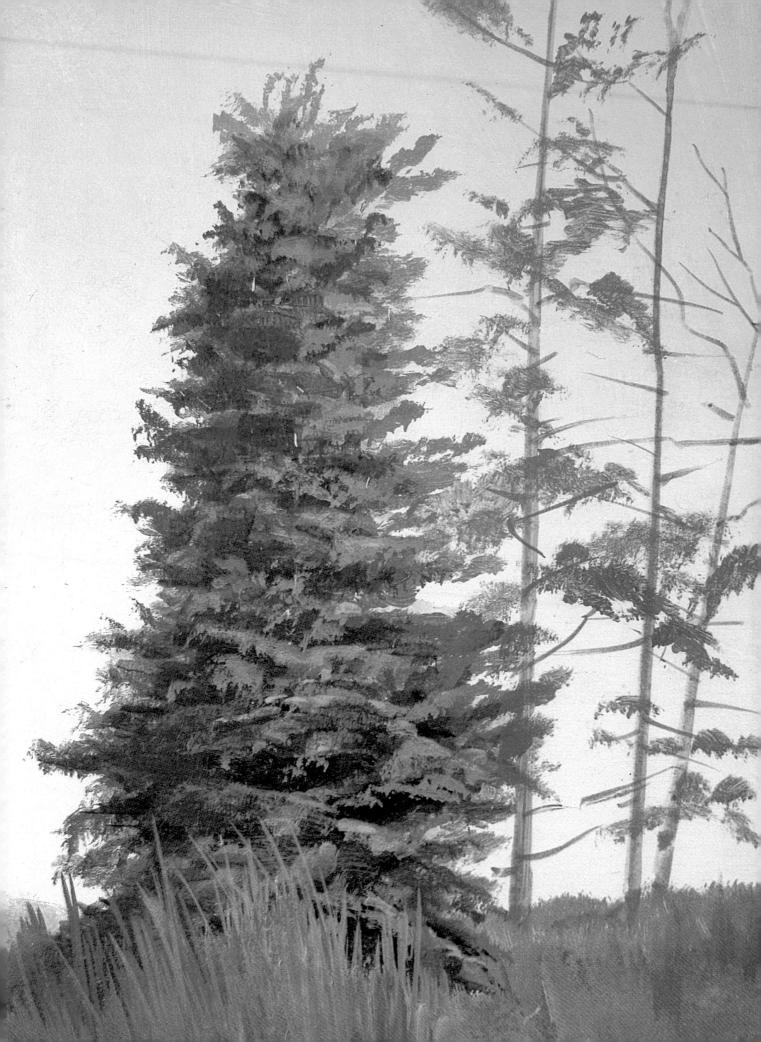

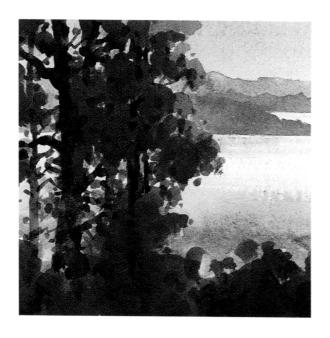

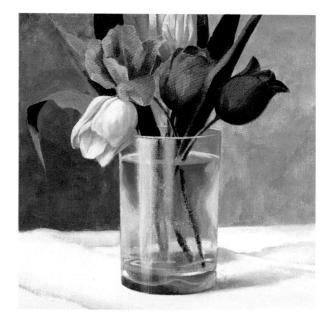

The Basics

Basic Painting Equipment 2
How to Choose the Right Surface 5
Getting Organized 9
Learning to Handle Color 10
Opaque Painting Technique 11
Transparent Painting Technique 13
Combining Opaque and Transparent
Techniques 15
Analyzing Lighting 16
Understanding Aerial Perspective 17
Four Ways to Improve Your Composition 18
Developing Good Painting Habits 19
Experiment with Offbeat Painting Tools 20
How to Correct Paintings 22
How to Preserve Acrylic Paintings 24

Beyond the Basics

Learning to Model Form 26
Drybrush for Texture 30
Blend with Scumbling 32
Underpainting and Glazing 35
Expressive Brushwork 37
Modeling the Forms of Fruit 40
Paint Vivid Flowers 43
Exploring the Colors of Summer 46
Make Autumn Colors Brilliant 51
Capture the Subtle Colors of Winter 56
Interpreting the Mood of the Coast 60
Painting a Portrait 64

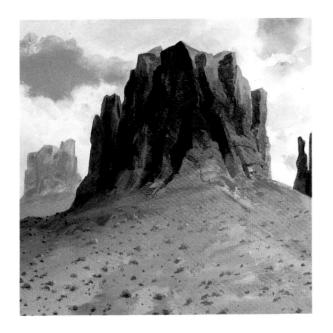

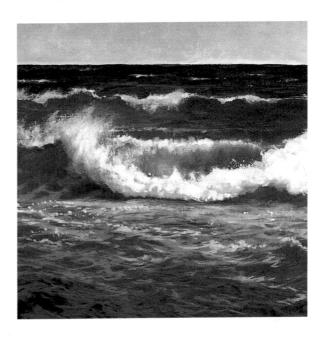

Landscape Subjects

Selecting Landscape Subjects 70
Mixing Colors for Landscapes 71
Rendering the Textures of a Tree 74
Paint an Atmospheric Landscape
of Evergreens 79
Simplifying the Detail of a Forest 83
Modeling Mountains 88
Hills: Tapestries of Color and Light 92
Interpreting the Hues of the Desert 95
Show the Movement of a Stream 100
Catching the Light on Snow 103
Build Interesting Cloud Shapes 107
How to Create Colorful Sunsets 111

Seascape Subjects

Selecting Seascape Subjects 116
Mixing Colors for Seascapes 117
Make Your Waves Shine with Light 120
Expressing the Power of Surf 125
Capture the Magic of Moonlight 129
Painting Fog as Veils of Color 133
Creating the Textures of a Rocky Beach 138
Modeling the Rhythmic Forms of Dunes 142
Shape Tide Pools with Light and Shadow 146

Bibliography 151

Index 152

Art Center College of Design Library 1700 Lida Street Pasadena, Calif. 91103

INTRODUCTION

What is Acrylic? The most important painting medium invented in the twentieth century is acrylic. Every type of paint is actually a combination of three ingredients: powdered color, called pigment; a liquid adhesive that blends with the powdered color and literally glues it to the painting surface; and a solvent that makes the paint even more fluid, then evaporates when the paint dries. With a few exceptions, the same pigments are used to make oil, watercolor, and acrylic paints. The liquid adhesive-or vehicle—in oil paint is linseed oil squeezed from the flax plant, and the solvent is turpentine. In watercolor, the vehicle is a water-soluble glue called gum arabic, and the solvent is water. In acrylic, the solvent is also water, but the vehicle is a liquid plastic.

Permanence. Artists have known about acrylics since the 1950s, when the first professionals began to experiment with the medium. The new plastic paint achieved worldwide popularity in the 1960s, when acrylic was discovered by art students and serious Sunday painters. The acrylic paintings produced in the 1950s and 1960s generally look as fresh as the day they were painted. They haven't darkened or cracked, as oil paintings sometimes do. And extensive tests conducted by manufacturers - subjecting acrylic paintings to tremendous wear-andtear that "ages" the colors very rapidly - indicate that acrylic may be the most durable painting medium ever invented. Professional artists who use acrylic are confident that their paintings will remain unchanged for centuries.

Versatility. Acrylic is particularly remarkable for the variety of ways in which you can use it. Used straight from the tube, perhaps thinned with a touch of water, acrylic has a thick,

creamy consistency, like a slightly more fluid version of oil paint. Diluted with much more water, acrylic produces washes of color as fluid and transparent as watercolor. Instead of diluting acrylic paint with water, you can add various painting mediums that will modify both the consistency and the appearance of the paint. One medium makes the paint dry as shiny as a newly varnished oil painting, while another makes it dry to a nonglossy finish, more like pastel. Still another medium will thicken the tube color so you can build up thick layers of paint with a knife or work with brushstrokes as juicy as those of Van Gogh.

Rapid Drying. Because the solvent for acrylic is water, the paint dries to the touch as soon as the water evaporates. This means that you can complete a painting in a matter of hours if you work fast. Equally important, you can pile on layer after layer of color, with just a brief wait between layers. As soon as one layer is dry. you can modify it or totally repaint it with a second layer - which won't disturb the first. This quality makes acrylic particularly good for glazing, which means brushing a transparent layer of color—thinned with water or medium-over a dried layer underneath. Suppose you're painting a portrait of a girl with a luxuriant head of curly hair. You finally get the shapes of the curls right, but the color isn't quite ruddy enough. You just let the first layer of paint dry, then glaze over it with a transparent, coppery mixture that intensifies the color, but still reveals the carefully painted shapes underneath.

Equipment. If you already have the necessary equipment for painting in oil or watercolor, you have a lot of the equipment you need for painting in acrylics. The bristle brushes used for oil painting will do just as well for

acrylic, provided that you lather them up carefully with mild soap and water to get rid of every trace of oil or turpentine. You can also use your watercolor brushes. But acrylic can be rough on those delicate, expensive sables, so many artists use the less expensive nylon, which handles like natural sable. Acrylic will also stick to the same surfaces as oil or watercolor. The canvas sold in art supply stores used to be coated with white oil paint—which repels anything watery, such as acrylic color-but more and more canvas is now sold with a white acrylic coating (or priming) that's fine for acrylic painting. A similar coating is used on most inexpensive canvas boards, so these are suitable for acrylic. And any surface that's good for watercolor watercolor paper, sturdy white drawing paper, illustration board—will be equally receptive to acrylic color. Just keep acrylic away from any surface that looks oily or waxy.

Convenience and Simplicity. Although every artist loves art supply stores and enjoys buying brushes, colors, and other gear, you really need very little equipment to paint in acrylics. A dozen tubes of color will give you a vast range of color mixtures. A half-dozen brushes will do practically every painting job. A couple of jars of water, a rectangle of illustration board or watercolor paper tacked to a drawing board, perhaps a jar of acrylic painting medium—and you're ready to paint.

New Edition. This is a new, updated, redesigned, all-color edition of a book originally called *The Acrylic Painting Book*. I hope you'll enjoy the fact that all the illustrations are now in color and that many of the illustrations are now reproduced even larger than before—so you can see each brushstroke as clearly as possible.

SECTION ONE

THE BASICS

BASIC PAINTING EQUIPMENT

Color Selection. The paintings in this book were all done with a dozen basic colors - colors you'd normally keep on the palette-plus a couple of others kept on hand for special purposes. Although the leading manufacturers of acrylic colors will offer you as many as thirty inviting hues, few professionals use more than a dozen. and many artists get by with fewer. The colors listed below are really enough for a lifetime of painting. You'll notice that most colors are in pairs: two blues, two reds, two yellows, two browns, two greens. One member of each pair is bright, the other subdued, giving you the greatest possible range of color mixtures.

Blues. Ultramarine blue is a dark, subdued hue with a hint of violet. Phthalocyanine blue is far more brilliant and has tremendous tinting strength—which means that a little goes a long way when you mix it with another color. So add it very gradually.

Reds. Cadmium red light is a fiery red with a hint of orange. All cadmium colors have tremendous tinting strength; add them to mixtures just a bit at a time. Naphthol crimson is a darker red and has a slightly violet cast.

Yellows. Cadmium yellow light is a dazzling, sunny yellow with tremendous tinting strength, like all the cadmiums. Yellow ochre (or yellow oxide) is a soft, tannish tone.

Greens. Phthalocyanine green is a brilliant hue with great tinting strength, like the blue in the same family. Chromium oxide green is more muted.

Browns. Burnt umber is a dark, somber brown. Burnt sienna is a coppery brown with a suggestion of orange.

Black and White. Some manufacturers offer ivory black, and others make Mars black. The paintings in this book are done with Mars black, which has slightly more tinting strength. But that's the only significant difference between the two blacks. Buy whichever one is available in your local art supply store. Titanium white is the standard white that every manufacturer makes.

Optional Colors. One other brown, popular among portrait painters, is the soft, yellowish raw umber, which you can add to your palette when you need it. Hooker's green—brighter than chromium oxide green, but not as brilliant as phthalocyanine—may be a useful addition to your palette for painting landscapes full of trees and growing things. If you feel the need for a bright orange on your palette, make it cadmium orange—although you can just as easily create this hue by mixing cadmium red and cadmium yellow.

Gloss and Matte Mediums. Although you can simply thin acrylic tube color with water, most manufacturers produce liquid painting mediums for this purpose. Gloss medium will thin your paint to a delightful creamy consistency; if you add enough medium, the paint turns transparent and allows the underlying colors to shine through. As its name suggests, gloss medium dries to a shiny finish like an oil painting. Matte medium has exactly the same consistency and will also turn your color transparent if you add enough medium, but it dries to a satin finish with no shine. It's a matter of taste. Try both and see which you prefer.

Gel Medium. Still another medium comes in a tube and is called gel because it has a consistency like very

thick, homemade mayonnaise. The gel looks cloudy as it comes from the tube, but dries clear. Blended with tube color, gel medium produces a thick, juicy consistency that's lovely for heavily textured brush and knife painting.

Modeling Paste. Even thicker than gel medium is modeling paste, which comes in a can or a jar and has a consistency more like clay because it contains marble dust. You can literally build a painting 1/4" to 1/2" (6 mm to 12 mm) thick if you blend your tube colors with modeling paste. But build gradually in several thin layers, allowing each one to dry before you apply the next, or the paste will crack.

Retarder. One of the advantages of acrylic is its rapid drying time, since it dries to the touch as soon as the water evaporates. If you find that it dries *too* fast, you can extend the drying time by blending retarder with your tube color.

Combining Mediums. You can also mix your tube colors with various combinations of these mediums to arrive at precisely the consistency you prefer. For example, a 50-50 blend of gloss and matte mediums will give you a semigloss surface. A combination of gel medium with one of the liquid mediums will give you a juicy, semiliquid consistency. A simple mixture of tube color and modeling paste can sometimes be a bit gritty; this very thick paint will flow more smoothly if you add some liquid medium or gel.

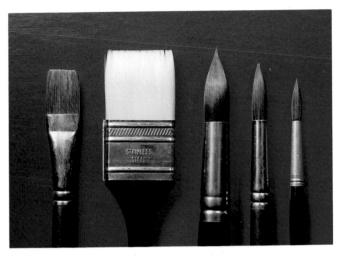

Softhair Brushes. For applying fluid color, diluted with water or liquid medium, many painters prefer softhair brushes. Scanning these brushes from left to right, you see a flat brush that's a blend of natural and synthetic hairs; a flat nylon brush; a big round watercolor brush that's made of synthetic hairs that behave like the more expensive sable; a medium-sized round brush that's also a blend of natural and synthetic hairs; and a small round sable for detail work.

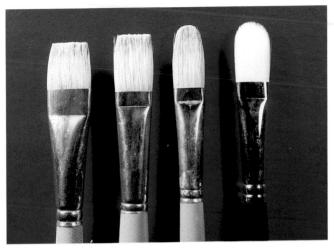

Bristle Brushes. For acrylic paintings, you can use the same bristle brushes that are normally used in oil painting. From left to right, you see a *bright*, with short, stiff hairs that carry lots of paint and make a heavily textured stroke; a *flat*, whose longer bristles make a squarish stroke; a *filbert*, whose long, tapered shape will make a softer stroke; and a *white nylon filbert*, which makes the softest stroke of all.

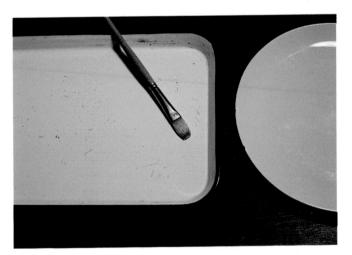

Simple Palettes. A white enamel kitchen tray (left) or a discarded white dinner plate (right) will make a very simple, very efficient palette. Your colors will be easy to mix on the bright white surface—and both of these palettes are easy to wash clean at the end of the painting day. You can rinse away the *wet* color with running water. To remove *dried* color, fill the palette with water and let the colors soak until they soften and you can peel them off.

Watercolor Palette. A plastic or enamel watercolor palette—with compartments for the moist colors—is also a popular acrylic palette. You do your mixing in the big, open space that's "walled in" to protect the fresh colors in the compartments. You can clean the watercolor palette in the same way that you clean the enamel tray or the dinner plate—although it may take a bit more soaking and scrubbing to clean out the compartments.

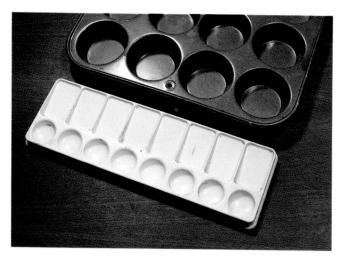

Two Other Palettes. Another type of watercolor palette will also do the job. The white plastic studio palette in the foreground gives you circular wells into which you squeeze your tube colors, plus rectangular compartments for mixing; the compartments slant down at one end so the color will run down and form a pool. In the background is a handy improvised palette: an ordinary muffin tin from the kitchen—with big wells for mixing lots of color.

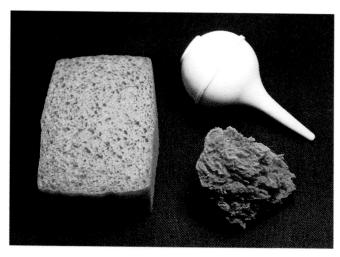

Sponges and Syringe. A big, coarse sponge (left) is enormously convenient for mopping up spills and cleaning up the studio at the end of the day. The small sponge (right foreground) is useful for wiping wet color off some area that you want to repaint and even for *applying* paint. A rubber syringe (right background) is perfect for adding small quantities of water to color mixtures and for moistening colors that are starting to harden on the palette.

Drawing Board and Tape. When you paint on water-color paper or any sturdy paper, it's best to tape the sheet down to a wooden drawing board, a rectangle of plywood, or a piece of fiberboard as you see here. Buy drafting tape with a special adhesive that makes the tape easy to remove without damaging the paper. The tape should be at least 1" (25 mm) wide so it overlaps at least 1/2" (12-13 mm) of the paper edge and holds it down securely.

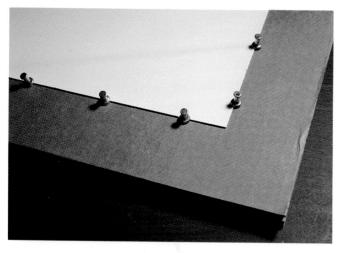

Use Tacks for Illustration Board. Illustration board is too thick to tape down, so use pushpins or thumbtacks (drawing pins) to secure the painting to a thick board. One of the softer fiberboards, about 3/4" (18 mm) thick, will take the pins more easily than hardboard. You can also make a thick, lightweight board by gluing together several sheets of brown corrugated board, salvaged from packing boxes—as you see here. The pins don't go through the painting, but just overlap the edges.

HOW TO CHOOSE THE RIGHT SURFACE

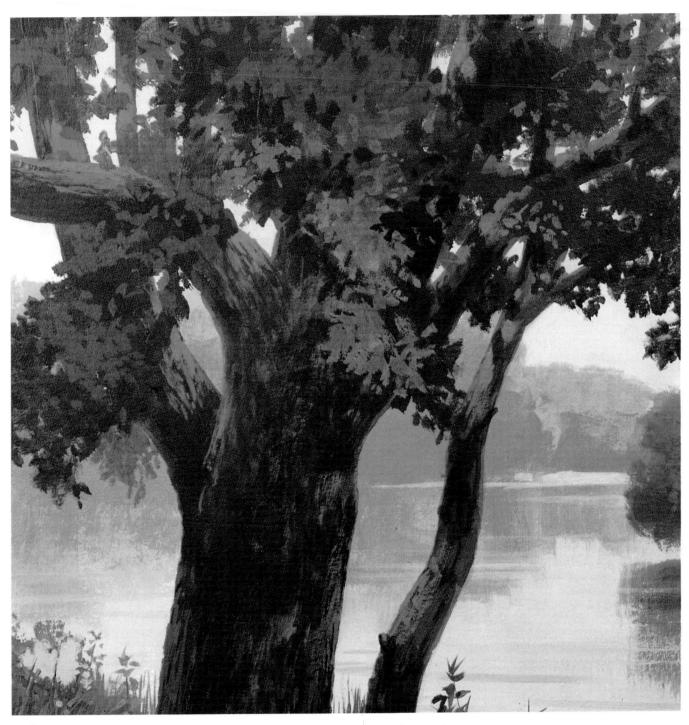

Illustration Board. Perhaps the most popular surface for acrylic painting is illustration board—white drawing paper mounted on thick cardboard. The standard illustration board has just a slight texture—or tooth—to respond to all sorts of brushwork. For example, the texture of the paper accentuates the rough brushwork on the tree trunks. On the other hand, the paper is just smooth enough for pre-

cise, detailed work, such as the weeds and grasses in the foreground, which are painted with a slender, pointed brush and fluid color. This all-purpose surface is frequently called a "kid finish," which means that it has a slight texture. You can also buy a "high" or "plate" finish that's absolutely smooth, but this is suitable only for *very* precise, detailed work.

HOW TO CHOOSE THE RIGHT SURFACE

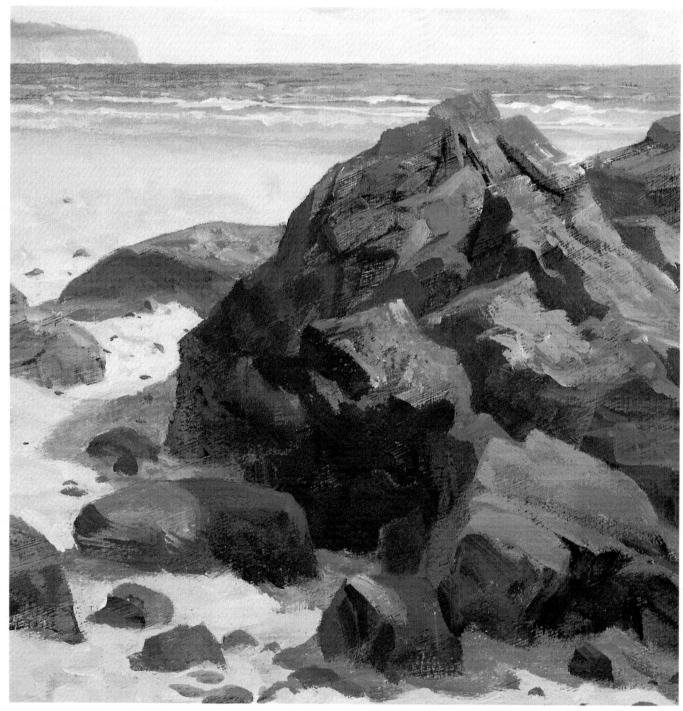

Gesso Board. Manufacturers of acrylic colors also make a thick, white paint for coating hardboard, cardboard, canvas, or any other painting surface. This acrylic gesso, as it's called, is the same chemical formula as the tube colors. As it comes from the can or the jar, the gesso is a very thick liquid. You can apply it directly from the jar, without any additional water, using a nylon housepainter's brush. The bristles really dig into the paint and leave a distinct mark on the surface.

For a slightly smoother surface, you can thin the gesso with enough water to produce a creamy consistency: you'll probably need a couple of coats. For a *really* smooth surface, add enough water to produce a milky consistency and apply three or four coats. Apply successive coats at right angles to one another: the strokes of the first coat should move from top to bottom, while the strokes of the second coat should move from left to right. If the hardboard has a smooth side and a

rough side, it's best to apply the gesso to the smooth side. If you're coating illustration board, paint an equal number of coats on both sides so that the board won't warp. This painting was done on a sheet of watercolor board—watercolor paper mounted on a sturdy cardboard by the manufacturer—which the artist then brushed with gesso to create a surface over which acrylic color flows very smoothly.

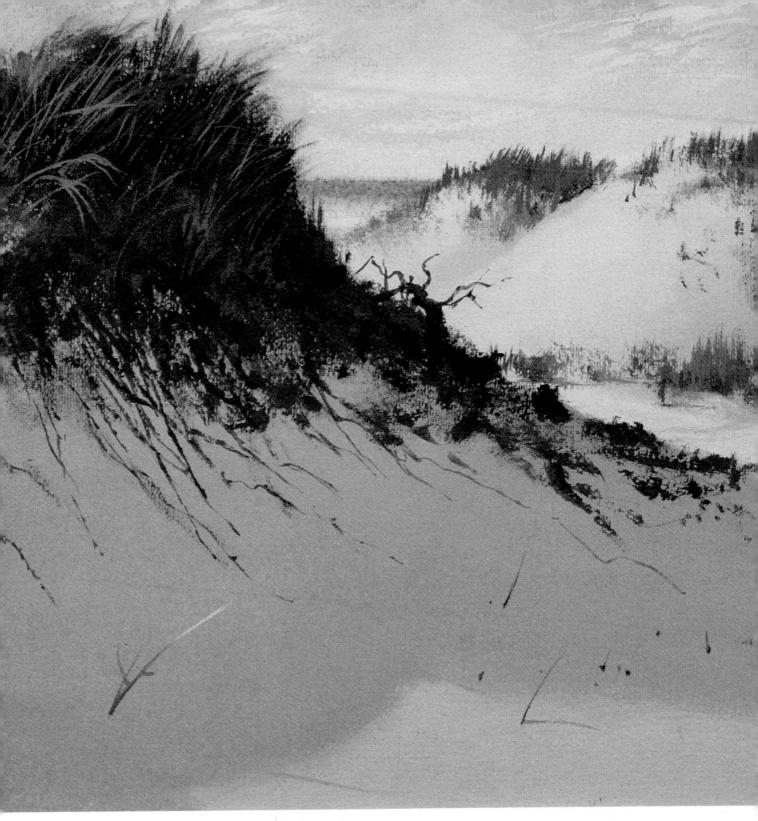

Watercolor Paper. If you discover that you like to work with very fluid color—diluted with lots of water so the paint handles like watercolor—watercolor paper is the ideal painting surface. Here's a section from a coastal scene painted on cold-pressed paper, which means a surface that has a moderate texture, not too rough and not too smooth. The most versatile watercolor paper is a fairly thick sheet

designated as 140-pound stock, heavy enough so that it won't curl too badly when it gets wet; it's moldmade, which means that it's machine-made, but surprisingly close to the expensive, handmade papers preferred by professionals; and it's cold-pressed—called a "not" surface in Britain. If you like bold, rough brushwork, try a rough surface instead of the cold-pressed.

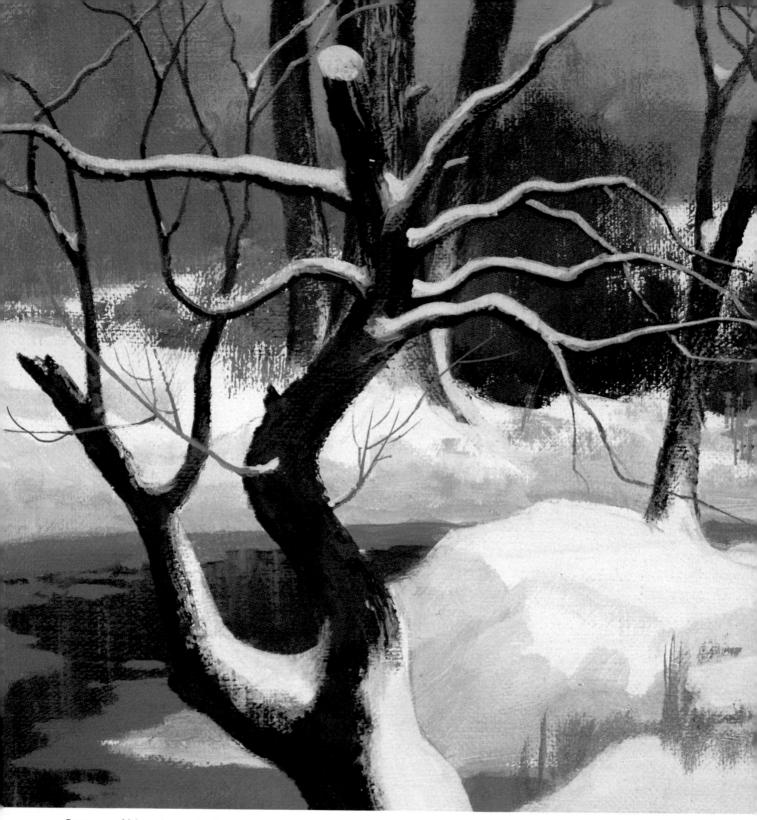

Canvas. Although canvas is most widely used for oil painting, it's also an excellent surface for acrylic. The weave of the canvas produces a beautiful texture that softens and enlivens the brushstroke. In this closeup of a snow scene, you can see how the texture of the canvas softens and blurs the stroke, helping to produce those subtle gradations from dark to

light. And the fibers of the canvas tend to appear within the strokes as flecks of light and dark, making the strokes look luminous and transparent. Canvas boards are the most inexpensive form of canvas: just thin fabric glued to cardboard and usually coated with white acrylic, which makes the surface particularly receptive to acrylic colors. You can also buy art-

ists' canvas in rolls, which you cut into sheets and nail to a rectangular frame made of wooden strips called canvas stretchers. If you buy canvas that's precoated with white paint, be sure it's white acrylic, not oil paint. Or buy so-called raw canvas, which is plain linen or cotton. Stretch it yourself, and then give it two or three coats of acrylic gesso.

Brushes. Because you can wash out a brush quickly when you switch from one color to another, you need very few brushes for acrylic painting. Two large flat brushes will do for covering big areas: a 1" (25 mm) bristle brush, the kind you use for oil painting; and a softhair brush the same size, soft white nylon or a blend of natural and synthetic hairs. Then you'll need another bristle brush and another softhair brush, each half that size. For more detailed work, add a couple of round softhair brushes-let's say a number 10, which is about 1/4" (6 mm) in diameter, and a number 6, which is about half as wide. If you find that you like working in the transparent technique, which means thinning acrylic paint to the consistency of watercolor, it might be helpful to add a big number 12 round softhair brush, either soft white nylon or a blend. Since acrylic painting will subject brushes to a lot of wear and tear, few artists use their expensive sables.

Painting Surfaces. If you like to work on a smooth surface, use illustration board, which is white drawing paper with a stiff cardboard backing. For the transparent technique, the best surface is watercolor paper - and the most versatile watercolor paper is moldmade 140-pound stock in the cold-pressed surface. Acrylic handles beautifully on canvas, but make sure that the canvas is coated with white acrylic paint, not white oil paint. Your art supply store will also sell inexpensive canvas boards-thin canvas glued to cardboard-that are usually coated with white acrylic, which is excellent for acrylic painting. You can create your own painting surface by coating hardboard with acrylic gesso, a thick, white acrylic paint which comes in cans or jars. For a smooth surface, brush on several thin coats of acrylic gesso diluted with water to the consistency of milk. For a rougher surface, brush on the gesso straight from the

can so that the white coating retains the marks of the brush. Use a big nylon housepainter's brush.

Drawing Board. To support your illustration board or watercolor paper while you work, the simplest solution is a piece of hardboard or fiberboard. Just tack or tape your painting surface to the board and rest it on a tabletop with a book under the back edge of your board so it slants toward you. You can tack down a canvas board in the same way. If you like to work on a vertical surface - which many artists prefer when they're painting on canvas, canvas board, or hardboard coated with gesso-a wooden easel is the solution. If your budget permits, you may buy a wooden drawing table, which you can tilt to a horizontal, diagonal, or vertical position just by turning a knob.

Palette. One of the most popular palettes is the least expensive—just squeeze out and mix your colors on a white enamel tray, which you can probably find in a shop that sells kitchen supplies. Another good choice is a white metal or plastic palette (the kind used for watercolor) with compartments into which you squeeze your tube colors. Some acrylic painters like paper palettes: a pad of waterproof pages that you tear off and discard after painting.

Odds and Ends. For working outdoors, it's helpful to have a wood or metal paintbox with compartments for tubes, brushes, bottles of medium, and other accessories. You can buy a tear-off paper palette and canvas boards that fit neatly into the box. Many acrylic painters carry their gear in a toolbox or a fishing tackle box, both of which also have lots of compartments. Three types of knives are helpful: a palette knife for mixing color; a painting knife with a flexible blade; and a sharp one with a retract-

able blade (or some single-edge razor blades) to cut paper, illustration board, or tape. Paper towels and a sponge are useful for cleaning up-and they can also be used for painting, as you'll see later. You'll need an HB drawing pencil or just an ordinary office pencil for sketching in your composition before you start to paint. To erase pencil lines, get a kneaded rubber (or "putty rubber") eraser, which is so soft that you can shape it like clay and erase a pencil line without abrading the surface. To hold down that paper or board, get a roll of 1" (25 mm) drafting tape and a handful of thumbtacks (drawing pins) or pushpins. To carry water when you work outdoors, you can take a discarded plastic detergent bottle (if it's big enough to hold a couple of quarts or liters) or buy a water bottle or canteen in a store that sells camping supplies. For the studio, find three wide-mouthed glass jars, each big enough to hold a quart or a liter.

Work Layout. Before you start to paint, lay out your supplies and equipment in a consistent way, so everything is always in its place when you reach for it. Obviously, your drawing board or easel is directly in front of you. If you're right-handed, place your palette, those three jars, and a cup of medium to the right. (Save your plastic margarine containers or yogurt cartons for your painting medium.) In one jar, store your brushes, hair end up. Fill the other two jars with clear water: one is for washing your brushes; the other provides water for diluting your colors. Establish a fixed location for each color on your palette. One good way is to place your cool colors (black, blue, green) at one end and the warm colors (yellow, orange, red. brown) at the other. Put a big dab of white in a distant corner, where it won't be fouled by the other colors.

LEARNING TO HANDLE COLOR

Setting the Polette. Naturally, you start the painting day by squeezing out your dozen colors on the palette. Squeeze the collapsible tube from the end, replace the cap, and then roll up the empty portion of the tube. You'll get more paint out of the tube this way—which obviously means that you'll save money on expensive artists' colors. Acrylic paint dries quickly, as you know, so keep an eye on the mounds of colors on your palette and periodically sprinkle a few drops of water on any mound that looks like it's starting to solidify.

Thinning with Water. To blend tube color with water, wet the brush first, then dip it into the paint—never vice versa. Touch the tip of the wet brush to the mound of color, then blend the color and the water on the mixing area of your palette. Keep the paint in the mixing area away from the edges of the palette where the moist paint is stored. Don't let the fluid mixtures foul the mounds of pure color.

Thinning with Medium. If you're going to thin your tube color with gloss or matte medium, start by wetting the brush thoroughly, then pick up some tube color on the tip and transfer the color to the mixing area. Dip the tip of the brush into the medium and blend it into the color that's waiting on the mixing surface. To keep the medium clean-so you can add it to other mixtures - it's a good idea to rinse the brush before you dip it into the cup of medium. If you want to blend tube color with gel medium, pick up some fresh color with the tip of the wet brush, squeeze out some gel onto the mixing surface, and blend them. If you want a lot of thick paint, just squeeze a gob of color and a gob of gel side-by-side on the mixing surface and blend them with a palette knife.

Keep Your Brush Wet. As you can see, it's essential to keep your brushes wet at all times. Always pick up color or medium with a wet brush and rinse the brush frequently so that no paint or medium ever dries on those delicate hairs. Once acrylic dries on a brush, the hairs will be stiff as a board. The dried paint will never wash out with water. You *can* buy a powerful solvent called a "brush cleaner," but even if you do succeed in removing the dried color, the brush is never the same.

Mixing Colors. The ideal way to mix colors is to transfer some color from the edge of the palette to the mixing surface - with a wet brush, of course—then rinse the brush before you pick up each successive color. But, in reality, many artists get carried away with the excitement of color mixing and don't take the time to rinse the brush every time they pick up a new color. If you don't have the patience to do all that rinsing, just keep your mounds of color as clean as possible by doing your mixing in the center of the palette. And do rinse your brush before you start a new mixture. If you don't, the first mixture will work its way into the second.

Avoiding Mud. Two or three colors, plus white, should give you just about any color mixture you need. One of the unwritten "laws" of color mixing seems to be that more than three colors—not including white—will produce mud. If you know what each color on your palette can do, you should never really *need* more than three colors in a mixture. And just two colors will often do the job.

Testing Mixtures. It's worthwhile to spend an afternoon just mixing colors. Be methodical about it: mix every color on your palette with every other color. You can brush samples of all

the mixtures on sheets of thick white drawing paper and label every sample to record the components of the mixture. You might have one sheet for blues, another sheet for greens, and so on. Try varying the proportions of the mixtures. For example, if you're mixing a red and a yellow to produce orange, start with equal amounts of red and yellow; then try more red and less yellow; finally, see what you get with more yellow and less red. You'll be astonished to see how many variations you can get with just two colors. And when you start working with three—varying the proportions of all three components—the sky's the limit!

Mixing on the Painting. The palette is only one place where you can mix colors. The special qualities of acrylic make it possible to mix on the painting surface too. When a layer of color is dry, there are ways to produce optical mixtures, which means putting one layer of color over another, so the underlying layer shows through, and the two layers "mix" in the eye of the viewer. Over one dried layer of color, you can brush a second color that's been thinned with enough water or medium to make it transparent. When the second layer dries, it's like a sheet of colored glass through which you can see the color beneath. That transparent color is called a glaze. Another type of optical mixture can be produced by scumbling. When the underlying color is dry, you apply a second opaque color with a back-andforth scrubbing motion that distributes a thin veil of paint through which you can still see the underlying hue. Unlike the glaze, the scumble consists of opaque color, but it's distributed so thinly that you can see through it.

OPAQUE PAINTING TECHNIQUE

Step 1. The simplest way to work with acrylic is to build up a picture with layers of opaque color, each layer opaque enough to cover the color underneath. Each layer is allowed to dry thoroughly before you apply the next layer. Colors are mixed on the palette with enough water to produce a consistency like milk or light cream. This is a logical, step-by-step procedure, so it's important to make a clear drawing on the painting surface—and to have a clear idea of the steps you'll follow when you start to paint. This demonstration is painted on a sheet of illustration board that's been brushed with two layers of acrylic gesso. The preliminary pencil drawing defines the shapes of the landscape precisely, but with minimal detail. The important job is to visualize the flat shapes, which the brush will follow carefully.

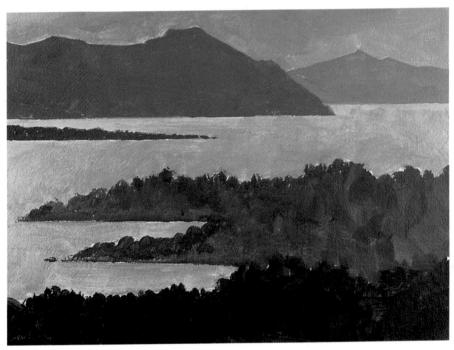

Step 2. Now each flat shape is filled with color to lay the foundation for the painting. Flat softhair brushes cover both the sky and the water with similar mixtures of ultramarine blue, a touch of yellow ochre, and white. (Remember that the water usually mirrors the sky color.) Darker versions of this same mixture are used to block in the pale mountain in the distance, the darker mountain to the left, and the still darker strip of land beneath the mountain at the left. The wooded shore in the immediate foreground is loosely painted with a flat bristle brush that carries a mixture of ultramarine blue, cadmium yellow, and burnt sienna. (The brushwork suggests the texture of the trees.) And the twin strips of wooded shore just beyond the foreground are painted with a variation of this same mixture-plus a touch of white and a bit less yellow.

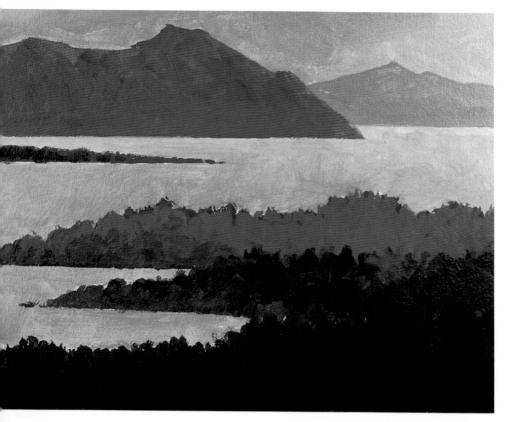

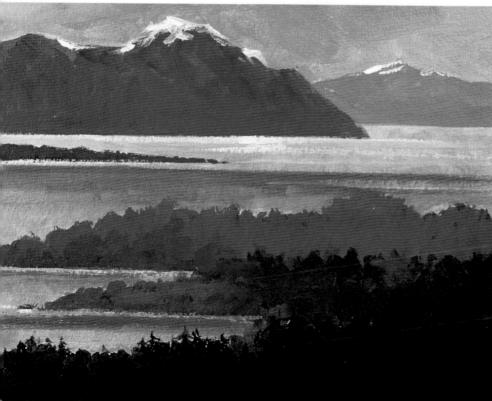

Step 3. By the end of Step 2, you have a flat, highly simplified, but complete pictorial design-a kind of 'poster" version of the painting. The next step is to develop the forms with broad strokes, building up the pattern of light and shadow, developing texture, and making broad adjustments in color. A flat softhair brush blocks in the shadows on the side of the dark mountain with ultramarine blue, burnt sienna, yellow ochre, and a hint of white. Touches of shadow are also placed on the low island with phthalocvanine blue and burnt sienna-and this same mixture darkens the wooded shore in the immediate foreground. Varying degrees of white and a whisper of yellow ochre are added to this mixture to develop the tone and texture of the other two strips of wooded shore-one of which is extended to the left. These wooded areas are painted with a flat bristle brush whose rough strokes allow a bit of the underlying color to come through.

Step 4. Details and finishing touches are saved for the final stage. A small, round softhair brush adds the sunlit snow to the mountain tops and reflected light on the water with strokes of white, modified with a speck of yellow ochre for warmth. The same brush picks up the original sky mixture to add dark strips to the water for shadows and reflections. The two areas of wooded shore beyond the foreground are left untouched, except for a touch of subtle color that lightens some of the foliage to create more atmosphere—the same mixture used in Step 2. Now the small round brush concentrates on the foreground, adding small strokes for trees with phthalocyanine blue and burnt sienna. The foreground isn't covered with trees the artist adds just enough detail to make you imagine more trees than he actually paints.

TRANSPARENT PAINTING TECHNIQUE

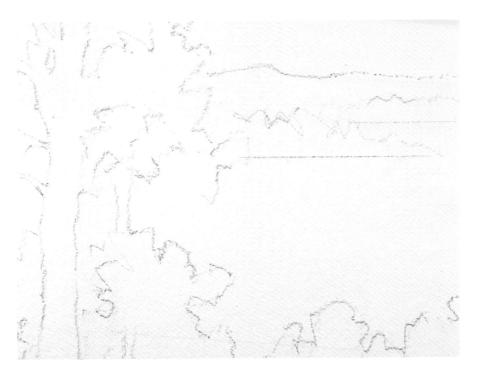

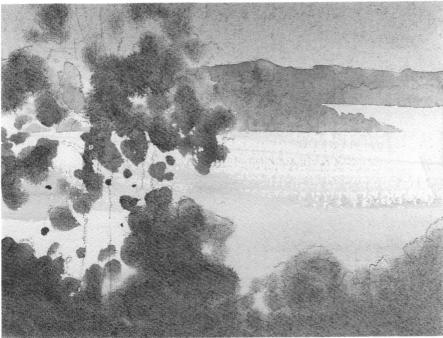

Step 1. If you add enough water, acrylic tube color behaves like watercolor. It becomes highly fluid and transparent, lending itself to the spontaneous brushwork that watercolorists treasure. In fact, many watercolorists actually paint "watercolors" in acrylic. The secret of a successful watercolor (even when it's painted in acrylic) is advance planning. So the artist begins with a loose, but clearly defined, pencil drawing on a sheet of cold-pressed watercolor paper. The pencil lines define the shapes of the foliage, tree trunks, and main branches in the foreground, leaving out smaller trunks and branches that may be added later. The drawing also traces the contours of the distant island and shoreline, but omits any suggestion of detail in the water, which remains blank paper.

Step 2. As in the opaque technique, the purpose of Step 2 is to create a flat, simplified, "poster" version of the painting to act as a foundation for the work to be done later. But now the artist works in pale washes of color because he knows that his colors are transparent and he can't cover any mistakes or change his mind. He's going to work from light to dark. First he paints the sky and water with ultramarine blue, softened by a touch of yellow ochre, and lightened with extra water where sky and water approach the horizon. The brush skims lightly over the water at one point to leave a ragged "drybrush" stroke that suggests a glint of light. Then the warm foliage is blocked in with broad strokes of cadmium yellow, muted by a touch of burnt sienna, and diluted to a pale wash. When the sky and water are dry, the shore and island are blocked in with a darker version of the sky mixture.

Step 3. Now the artist concentrates on the foreground. The hot autumn foliage is painted with broad strokes of cadmium red, cadmium orange, and burnt sienna. Some strokes contain more red, while others contain more yellow-and they all flow into one another as the artist works quickly, painting one stroke next to (or over) another. While the foliage is still wet, the point of the round softhair brush paints the trunks and branches with rapid strokes that blur into the hot color of the leaves. This dark mixture is a combination of burnt umber and ultramarine blue-which is also used to suggest some patches of shadow among the leafy clusters. Notice that the underlying golden tone shines through here and there, and that the brush defines the foliage as big masses, picking out very few individual leaves.

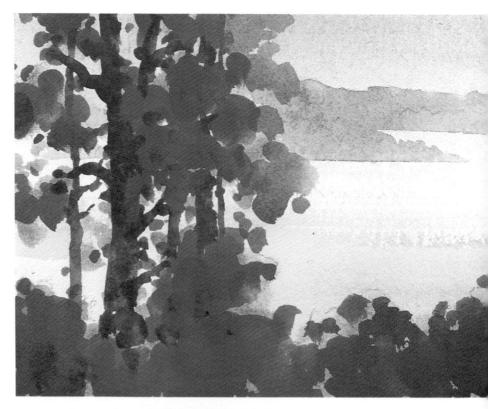

Step 4. In Step 1, the distant land was painted as a single shape. Now a darker version of the original mixture is used to repaint this area and divide it into three shapes, one behind the other. The same mixture darkens the water in the foreground and adds dark streaks to the more distant water. A big round brush picks up a mixture of burnt umber and ultramarine blue to add more shadows to the foliage. And a smaller brush adds the finishing touches and details: smaller tree trunks and branches with ultramarine blue and burnt sienna; and a few leaves (but not too many) with various combinations of cadmium red, cadmium yellow, and yellow ochre. As you look at the finished painting, notice how the golden undertone, painted over the foliage in Step 2, still shines through the darker layers of Steps 3 and 4, enriching and unifying all the color mixtures.

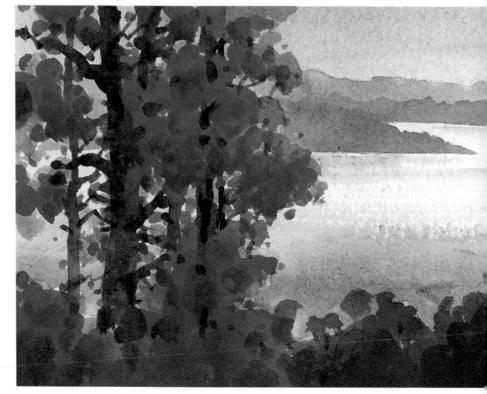

COMBINING OPAQUE AND TRANSPARENT TECHNIQUES

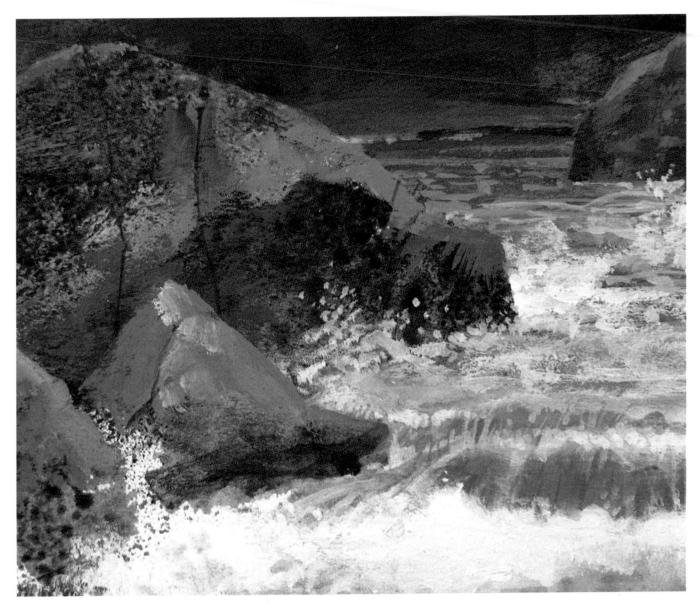

Opaque over Transparent.

Acrylic paintings often combine opaque and transparent color. The usual way to combine them is to begin with transparent color and complete the painting with opaque color that allows the transparent passages to shine through at certain spots. In this close-up of the demonstration painting of the stream on page 102, the rocks have been started with transparent color in the shadows; over this transparent undertone, short, thick strokes

of opaque color are added to accentuate the lights. The cool, transparent undertone of the water shines through the opaque and semiopaque strokes of the foam. Note how the foam is painted with short, thick dabs where the "white water" is most dense; with small dots to suggest flecks of foam splashing upward; and with slender lines where the foam trickles over the dark water. A classic "rule" is to paint transparent darks and opaque lights.

ANALYZING LIGHTING

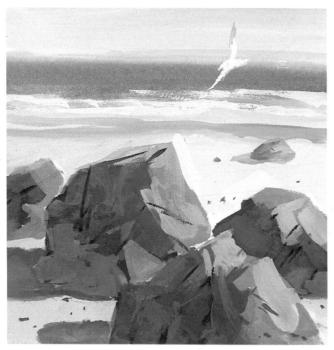

Identifying the Light Direction. When you're painting the light and shadow planes of any object, it's helpful to identify the direction of the light. The sun is definitely coming from the right-hand side of these rocks, so the lighted planes are on the right and the shadow planes are on the left. The rocks also cast shadows on the sand to the left.

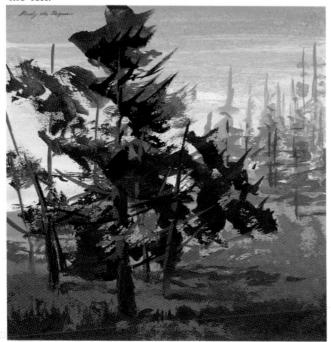

Look for the Cast Shadows. If you're not sure about the direction of the light, look for the cast shadows—those that are thrown on the ground. These trees cast shadows to the right, so the light source must be on the left. Once you know the direction of the light, you can even exaggerate the lights and shadows to make the forms look more three dimensional.

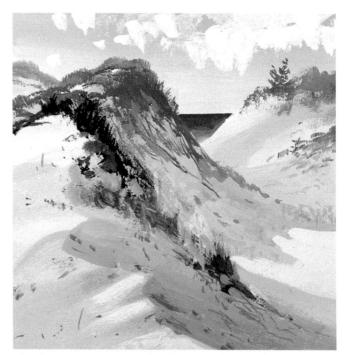

Shadows Contain Light. The sun is to the left of the dunes, so the lighted areas are on the left and the shadows are on the right. But these shadows aren't just dark patches; they're filled with light that's reflected from the sky. Always look for the light *within* the shadows.

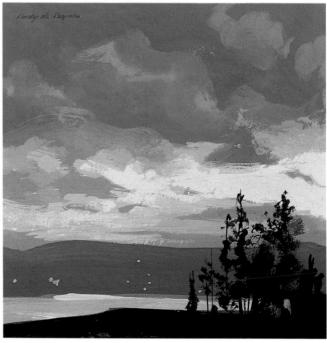

Back Lighting Creates Silhouettes. Early in the morning and late in the afternoon—particularly at sunrise and sunset—the sun is low in the sky, *behind* the shapes of the landscape. This effect is called back lighting and throws the shapes—like these trees and the hills beyond—into silhouette. Many painters prefer to capture these dark, dramatic shapes.

UNDERSTANDING AERIAL PERSPECTIVE

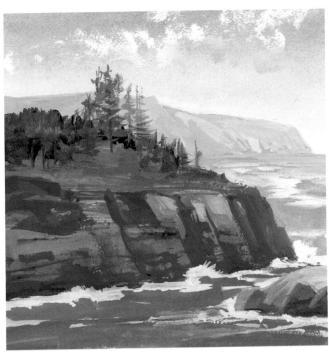

Near and Far. The near headland is darker, more colorful, more detailed, and contains more contrasts of light and shadow than the distant headland—which is paler, more subdued in color, and much less detailed. This familiar phenomenon is called aerial perspective.

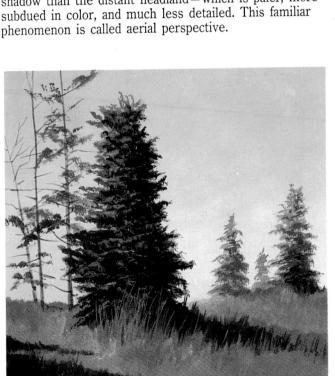

Spatial Planes. Aerial perspective helps you to establish spatial planes in your outdoor paintings. The biggest, darkest tree is in the immediate *foreground*. The second largest tree is paler, as well as smaller, and you know it's in the *middle ground*. The smaller trees become paler still as they move into the *distance*. The most distant tree is smallest and palest.

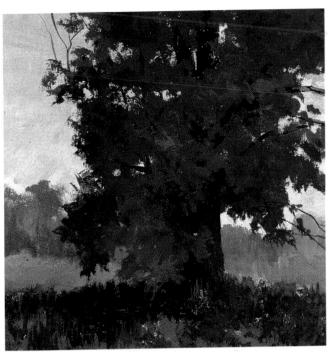

Bright and Subdued. To create a sense of deep space in a landscape, you can exaggerate aerial perspective. The brilliant colors of the foliage place the big tree strongly in the foreground—in contrast with the more subdued and distinctly cooler foliage at the horizon. Distant colors do tend to look cooler—which means bluer.

Overcast Day. Aerial perspective may be more subtle on an overcast day—but the "laws" still work. You can see darker tones, more detail, and stronger color in the *fore-ground*; paler, more subdued color and less detail in *middle ground*; and still quieter color, with minimal detail, in the distant planes.

FOUR WAYS TO IMPROVE YOUR COMPOSITION

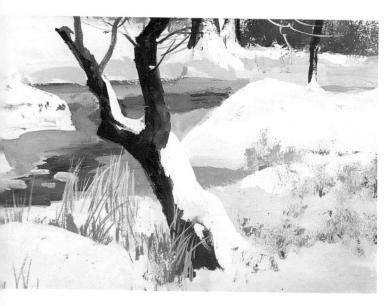

Asymmetrical Design. Place the center of interest off center, like this tree, which is just a bit to the left of the center line of the painting. (The tree could also be a bit to the right of the center line.) Don't divide your composition in equal halves by placing the center of interest right in the middle. Asymmetrical design is more interesting than symmetrical design.

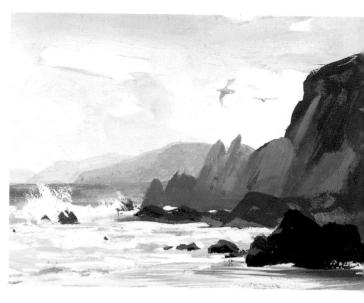

High or Low Horizon. For the same reason, place your horizon line below the center of the picture—as you see here—or above the center. Don't divide the picture in two equal halves by running the horizon straight through the middle. Once again, asymmetry is more interesting than symmetry.

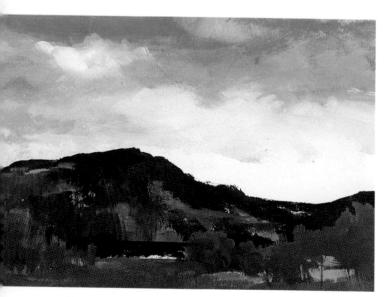

Unequal Spaces. In painting landscapes and seascapes, give the sky more space and the land less—as you see here—or reverse the arrangement, giving more space to the land and less to the sky. And while you're looking at this picture, notice the location of the peak that's the focal point of the painting—off to the left, *not* dead center like a bull's-eye.

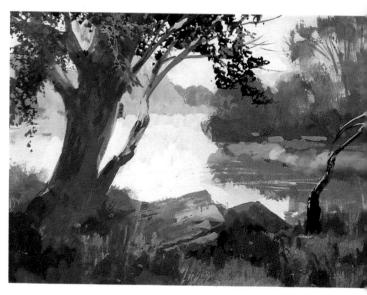

Maximum Contrast. Save your strongest contrast for the focal point of the picture. Here, the strongest contrast of light and dark is where the dark tree trunk is silhouetted against the bright water. In the same way, you can place your strongest contrast of *colors* at the center of interest. It's contrast that carries the viewer's eye to the focal point.

DEVELOPING GOOD PAINTING HABITS

Learning the Rules. Acrylic is extraordinarily durable, but this can be a problem if you don't learn certain "rules." The basic thing to remember is that acrylic, once it dries, is almost impossible to remove from any absorbent surface. So be sure to wear old clothes when you paint. Like every artist, you'll get paint on your clothes, and you won't want to bother washing out every spot before it dries. So simply expect to ruin what you wearand wear something you were ready to throw out anyhow. This includes footwear: wear your most battered old shoes, sandals, or sneakers, so you won't worry when they're spattered with paint. You can also expect drops of paint to land on the top of your work table, the floor, and perhaps even the wall. So try to avoid working in a room where you've got to worry about antique furniture, your best rug, or new wallpaper. It's best to work in a room where you can really make a mess. If that's not possible, protect your surroundings with newspapers or the kind of "dropcloth" used by house painters.

Care of Brushes. Your brushes are your most valuable equipment. While you're painting, always keep your brushes wet, wash them frequently, and (above all) never let acrylic paint dry on the brush. When you're finished, rinse each brush thoroughly in clear water-not in the muddy water that remains in the jars. That rinsing should remove most of the visible color, but there's often some invisible paint, particularly at the neck of the brush, where the hairs enter the metal tube called the ferrule. So it's wise to stroke the brush gently across a bar of mild soap (not corrosive laundry soap) and lather the brush in the palm of your hand with a soft, circular motion until the last trace of color comes out in the lather. Rinse again. When all your brushes have been

washed absolutely clean, shake out the water and shape each brush with your fingers. Press the round brushes into a bullet shape with a pointed tip. Press the flat brushes into a neat square with the hairs tapering in slightly toward the forward edge. Don't touch them again until they're dry.

Storing Brushes. Allow the brushes to dry by placing them, hair end up, in a clean, empty jar. When they're dry, you can store them in this jar unless you're worried about moths or other pests who like to eat natural fibers. If these insects are a problem, store bristles, sables, and other natural hairs in a drawer or box. Just make sure that the hairs don't press against anything that might bend them out of shape. Sprinkle mothballs or mothkilling crystals among the brushes. You don't have to worry about synthetic fibers like nylon, which you can leave in the jar if you prefer.

Cleanup. As you work, you'll certainly leave droplets and little pools of liquid color on your work table, your drawing board or drawing table, your easel, and your paintbox. Ideally, you should sponge these up as they happen, but it is hard to do this in the excitement of painting. So sponge up what you can - while it's still wet but then be prepared for more cleanup work after the painting session is over. At that point, the droplets and spills will be dry. If they've fallen on newspaper or a dropcloth, you can just toss out the papers, fold up the dropcloth, and forget about them. But you will want to remove dried color from other surfaces. Some of the color will come off if you scrub vigorously with a damp sponge or a wet paper towel: the paint won't really dissolve, but the dampness will soften it, and the friction will rub it away. If that doesn't work, try a mild household cleanser.

Cleaning Your Palette. By the time you've finished painting, a lot of paint will certainly have dried on your palette. You can easily wash off the remaining liquid color, but that leathery film of dried color won't come off under running water. If you're working on an enamel tray or a palette that's made of metal or plastic, the simplest solution is to fill the tray or palette with a shallow pool of cold water and let the dried paint soak for half an hour. The color won't dissolve, but the water will loosen it, so you can peel off the dried color or rub it away with your fingertips. A blunt tool, such as a flat wooden stick or a plastic credit card, may also help. Don't use a razor blade or a knife, which will scratch the palette. Of course, if you use a tear-off paper palette, just peel away the top sheet and you're done.

Care of Tubes and Bottles. At the end of the painting session, take a damp paper towel and wipe off the "necks" of your tubes and bottles to clean away any traces of paint or medium that will make it hard to remove the caps the next time you paint. Do the same inside the caps themselves. If you do have trouble getting off the cap, soak the tube or bottle in warm water for ten or fifteen minutes. That should soften the dried color in the neck, so you can then wrestle off the cap.

Washing Your Hands. There's no way to avoid getting paint on your hands. So don't eat or smoke while you paint, since certain pigments (such as the cadmiums) are mildly toxic and should be kept away from your mouth. Wash your hands carefully with soap and water after a painting session. Human skin contains oil, so it won't be too hard to remove dried acrylic color. A small scrub brush will help.

EXPERIMENT WITH OFFBEAT PAINTING TOOLS

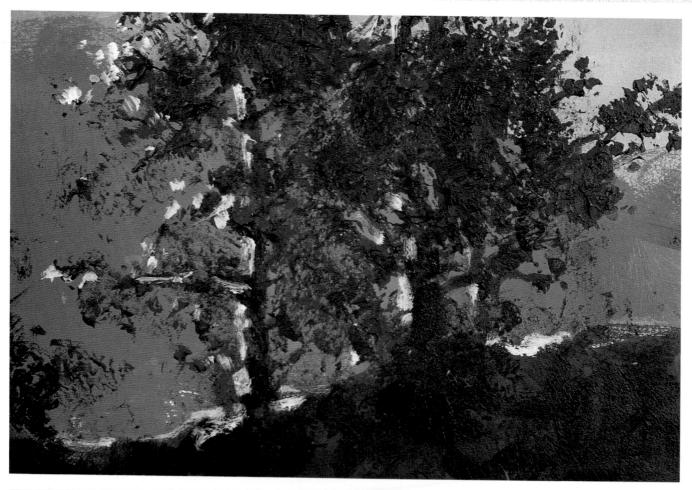

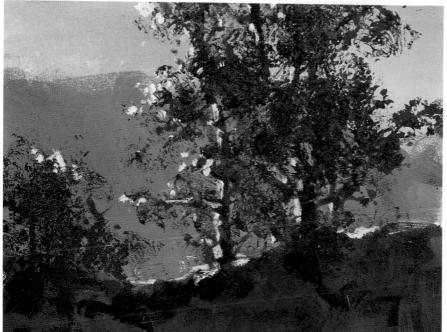

Finished Painting. In the completed painting, you can see how the complex forms and details of the foliage are silhouetted against a flat, simple background of hills and sky. Try the imprinting method with other improvised painting tools: a crumpled paper towel, a scrap of rough fabric, *anything* with an interesting texture.

Painting with a Sponge. Brushes aren't the only painting tools. These trees were painted by mixing a pile of thick, gummy, undiluted color on the palette; dipping a small, slightly moistened, natural sponge into the pasty color; and *imprinting* the texture of the foliage by pressing the sponge against the surface of the gesso board. When the color was dry, the tip of a small softhair brush was used to draw trunks, branches, and the flashes of light on the edges. This is a life-size close-up of part of the painting shown at left.

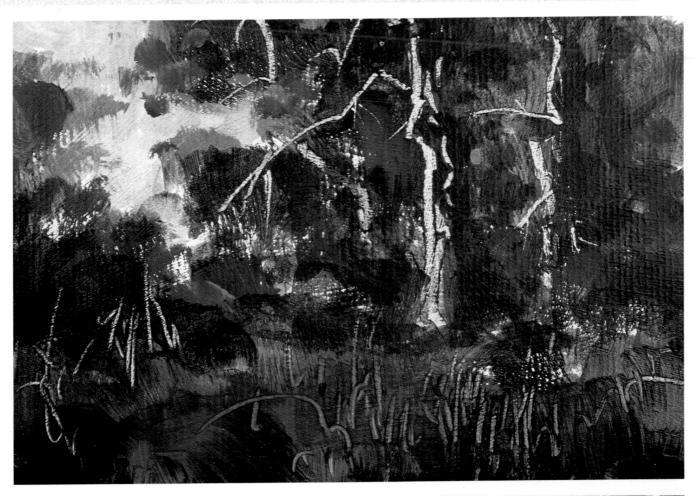

Scraping and Scratching. The sunlit edges of these tree trunks and branches were "painted" with the sharp tip of the brush handle. The color was mixed on the palette with some gel medium and then brushed quickly over the gesso-coated watercolor board. While the color was still moist, the brush handle was used to scrape away the color to reveal the pale tone of the painting surface. The weedy area was underpainted with yellow ochre, and then allowed to dry. Next, a darker mixture of burnt sienna and cadmium yellow (with some gel medium) was brushed over the underpainting and scratched-while still wet - with a chopstick to suggest sunlit grass and weeds. This is a closeup of a section of the painting shown at right.

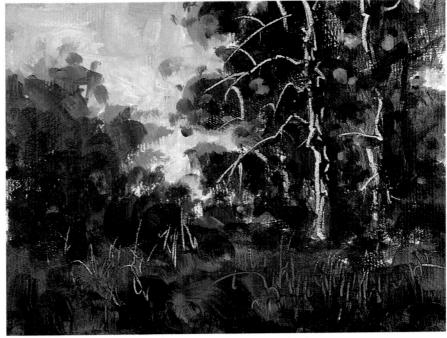

Finished Painting. Use this technique selectively. Don't distract and bewilder the viewer by overdoing it. Experiment with other tools, such as sharp and blunt knife blades, toothpicks, spoons, plastic credit cards—any tool that will push aside the moist color without tearing or abrading the painting surface.

HOW TO CORRECT PAINTINGS

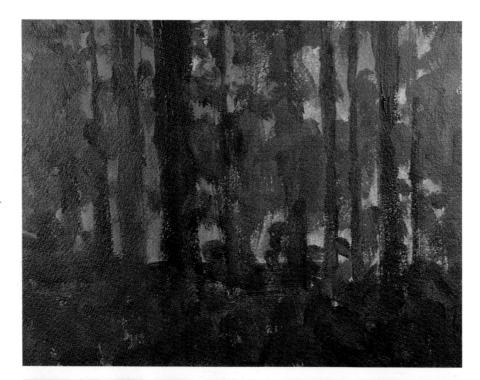

Step 1. Acrylic paintings are easy to correct when they go wrong. Because acrylic colors dry so quickly, corrections can be made very swiftly by a variety of methods that you'll see in a moment. Here's a landscape that's gotten off to a bad start. The idea was to paint a forest in autumn with lots of warm, rich colors—but the whole tonality of the painting has veered off the track and turned to a monotonous, muddy brown. There's no light, no sky, no variety of color. If this were a watercolor, you'd have to throw out the painting and start on a fresh sheet. If you were working in oil, you'd have to scrape it off. But acrylic gives you a number of solutions.

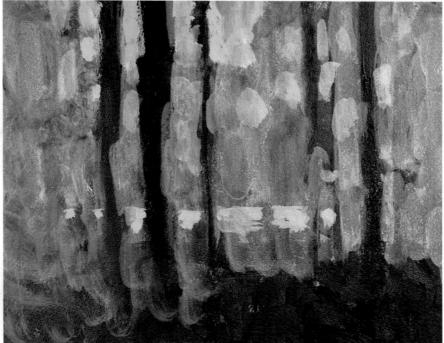

Step 2. Because acrylic can be overpainted as soon as it dries, it's easy to make a fresh start. The artist takes advantage of the opacity of titanium white to block in some patches of sky with white, ultramarine blue, and a speck of phthalocyanine green. He repeats this mixture when he adds a few strokes to suggest a distant lake at the horizon, glimpsed through the woods. Finally, he adds a lot of water to this mixture to scumble a mist of cool color over some of the trees. which now drop back into the middle distance. But he does leave some tree trunks dark and untouched, so they remain in the foreground. All this is done very roughly, with just a few strokes, and in just a few minutes. But now the painting is ready to move in a new direction.

Step 3. Over the very loose foundation colors of Step 2, the artist begins to develop the colors of autumn foliage. With loose brushwork, he builds up the quiet tones of the distant foliage with warm grays: mixtures of ultramarine blue, burnt sienna, yellow ochre, and white. He darkens and redefines the dark trunks in the foreground with ultramarine blue, burnt umber, and yellow ochre. And he starts to indicate the hot colors of autumn leaves with scattered strokes of cadmium red, cadmium vellow, and burnt sienna in varied proportions. Where the sun breaks through the woods and strikes the edges of trunks and branches, the tip of a small, round softhair brush traces ragged lines of yellow ochre and white. Notice that the foundation colors of Step 2 still shine through and unify the color scheme.

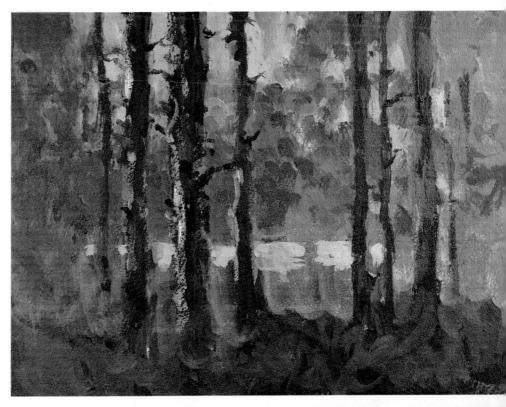

Step 4. But what happens if you want to change your mind again? Perhaps you decide - in midstream - that this autumn landscape should really be a spring landscape! It's easy with acrylic. Another scumble and the picture is off to another fresh start. This time, the artist mixes a pale, yellowgreen blend of ultramarine blue, cadmium yellow, and gloss painting medium-which is then loosely brushed over the foliage with a big bristle brush. The casual, scrubby brushwork allows lots of the underlying color to shine through. But now the overall tonality of the painting tells us that it's spring. And the artist begins to build up those touches of delicate green and pink that are so typical of the season. The painting still has a way to go, but the foundation has been laid for a new picture.

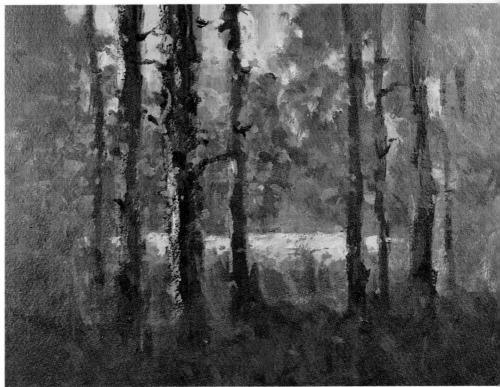

How to Preserve Acrylic Paintings

Permanence. The surface of an acrylic painting is far tougher than the surface of an oil or watercolor painting, but *all* paintings require special care to insure their durability. Although the subject of framing is beyond the scope of this book, here are some suggestions about the proper way to preserve finished paintings.

Permanent Materials. You can't paint a durable picture unless you use the right materials. All the colors recommended in this book are chemically stable, which means that they won't deteriorate with the passage of time and won't produce unstable chemical combinations when they're blended with one another. However, it's not always a good idea to mix one brand of acrylic color with another. There are sometimes slight variations in the formulas of the different manufacturers. But the biggest problem isn't the acrylic paint; it's the painting surface, which is often less durable than the paint itself. While you're learning. there's nothing wrong with working on illustration board or canvas board; but remember that the cardboard backing will deteriorate with age. Once you feel that your paintings are worth preserving, work on real artists' canvas or prepare your own boards by coating hardboard with acrylic gesso. And if you're working on watercolor paper, invest in 100% rag stock, which means paper that's chemically pure and won't discolor with age.

Matting. A mat (which the British call a mount) is essential protection for an acrylic painting that's done on watercolor paper or illustration board, since the paper isn't nearly as tough as the paint. The usual mat is a sturdy sheet of white or tinted cardboard, generally about 4" (100 mm) larger than your painting on all four sides.

Into the center of this board, cut a window that's slightly smaller than the painting. You then "sandwich" the painting between this mat and a second board the same size as the mat. Thus, the edges and back of the picture are protected, and only the face of the picture is exposed. When you pick up the painting, you touch the "sandwich," not the painting itself.

Boards and Tape. Unfortunately, most mat (or mount) boards are far from chemically pure, containing corrosive substances that will eventually migrate from the board to discolor your painting. If you really want your painting to last, you've got to buy the chemically pure, museum-quality mat board, sometimes called conservation board. Of course, ordinary mat board does come in lovely colors and textures, while the museum board comes in a more limited color selection. But it's easy to mix acrylic colors to produce the hue that you want for your mat. Thin the color to the consistency of cream, and brush it over the museum board. Brush the color on both sides of the board, so it won't curl. Avoid pasting your paintings to the mat or the backing board with masking tape or Scotch tape. The adhesive remains sticky forever and will gradually discolor the painting. The best tape is the glue-coated cloth used by librarians for repairing books. Or you can make your own tape out of strips of drawing paper and white watersoluble paste.

Framing. If you're planning to hang an acrylic painting that's done on paper or illustration board, the matted picture must be placed under a sheet of clear glass (or plastic) and then framed. Most painters feel that a matted picture looks best in a simple frame: slender strips of wood or metal

in muted colors that harmonize with the painting. Avoid bright mat colors or ornate frames that command more attention than the picture. An acrylic painting on canvas, gesso board, or canvas board doesn't need a mat or glass. A frame is enough. Since there's no mat, you can choose a heavier, more ornate frame, like those used for oil paintings. If you're planning to make you own mats and frames, buy a good book on picture framing. If you turn the job over to a commercial framer, make certain that he uses museum-quality mat board and tell him not to use masking tape or Scotch tape — which too many framers use just to save time and money.

Varnishing Acrylic Paintings. The tough surface of an acrylic painting can be made still tougher with a coat of varnish. The simplest varnish is an extra coat of gloss medium, thinned with some water to a more fluid consistency than the creamy liquid in the bottle. At first, this coat of medium will look cloudy on the painting, but will soon dry clear. If you want a nonglossy finish, follow the coat of gloss medium with a coat of matte medium, again diluted with water to a fluid consistency. If the manufacturer of your colors recommends that you use a varnish that's different from the medium, follow his advice. Apply the medium or varnish with a big nylon house painter's brush. Work with straight, steady strokes. Don't scrub back and forth too much or you'll produce bubbles. For an acrylic painting framed under glass, varnish is optional. Without glass, a coat or two of varnish will give you a surface that cleans with a damp cloth and resists wear for decades to come.

SECTION TWO

BEYOND THE BASICS

LEARNING TO MODEL FORM

Step 1. To learn how to model form in acrylic - that is, how to paint something so it looks three dimensional start with some familiar shape like an apple. It's important to begin with a careful pencil drawing of the form. This study of an apple begins with a line drawing that defines the round shape of the apple, its stem, and a couple of leaves. Then a bristle brush scrubs in the background tone, which is a mixture of ultramarine blue, burnt sienna, yellow ochre, and white. Notice that the tone is darker in the foreground, where it contains a bit more ultramarine blue and burnt sienna. It doesn't matter if these strokes overlap the edges of the apple.

Step 2. The lines between the boards of the tabletop are drawn with a sharp pencil and a ruler. Then the artist, Rudy de Reyna, uses a round softhair brush to draw the grain of the tabletop with a paler version of the same mixture used to paint the background in Step 1 (more white is added). He uses that mixture again with less white and more ultramarine and burnt sienna to create the shadow cast by the apple. The shadow is painted with a bristle brush. Then the lines of the wood grain within the shadow are added with the tip of the round softhair brush.

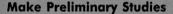

You'll do a better job of rendering three-dimensional form if you:

- 1. Make a pencil drawing of the form on a separate sheet of paper before you start to paint.
- 2. Start that preliminary study with a careful line drawing that defines the contours.
- **3.** Then block in the shadows so that you have a clear idea of the distribution of light and shade.
- **4.** Finish the drawing by blocking in the cast shadow—the shadow that the form casts on the tabletop or on any other nearby surface.
- **5.** Draw and redraw the form until you've got it right. Then you're ready to paint.

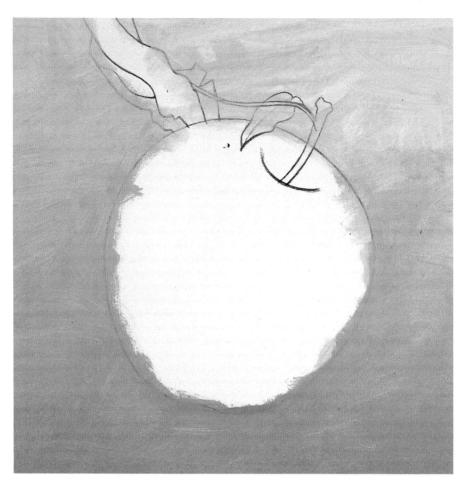

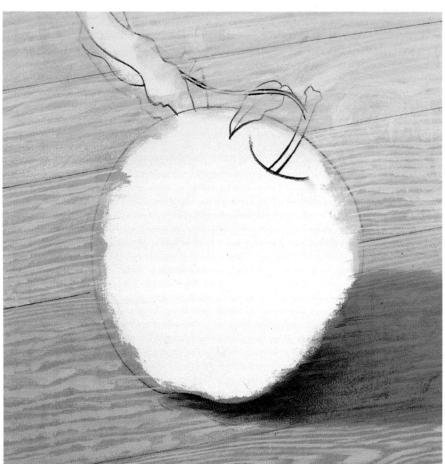

Step 3. Now the entire shape of the apple is covered with a flat color. This is a blend of cadmium red, naphthol crimson, yellow ochre, and white, applied with a flat bristle brush. A very thin wash of yellow ochre, ultramarine blue, and burnt sienna—containing lots of water, but no white—is brushed over the leaves. A darker version of this same mixture, with less water, is used for the shadow areas on the leaves. The intricate forms of the leaves are painted with a round sable.

Rendering Cast Shadows

When you make those preliminary drawings, pay particular attention to the cast shadows. Properly rendered, a cast shadow can "anchor" the form (like this apple) to the surface it rests on. Badly rendered, a cast shadow can look like a black hole in your painting. Observe and render the outer contour of the cast shadow as carefully as you render the form that casts the

shadow. Note that a cast shadow is usually darker at the point where it touches the form and lighter at the edges. Paint the cast shadow so you can see through it. Let some underlying color and detail come through. Above all, don't paint a cast shadow as if it's a black patch of inky darkness. Shadows are transparent—and usually lighter than you think.

LEARNING TO MODEL FORM

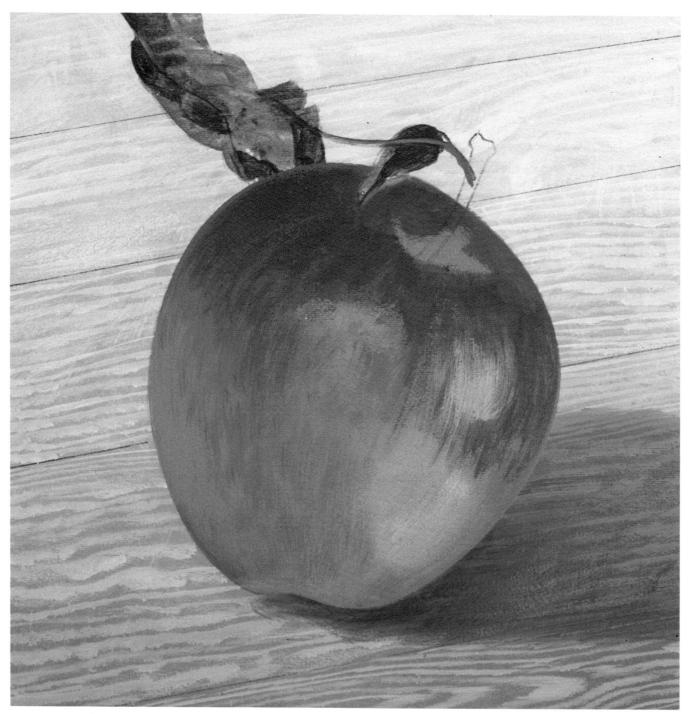

Step 4. Now it's time to start modeling the apple—which means adding darks and lights on top of the flat tone painted in Step 3. A round softhair brush paints the dark red at the top of the apple in short, slender strokes that curve to follow the round shape. The artist makes these strokes with a mixture of naphthol crimson, cadmium red, yellow ochre, and white.

More white is added to these strokes as they move downward from the midpoint of the apple to the bottom. The highlights on the apple are mainly yellow ochre and white, with just a hint of the reddish mixture that's used to paint the rest of the apple. These lights are painted with scumbling strokes, so they seem to blend into the red.

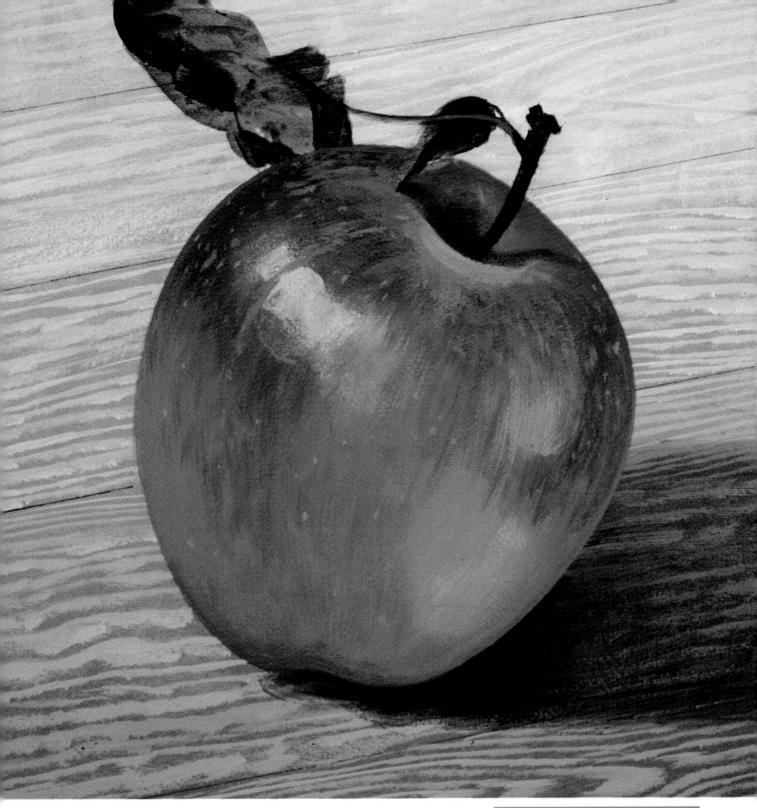

Step 5. Here's an enlarged close-up of the apple, so you can really see the brushwork. The precise details of the apple are saved for the final stage. The subtle tone around the stem is painted with the tip of a round softhair brush carrying a mixture of ultramarine blue, yellow ochre, and burnt umber. Tiny spots of this mixture are

added to the sides of the apple with the point of the brush. The stem is a dark mixture of burnt sienna and ultramarine blue. You'll enhance the three-dimensional feeling if your brushstrokes follow the form, just as the strokes curve around the apple here.

Five Basic Steps in Modeling Form

- 1. Make a careful pencil drawing to define the shape.
- **2.** Block in the shape with flat color that's lighter than the shadows, but darker than the lighted areas.
- 3. Brush in the shadow areas.
- 4. Brush in the lighted areas.
- **5.** Add the final touches: highlights, dark accents, details.

DRYBRUSH FOR TEXTURE

Step 1. Another way to create subtle gradations from dark to light is the technique called drybrush. The brush isn't literally dry, but carries tube color that's been thinned with just a little water. The brush travels lightly over the painting surface, hitting the high points of the texture and skipping over the low spots in between. The more pressure you apply on the brush, the more color you deposit, Painting a slightly complicated natural form, such as this green pepper, will give you an opportunity to develop your skill with drybrush. Once again, start with a simple pencil drawing and then brush in the background with free strokes. This demonstration is painted on watercolor paper whose slightly rough texture is especially good for drybrush. The tones of the wooden tabletop are drybrush strokes made by the edge of a bristle brush, dampened with a mixture of ultramarine blue, burnt sienna, and white. The lighter strokes obviously contain more white. For the shadowy wall at the top of the picture, the same brush carries the same mixture.

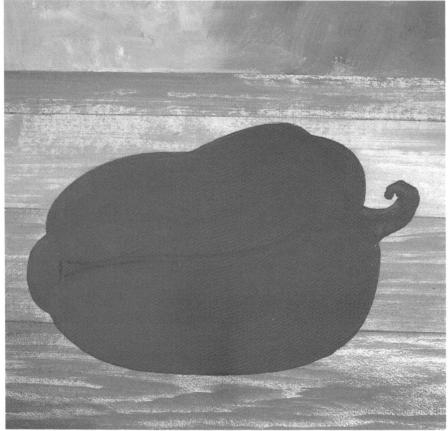

Step 3. Following the lines of the drawing, the artist adds the darks with a mixture of phthalocyanine green, burnt umber, and yellow ochre. There's just a bit of color on the brush, so the bristles are damp, not wet. And the brush skims quickly over the surface of the paper, depositing ragged, broken strokes rather than solid color. The darks are built up gradually, one stroke over another. The same method is used to paint the shadow cast by the pepper and to darken the grain of the tabletop in front of the pepper - mixtures of ultramarine blue, burnt umber, yellow ochre, and white. These soft drybrush strokes are executed with a round softhair brush.

Step 4. The light areas between the shadowy strokes on the pepper are strengthened with the same green mixture that was used in Step 2, but with a bit more white added. Finally, the highlights are added with the tip of a round softhair brush. These are mainly white, with just a bit of the green mixture, plus lots of water. As you can see, drybrush is used mainly for modeling, while more fluid color is used for the precise, final touches.

Drybrushing Tips

- 1. Thin your color with a bit of water, but not too much, or the color will become runny and will flow onto the painting surface.
- 2. If you want color that's thick, but still fluid, dilute your mixture with gloss or matte medium.
- **3.** If there's too much color on your brush *or* the color is too runny, wipe the brush on a paper towel to make the color "drier."
- **4.** Paint on a surface with a distinct texture: watercolor paper, kid finish illustration board, canvas, or a gesso panel on which the gesso has been roughly applied.

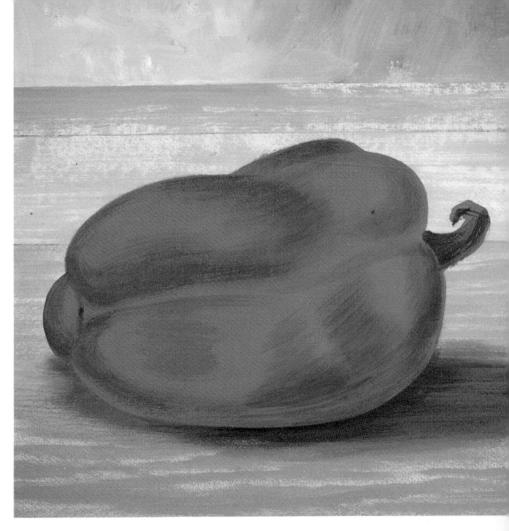

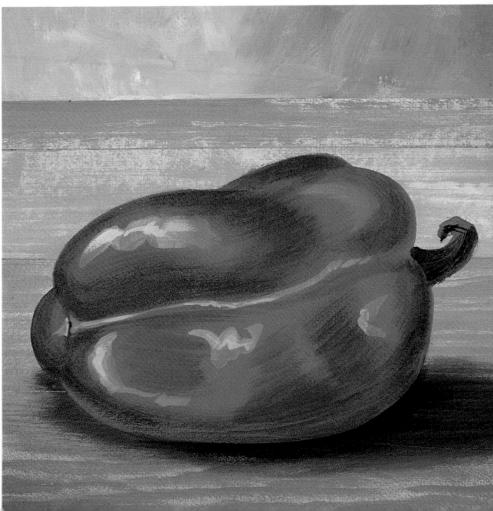

BLEND WITH SCUMBLING

Step 1. Acrylic paint dries so quickly that it's hard to blend one wet stroke smoothly into another. Instead, you apply a series of individual strokes with a quick back-and-forth scrubbing motion that blurs the mark made by the brush. One stroke overlaps another, and they seem to blend in the viewer's eye. The technique is called scumbling. Painting the fuzzy surface of a peach is particularly good practice in scumbling. To make the job a bit easier, select a sheet of textured watercolor paper that will accentuate the scrubby character of the back-and-forth scumbling strokes. This demonstration begins with a pencil drawing that carefully defines the contours of the peaches, the dish, and the line of the tabletop. A flat softhair brush covers the background with a fluid tone of black, yellow ochre, and a touch of white. The same brush covers the tabletop with this mixture, plus phthalocyanine blue and a lot more white.

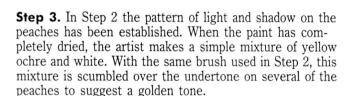

Keep Strokes Thick and Light

The whole trick to scumbling is to work with thick color and light strokes, gradually laying one stroke over another so that the color builds up gradually. These ragged, scrubby strokes do overlap just a bit, but they seem to blur softly into one another.

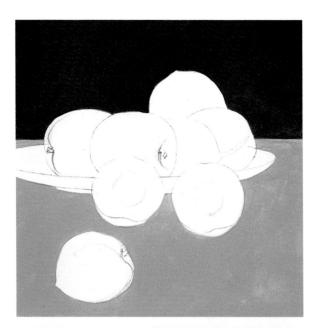

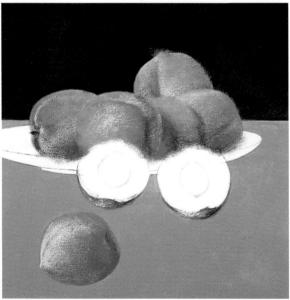

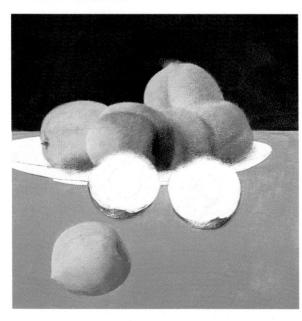

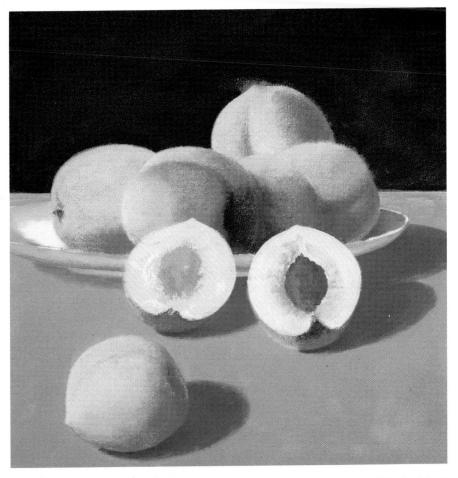

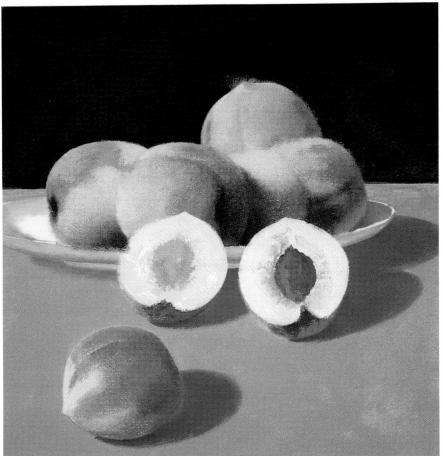

Step 4. The lighter tops of the two peaches to the right are scumbled with this yellow ochre and white mixture. The shadows cast by the peaches on the table are strengthened with the same mixture used in Step 2. The ruddy tone used in Step 3 is added to the undersides of the two peach halves. The shadows are scumbled with ultramarine blue, naphthol crimson, yellow ochre, and white. Now the juicy insides of the peaches are painted with a round softhair brush and mixtures of yellow ochre, cadmium red, ultramarine blue, and white.

Tips About Scumbling

- 1. Pick up just a bit of color on the tip of your brush.
- **2.** Don't load your brush with too much color or the color will pile up on the painting and make scumbling impossible.
- **3.** Add a touch of medium—liquid or gel—to improve the consistency of your color.
- **4.** Move your brush so one scumbling stroke overlaps another and the strokes seem to merge.
- **5.** Work quickly. Don't let the paint dry before you finish scumbling that area of the painting.

Step 5. The warm tones of the peaches are now scumbled with a flat bristle brush—carrying a mixture of naphthol crimson, yellow ochre, ultramarine blue, and white. The lighter areas are strengthened with more scumbling strokes of yellow ochre and white. Placed side-by-side, these scrubby strokes of thick color, broken up by the texture of the paper, seem to blend into one another.

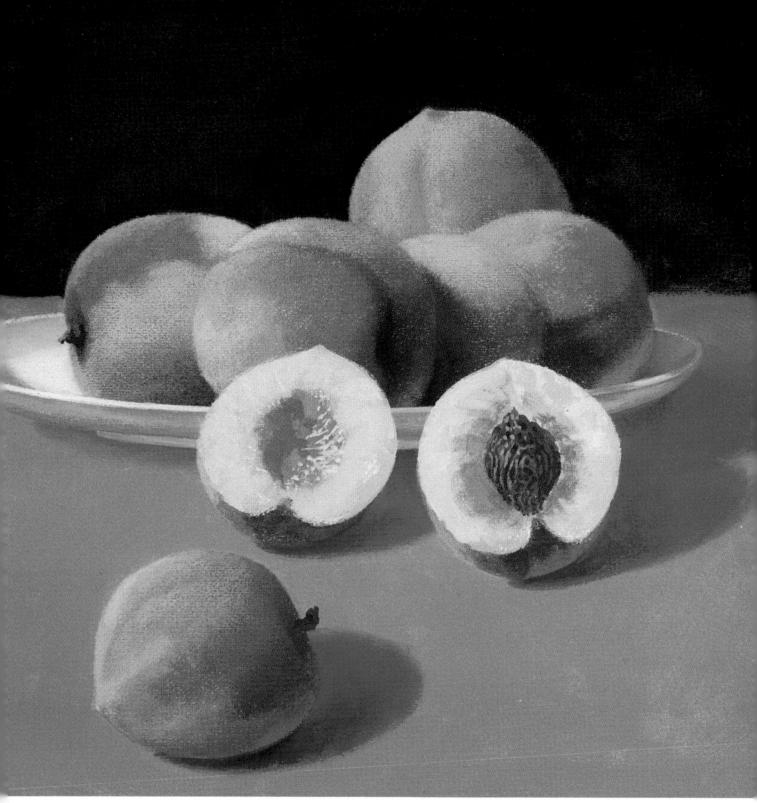

Step 6. The precise details are saved for the final stage, as usual. Now the tip of a round softhair brush picks up fluid color to paint the pit of the peach to the right, plus the juicy fibers of the peach to the left. The darks of the pit are ultramarine blue and burnt sienna. The warm glow around the pit is the same mixture used for the ruddy tones in Step 5. This same

warm mixture appears inside the cut peach to the left, with the glistening fibers painted in a pale mixture of yellow ochre and white. The slender pointed brush is also used to paint the precise form of the plate with the same mixture used for the shadows in Step 4, plus more white. Dark notes are discreetly added to complete the stems of the peaches and to darken

the shadows right under the edges of the peaches on the tabletop. Such subtle darks aren't black, but blue-brown mixtures, such as ultramarine blue and burnt umber. Study the brushwork carefully. The beautiful gradations on the peaches *are not* the result of blending one wet color into another, but the result of placing scumbled strokes side-by-side.

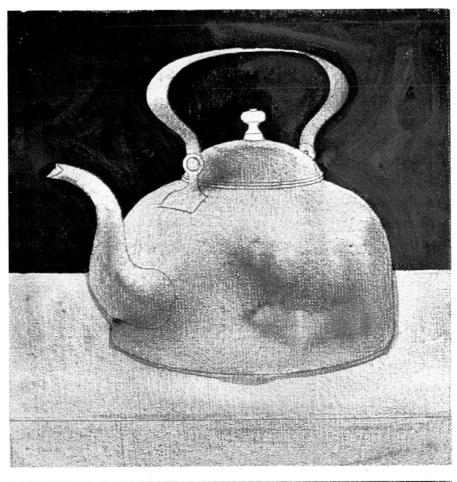

Step 1. Underpainting and glazing is an old-master technique that takes advantage of the transparency of the acrylic painting medium. To practice this technique, find some common household object like this kettle. This demonstration is painted on a canvas board and begins with a pencil drawing of the intricate forms of the kettle, plus the lines of the tabletop. Then the shadow areas of the kettle and table are painted with a fluid mixture of black, white, and ultramarine blue, diluted with lots of water. A thicker version of the same mixture (less water) is used for the background, which is painted very carefully around the shape of the kettle.

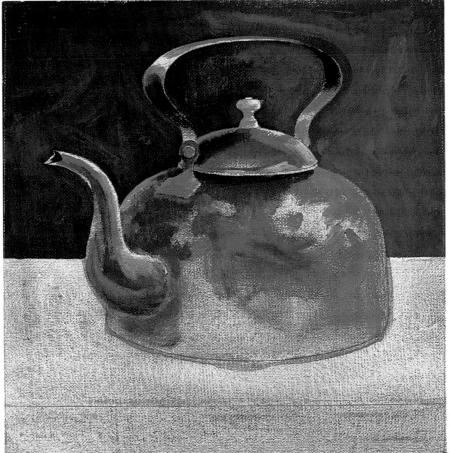

Step 2. For the first step, where you're working with very fluid paint, you can use a softhair brush. But now it's best to switch to a bristle brush to carry the thick color of Step 2. The pattern of shadows on the kettle is painted with a really thick and opaque version (much less water) of the same mixture of black, white, and ultramarine blue used in Step 1.

Warm and Cool Underpainting

This underpainting is on the cool side: a mixture of black, white, and ultramarine blue to produce a grayish tone that's often called by the French word *grisaille*. As you experiment with the underpainting and glazing technique, you may also like to try some warmer underpainting mixtures. Ultramarine blue, burnt sienna or burnt umber, and white will give you a lovely range of warm and cool grays. If the mixture is dominated by burnt sienna or burnt umber, you'll get a variety of lovely warm grays. If ultramarine blue dominates, you'll get various cool grays—depending on how much blue you add. A touch of yellow ochre will add a hint of gold to warm grays.

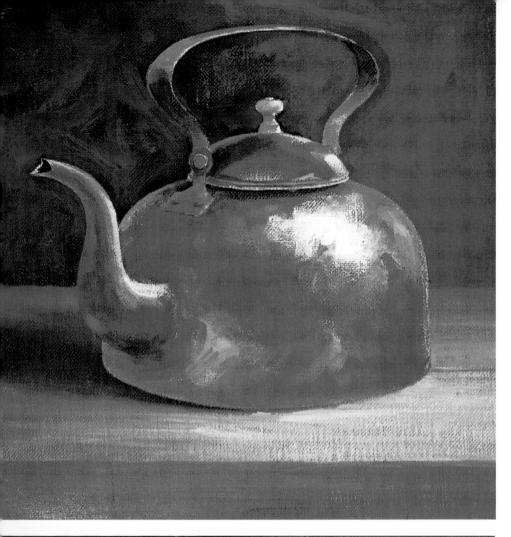

Step 3. The pattern of lights and shadows is now completed. De Reyna adds a bit more white to the same mixture for the middletones and a lot more white for the lightest areas. He follows the same procedure to create the values on the tabletop. Then the same dark mixture for the background is picked up for the shadow that's cast on the table by the kettle. As you can see, the entire painting is painted in monochrome, concentrating only on the pattern of light and shade. You add color only in the last step.

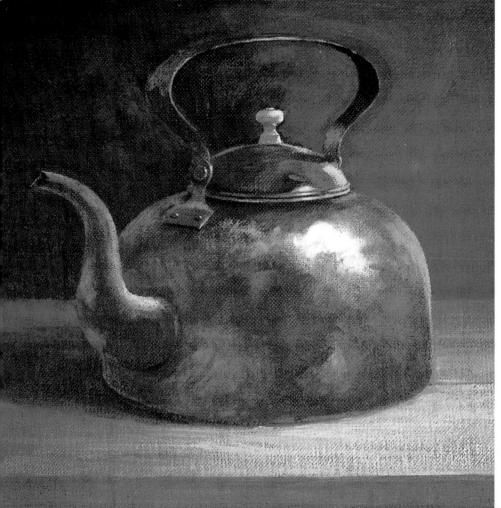

Step 4. A fluid, coppery color is mixed on the palette—burnt sienna, cadmium red, yellow ochre, and gloss medium. This luminous, transparent mixture—called a glaze—is brushed over the entire kettle, which suddenly turns a warm, metallic hue. A few touches of ivory black are added to strengthen the darks on the kettle. A much paler glaze of burnt sienna, yellow ochre, and ivory black—with lots of gloss medium—is carried over the background and the tabletop to add a touch of warmth.

Use Underpainting and Glazing When:

You're painting a subject in which the lights and shadows are complicated. First you paint the lights and shadows in monochrome; then you complete the job with colored glazes.

EXPRESSIVE BRUSHWORK

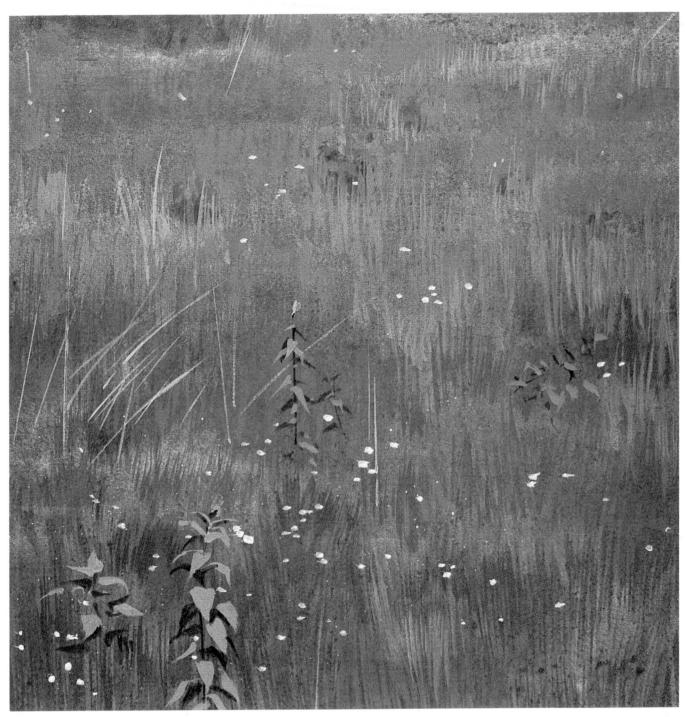

Precise Brushwork. Just to prove that there are no ironclad rules about the "right" brushwork for the subject, here's another complex subject—this time painted with lots of small strokes. But look closely and you'll see that this precise brushwork is built up over a foundation of broader brushwork. Behind the slender strokes that suggest blades of grass and weeds, you can see broad tones of gold, golden brown, and subtle green. The artist has begun with big

brushes and broad strokes to establish the overall colors of the meadow. Then, when these undertones are dry, he's gone back over the painting with the tip of a round brush, adding slender strokes *very selectively*. These small strokes don't cover the entire meadow. They're painted in clusters—with lots of the broad undertones shining through. The artist doesn't tire the viewer with too much detail, but adds just enough precise brushwork to *suggest* detail.

EXPRESSIVE BRUSHWORK

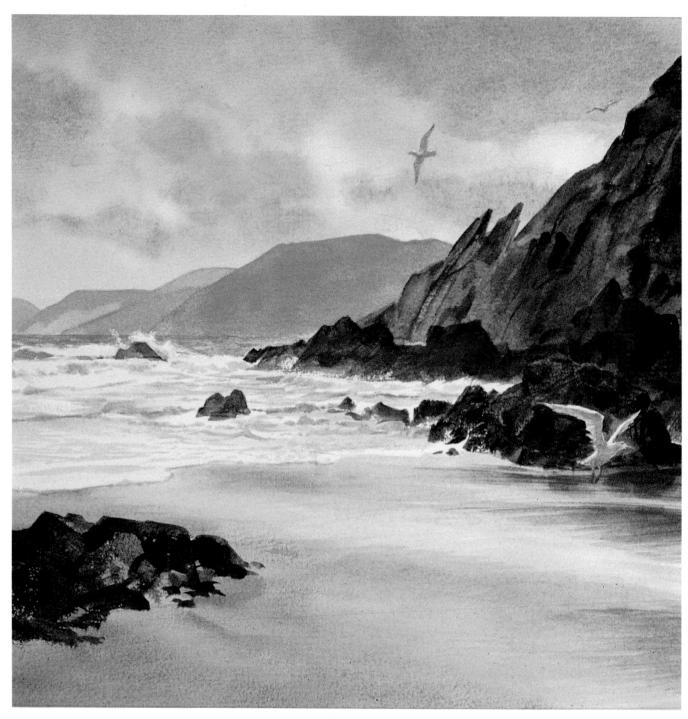

Controlling the Wet-in-Wet Technique. The sky and the fore-ground beach of this coastal landscape are painted with transparent color—diluted with lots of water—in a technique that's familiar to watercolorists: the wet-in-wet method, sometimes called the wet paper technique. Working on watercolor paper, the artist brushes the sky area with clear water, allows the water to sink in for a few seconds, and then brushes in the

clouds. The brushstrokes spread and blur on the wet surface. When the clouds are dry, he wets the paper again and brushes in the cool tones between the clouds. The shadows on the sand are executed in the same way. The area is brushed with clear water and then the dark shapes are painted into the damp surface. If you work quickly, you can blot up some wet color with a tissue, as the artist has done in the right foreground. Two

tips about the wet-in-wet technique. First, keep your drawing board flat, not slanted, so the color is less likely to run downward and more likely to stay where you want it. Second, plan your wet-in-wet shapes carefully; you can't correct dried acrylic by scrubbing it off—and you can't cover up a mistake when you work in transparent color.

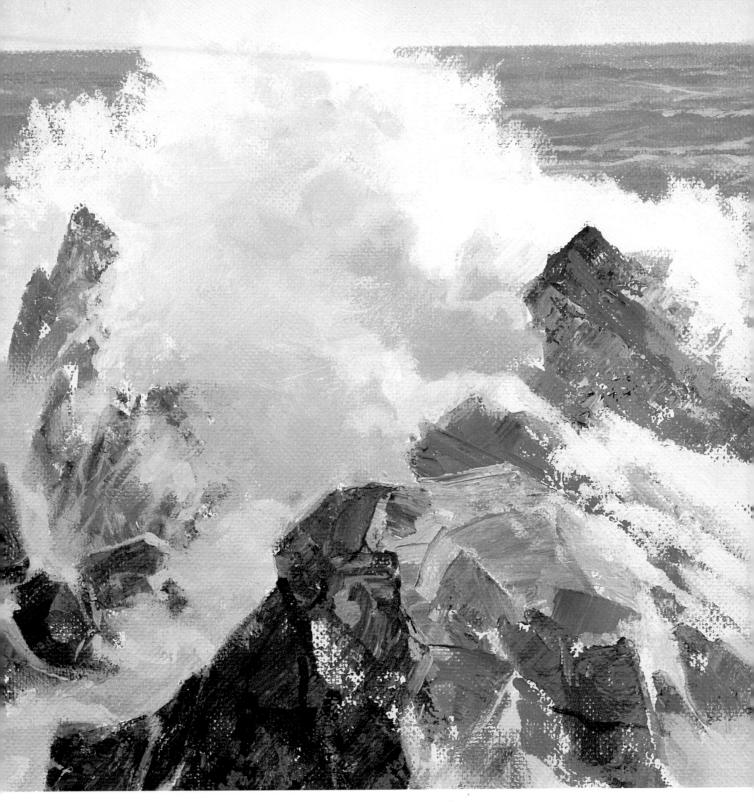

Impasto. The thick knife strokes on the lighted tops of the rocks are a striking example of *impasto*, an Italian word that's come into the English language to describe thick paint. You can use the thick color that comes straight from the tube—undiluted with water or medium—for impasto brushwork or knife work. And you can create still

richer, thicker, more buttery consistency by blending your tube color with gel medium. Apply impasto color with bristle brushes—softhair brushes aren't stiff enough to carry the heavy paint—or with a painting knife (not a palette knife) that's specially designed for this job.

MODELING THE FORMS OF FRUIT

Step 1. Now that you've tried out a variety of acrylic painting techniques, it's time to put them to work on a more ambitious still life. A wooden bowl of fruit, with so many different colors and textures, is a good subject. Once again, begin with a careful pencil drawing that defines the outer edges of all the forms. This demonstration begins with a background tone of black, white, and a little yellow ochre, applied with a bristle brush. The strokes are bold and obvious. Notice how the background is darker behind the fruit—to dramatize their shapes and colors.

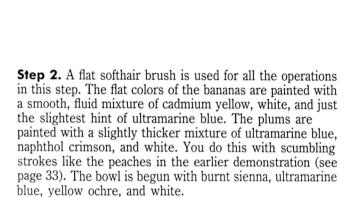

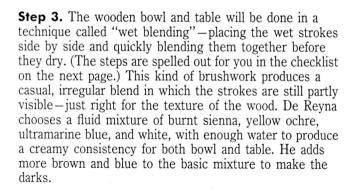

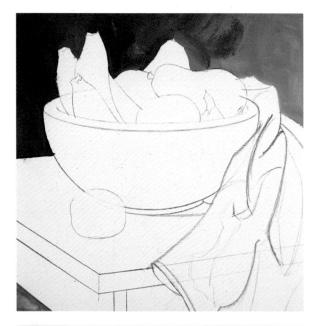

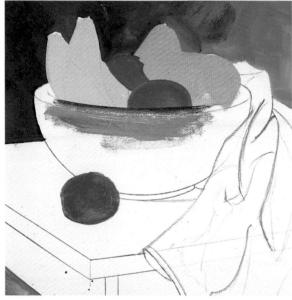

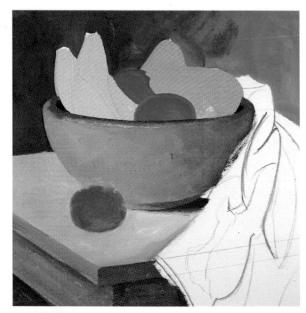

Step 4. The darks of the banana and the shadow side of the more distant pear are painted with touches of a mixture of burnt sienna, yellow ochre, ultramarine blue, and a bit of white. The warm notes in the pears are burnt sienna, cadmium yellow, and vellow ochre. The grain of the wood is drybrushed with a darker version of the mixture used in Step 3-more blue and brown. The plum in the back of the bowl is modeled by scumbling phthalocyanine blue, naphthol crimson, and white. The napkin is painted with strokes of ultramarine blue, burnt sienna, yellow ochre, and white.

How to Do Wet Blending

- 1. If you want to blend light into shadow, be sure that you have a clear idea of the shape of the light area and the shape of the shadow—and exactly where they meet.
- 2. If you want to blend one color into another, decide exactly where the colors should meet and blend.
- **3.** Mix each color separately on your palette—to the consistency of thin cream.
- **4.** Block in the light and shadow areas—or the color areas—as *separate* shapes. Don't smooth out your strokes. Let them show.
- 5. While these shapes are still wet, blend them together at the point where they meet. Working back and forth with your brush, carry light into shadow and shadow into light—or one color into another—until the shapes start to merge.
- **6.** Don't try to iron out every stroke. As soon as the brushstrokes begin to melt together and *suggest* a blend—stop!
- Step 5. A round softhair brush paints the lighted sides of the bananas with vellow ochre, cadmium yellow, white, and a touch of burnt umber. The shadow sides are scumbled with burnt umber, yellow ochre, ultramarine blue, and white. To make the big pear rounder, the darker tones are scumbled with ultramarine blue, yellow ochre, burnt sienna, and white-with wet, juicy highlights of white and yellow ochre brushed onto both pears when the scumbles are dry. The other plum in the bowl is scumbled with the same mixture used in Step 4, adding a bit more crimson and a lot of white in the highlights.

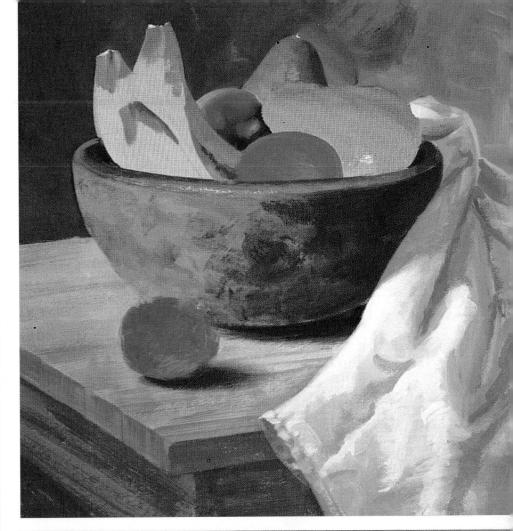

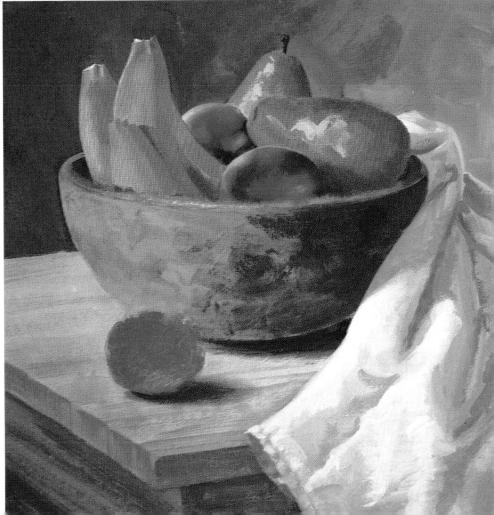

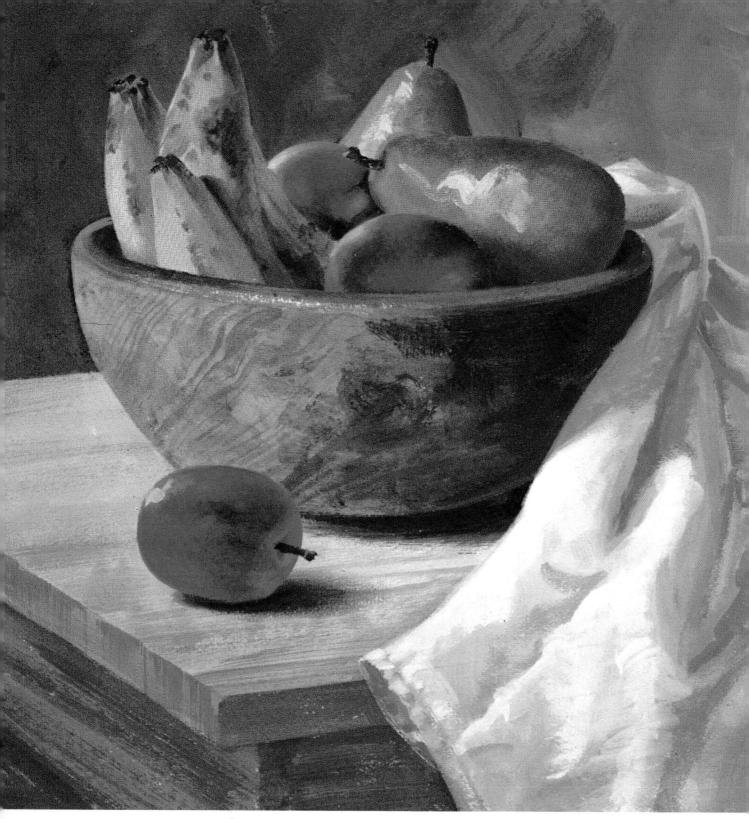

Step 6. Here you can see how the finishing touches are added in the final stage. The tip of a bristle brush adds quick dabs of burnt sienna, ultramarine blue, and yellow ochre to suggest the dark spots on the bananas. The point of a round softhair brush adds the stems with ultramarine blue and burnt umber. Compare the highlights on the pears and the plums. The former are quick, fluid strokes, while the latter are thick scumbles. A round

softhair brush traces the lines of the grain in the wooden bowl with a mixture of ultramarine blue, burnt umber, and white. The same mixture—and the same brush—add a bit more grain to the table. The plum on the table is modeled by scumbling with the same mixtures as the plums in the bowl. You can see quite clearly that the shadow under the plum is drybrushed with the same colors used on the shadow side of the bowl.

A Quick Review

By now you've noticed that there's a definite pattern to the steps in all these paintings:

- 1. Cover the shapes with flat tones.
- **2.** Model the lights and darks over the flat tones.
- **3.** Add highlights, textures, and details.

PAINT VIVID FLOWERS

Step 1. For your next still life project, try the more complex shapes of flowers, perhaps in a transparent vase—a particularly interesting challenge to paint. This demonstration is painted on a canvas board, whose woven surface will soften the strokes. You'll need to make a precise pencil drawing of the flowers, leaves, and stems. Pick a simple, geometric vase, nothing ornate. As usual, this demonstration begins with a freely painted background—broad bristle brushstrokes of ultramarine blue, burnt sienna, black, and a fair amount of white on the right side.

Step 2. The flat undertones of the flowers are painted with liquid color and a bristle brush. The yellow flowers are covered with a shadowy tone of yellow ochre, white, and ultramarine blue; the more brilliant colors will be painted over these muted tones in the later steps. In the same way, the white flower begins as a shadowy tone of ultramarine blue, burnt umber, and white. Only the red flower is painted with its full brilliance, since this will be the brightest note in the picture—a mixture of cadmium red and naphthol crimson, with a touch of ultramarine blue.

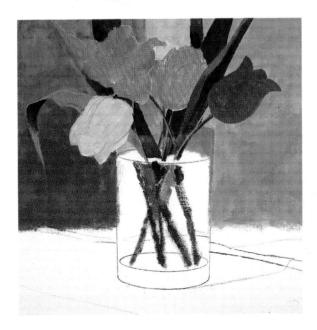

Step 3. The darks of the leaves and stems are painted with a mixture of ultramarine blue, yellow ochre, and burnt sienna. Then the lights are painted right over the darks with cadmium yellow, ultramarine blue, burnt sienna, and white. Inside the vase, notice how roughly the stems are painted, since they'll be partly obscured by the reflections in the glass.

No Trick to Painting Water

There's no special trick to painting water or glass; you just have to *forget* that you're painting a transparent substance and simply paint the patches of light and dark

PAINT VIVID FLOWERS

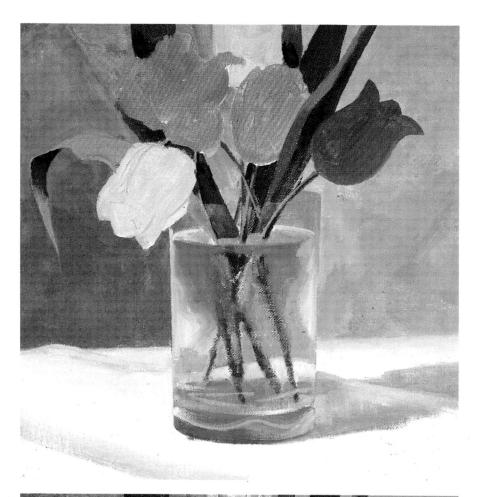

Step 4. Clear glass and clear water have no color of their own, but simply reflect the color of their surroundings. In Step 1, the color of the background was carried into the upper portion of the vase. Now the same color is carried down into the water to the very bottom of the vase. The mixtures are ultramarine blue, burnt sienna, black, and white, with more white for the lights and middletones. The same mixtures are used to paint the shadows of the folds in the tablecloth.

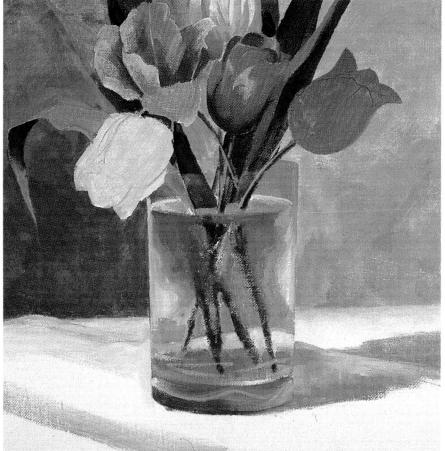

Step 5. The dark tones on the yellow flowers are added with a fluid mixture of burnt sienna, yellow ochre, and ultramarine blue, diluted with plenty of water so the color really flows onto the canvas. A flat softhair brush applies the color very smoothly. The rough brushwork done in the background will now accentuate the smoother brushwork of the flowers and the leaves.

Keep Flower Arrangements Simple

- 1. Paint just a few flowers, not a huge bouquet that looks like it was ordered for a banquet.
- 2. Arrange the flowers casually in the vase—don't waste time making a "perfect" arrangement. Formal flower arrangements make dull paintings.
- **3.** Choose simple flowers with simple shapes—not exotic blooms! Daisies make better paintings than orchids.

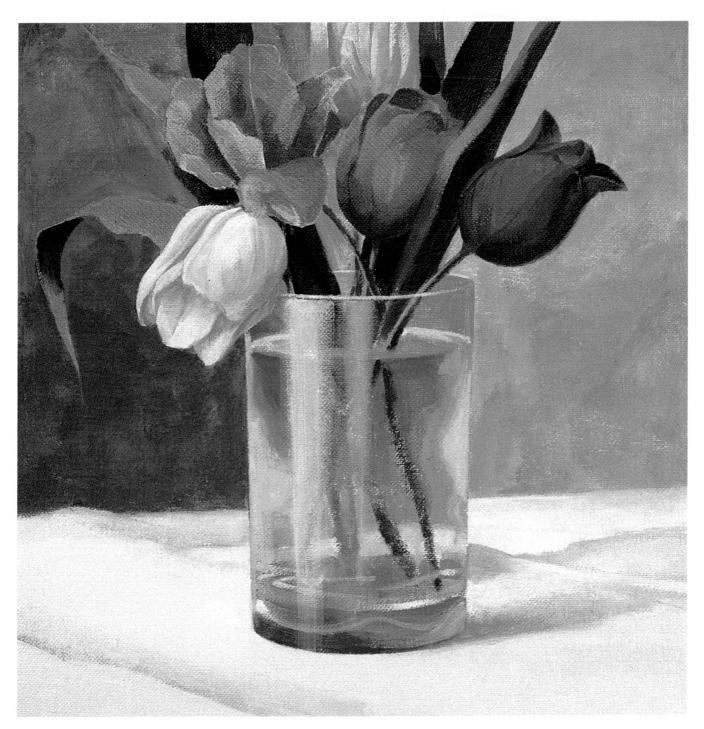

Step 6. The light areas of the yellow flowers are applied with a round softhair brush, carrying a fluid mixture of cadmium yellow, yellow ochre, a little burnt sienna, and white. The edges of the strokes are scumbled, so they seem to merge softly with the shadow tones. Strong darks are added to the undersides of the red and yellow flowers with burnt umber and ultramarine blue. This same mixture, with a lot of water, is used to add some subtle darks to the bright side of the

red flower. (Observe how the texture of the canvas breaks up and softens the brushstrokes.) The white flower is painted in the same way as the yellow ones. Soft shadows are added with ultramarine blue, burnt sienna, and white. Then the lights are added with almost pure white, faintly tinted with the shadow mixture. The vertical highlights and the bright edges of the vase are painted with this same mixture—mostly white, with just a *little* burnt sienna and ultramarine blue.

The highlights on the glass are painted with just enough water to make the tones translucent, so you can still see the stems within the glass and the background tone beyond. Some of this mixture is brushed into the center of the shadow on the tablecloth, which seems a bit too dark in Step 5. It's worth noting that the bright tones of the flowers look even brighter because they're surrounded by muted colors.

EXPLORING THE COLORS OF SUMMER

Step 1. Having practiced your basic techniques on several still life subjects, this is a good time to try a landscape. Begin with a pencil drawing on illustration board of the main shapes-trunks, branches, rocks, and the masses of leaves-but don't try to draw every leaf. Everything in Steps 1 and 2 will be done with the bold strokes of a bristle brush. Here, the sky is painted right over the pencil lines with phthalocyanine blue, ultramarine blue, a little burnt sienna, and lots of white. The mixture contains plenty of water, so the color doesn't completely obscure the pencil lines.

down over the water with just a bit more white. Then the trees are painted with short, scrubby strokes of phthalocyanine green, cadmium yellow, a little burnt umber, and white. The distant trees contain more white, while the darker trees on the right contain more green and brown. The reflections in the water are the same mixtures, softened with a bit more brown. The warm strip along the shore to the right is burnt umber, phthalocyanine green, and white.

Paint Indoors or Out

You can make some sketches outdoors and then go back home to paint your picture from these sketches. Or you can load your paintbox, take along a big plastic bottle of water, and try painting on location.

Step 3. Shifting to a flat softhair brush, the trunks are painted with a thick mixture of black, white, and yellow ochre. Notice how the strokes follow the direction of the trunks and branches. The mixture must be thick enough to pick up with a painting knife, which is used to paint the rocks with straight, squarish strokes. The darks of the rocks are painted first; then more white is added to the mixture, and the lighter tones are painted right on top of the darks. The knife strokes are rough and imprecise—just right for the texture of the rocks.

Step 4. The tip of a filbert is tapped against the painting surface to suggest clusters of leaves. The leafy tones are phthalocyanine green, burnt sienna, yellow ochre, plus a touch of white for the lighter leaves. The same mixtures are used to paint the darks and lights of the grass. The tip of a round softhair brush paints the darks first; while these tones are still wet, lighter strokes are painted over and into them. The vertical strokes follow the direction of the grass.

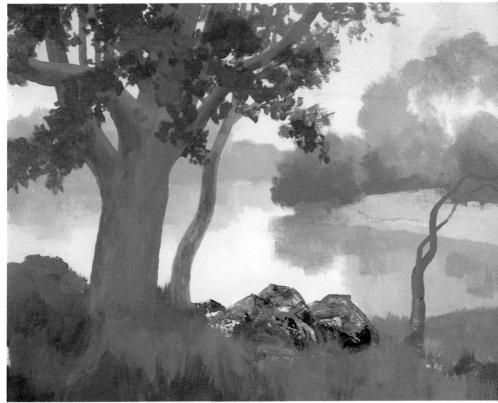

Enrich the Color of Your Painting

A very fluid, transparent glaze is an almost invisible way to enrich the color of your painting in the final stages.

EXPLORING THE COLORS OF SUMMER

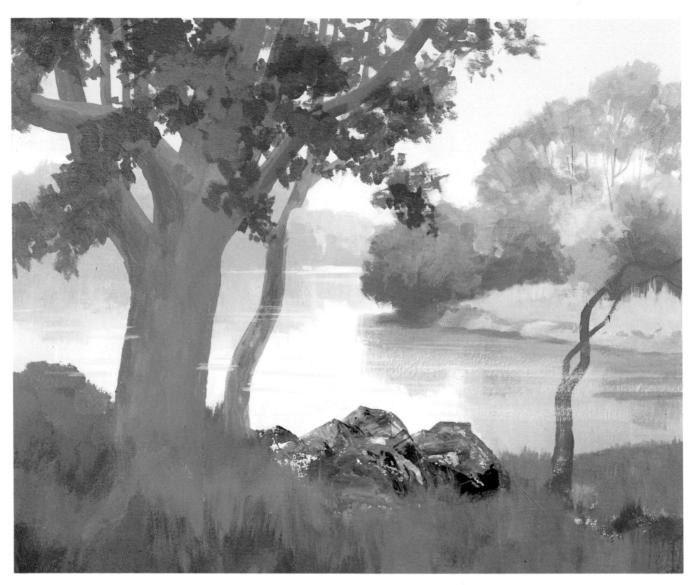

Step 5. Some light tones are added to the trees on the most distant shore-chromium oxide green, ultramarine blue, yellow ochre, and a lot of white—so you can now see a clear division between light and shadow. This same mixture, with a little less white, adds some lighter details to the foliage on the shore to the right. For the light shining on the water, even more white is added to the mixture; now the mixture is fairly thick, and it's drybrushed across the water with the horizontal strokes of a round softhair brush. It doesn't matter if some of these lines are carried over the trees, which will be darkened in the next step.

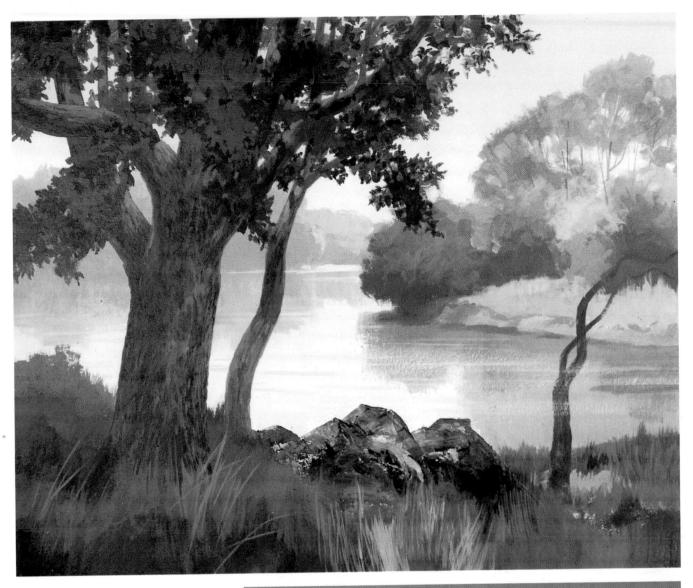

Step 6. Phthalocyanine green and burnt umber are diluted with water to make a glaze. De Reyna brushes this mixture over the trunks and branches. When that has dried, he adds more brown to the same mixture to create the dark textures of the bark. Individual blades and clusters of grass are added to the immediate foreground with mixtures of phthalocyanine green, cadmium yellow, and a touch of burnt sienna, plus a little white to make the strokes stand out against the darker background. Touches of the same green mixtures are added to the foliage with the tip of a round softhair brush.

Visualize the Landscape in Planes

To create a clear sense of space in a landscape, professionals often visualize an outdoor subject as a series of planes.

- 1. In this landscape, the big tree to the left, the smaller tree to the right, the rock formation, and the grassy shore beneath them are all in the *foreground* plane.
- 2. The water and the paler mass of trees on the shore in the middle of the picture are in the middle ground plane.
- 3. The very pale shore at the horizon—and the reflection beneath the shore—are in the distance.
- **4.** Dividing your subject into foreground, middle ground, and distance will help you to plan your composition and your color more effectively.

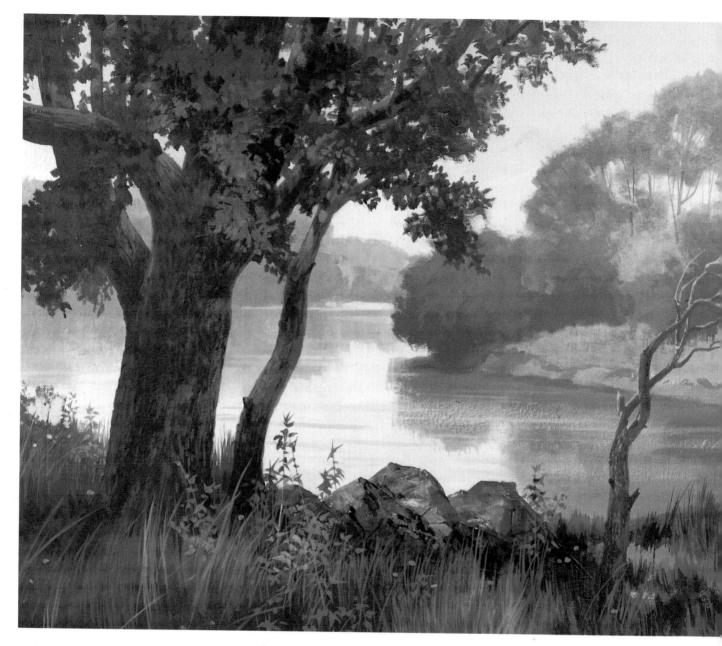

Step 7. The last precise details are saved for this final step. More blades of grass, plus some leafy weeds, are added to the foreground with the same mixtures used in Step 6. Notice, however, that the *entire* foreground isn't covered with these strokes; you can still see lots of the broad, rough brushwork from Step 4. A few tiny touches of cadmium yellow suggest scattered wildflowers among the weeds. A few more touches of really bright green—phthalocyanine green,

cadmium yellow, and white—are added to the foliage. The small tree to the right is completed with strokes of ultramarine blue, burnt umber, and white. You'll notice a slight change in the color of the trees on the distant shore to the right. They're enriched with a glaze of chromium oxide green, yellow ochre, and water. This transparent tone is carried down over the reflection of these trees in the water to the right.

MAKE AUTUMN COLORS BRILLIANT

Step 1. The shapes of the trees, road, and clouds are drawn in pencil on illustration board. Then the dark trunks are drybrushed with a bristle bright, carrying a blackish mixture of ultramarine blue and burnt sienna. The blue patches in the sky are painted with ultramarine blue, yellow ochre, and white. Some burnt sienna is added to this mixture for the shadow areas of the clouds. Then the sunlit edges of the clouds are scumbled with a mixture of white and yellow ochre, connecting the blue and the gray. (These cloud tones will flow more softly if you add gloss or matte medium.) The white and yellow ochre mixtures are carried down toward the horizon; this will add a warm glow to the lower sky.

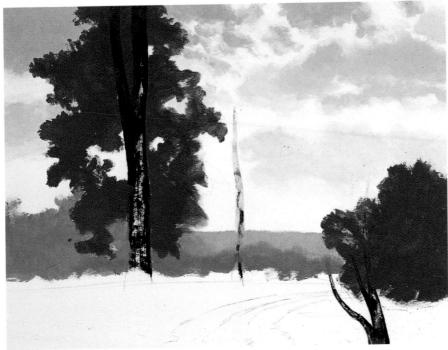

Step 2. The brilliant tones of the autumn trees are painted with scrubby, scumbling strokes of cadmium red and yellow ochre, applied with a bristle bright. These slightly ragged strokes suggest the texture of the foliage. The strip of landscape at the horizon is painted with a mixture of ultramarine blue, naphthol crimson, burnt sienna, and white-with a bit less white at the lower edge. The short, stiff bristles of the bright give this shape a ragged edge. Notice that the hot color of the foliage begins to run over the dark tree trunks, but the color is still quite thin and doesn't obscure the trunks just yet. In later stages, the trunks will begin to disappear under foliage.

MAKE AUTUMN COLORS BRILLIANT

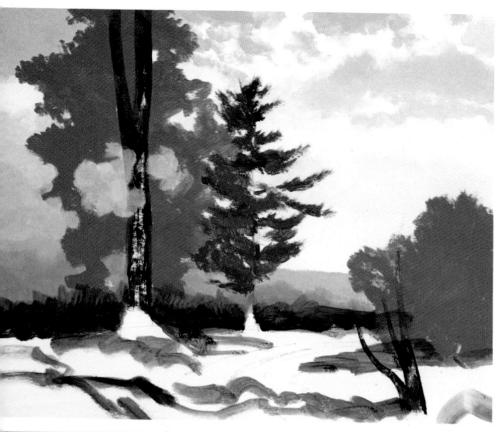

Step 3. The same stiff, short brush scrubs in the foliage of the dark evergreen with ultramarine blue and yellow ochre. At the extreme left, the lower sky is darkened with a thin, fluid mixture of ultramarine blue, burnt sienna, and white, scumbled downward to blur the outline of the distant horizon. Some of the blue sky mixture from Step 1 is painted into the center of the tree to suggest gaps in the foliage where the sky shines through. The dark mass of trees just below the horizon, plus some of the darks in the foreground, are brushed in with a very fluid mixture of burnt umber, ultramarine blue, a little naphthol crimson, and lots of water.

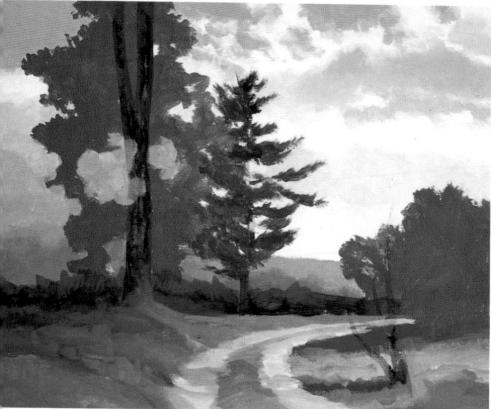

Step 4. The cool tones of the grass are scrubbed in with a bristle bright and a mixture of ultramarine blue, yellow ochre, burnt sienna, and white—with less white in the shadows and more white in the sunlit patches. The road is painted with ultramarine blue, burnt sienna, and white, with more blue in the shadows. Notice that the tree in the lower right is beginning to disappear under all that paint; but its shape will be strengthened in the final stages.

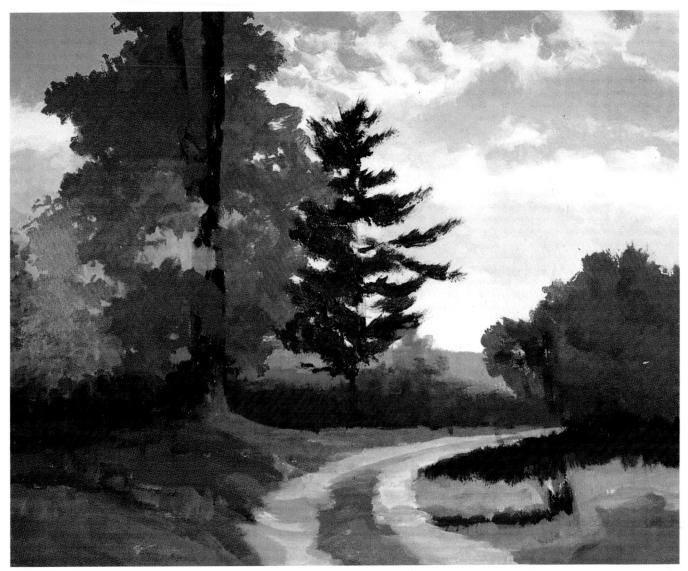

Step 5. De Reyna brushes in the lighter trees at the left with cadmium red, cadmium yellow, burnt sienna, and white dabbed onto the board with the tip of a filbert. He makes short, scrubby strokes with the same brush to create the shadows on the big tree and on the smaller tree to the right; this is a mixture of ultramarine blue, burnt sienna, and cadmium red. As he paints, he lets the colors of the foliage gradually run over the shapes of the tree trunks. The same shadow mixture, with more blue added, is scrubbed in over the dark strip at the horizon.

Broad Brushwork

The brilliant colors of the big tree are painted entirely with very broad, rough strokes. In fact, the color is scrubbed on so freely that one stroke seems to merge with the next—it's difficult to decide where one stroke begins and another ends. The artist focuses on the overall shape of the tree. He distinguishes between the sunlit and the shadowy foliage, but makes no attempt to suggest individual leaves. The detailed, precise

brushwork is restricted entirely to the slender lines of the branches. If the dense mass of autumn trees were painted with many tiny strokes, there would be more detail than the viewer could stand.

Why choose precise brushwork for one and rough brushwork for another? Both kinds of brushwork are equally effective. But there are no "rules." Simple brushwork is often the best way to paint a complex subject.

MAKE AUTUMN COLORS BRILLIANT

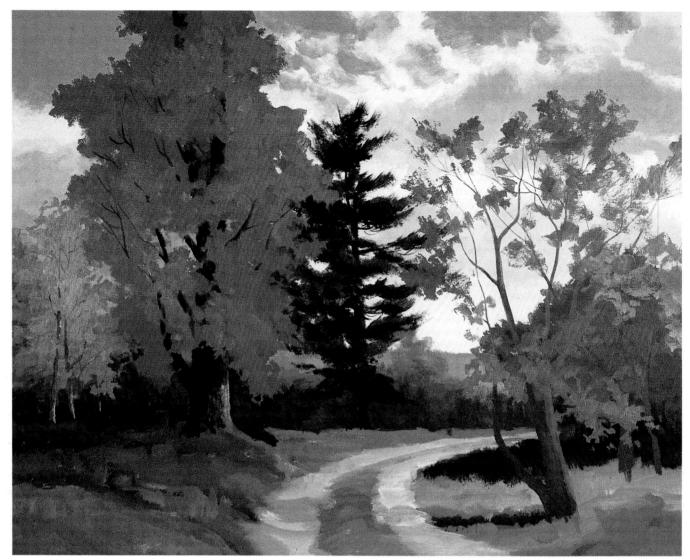

Step 6. The tip of a filbert now adds lighter, sunlit foliage to the trees at the left with cadmium red, cadmium yellow, and yellow ochre. The big tree trunk is now partially covered by foliage. A round softhair brush adds trunks to the smaller trees at the left and branches to the big tree—a mixture of ultramarine blue and burnt

umber. The light edges on the trunks are white with just a hint of burnt umber. A trunk and branches are added to the evergreen with the same dark mixture, which is also used to reconstruct the tree at the right. Then the light foliage mixture is scattered across the right with taps of the filbert.

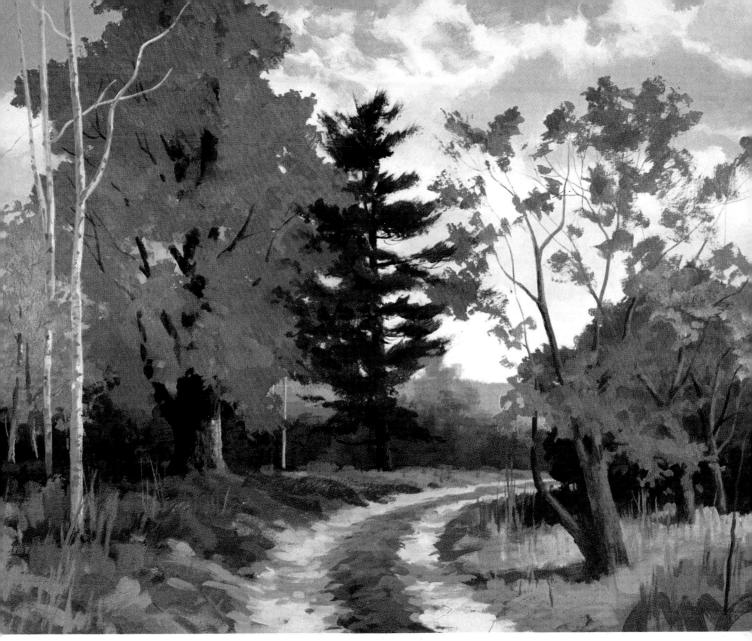

Step 7. Clumps of dead weeds are suggested in the foreground with a round softhair brush. These strokes are all mixtures of ultramarine blue, burnt sienna, yellow ochre, and white, with more brown in the warmer strokes, more blue in the cooler strokes, and more white in the paler tones. The artist uses the very tip of the brush to indicate individual blades of dried grass with that same pale mixture. The pale trunks of the

birches at the left are painted with two mixtures: white with a faint tinge of burnt umber on the sunlit side; burnt umber, ultramarine blue, and white on the shadow side—with a darker version of this same mixture for the flecks on the bark. This dark mixture is also used to add dark edges to the trees and branches on the right. The somber, grassy tones in the center of the picture, running up the road and reappearing under the evergreen,

are ultramarine blue, yellow ochre, white, and an occasional hint of burnt sienna. Although the painting seems to be full of rich detail, the entire landscape is very loosely painted. It's hard to pick out a single leaf—the leaves are just rough touches made by the tip of the brush. Although the ground *seems* to be covered with withered weeds and grasses, only a few individual blades are suggested by the brush.

CAPTURE THE SUBTLE COLORS OF WINTER

Step 1. The key to this stark winter landscape is the pattern of the dark trunks and branches. Therefore, the preliminary pencil drawing defines these shapes very clearly, tracing the outline of every trunk and branch. This painting is on a canvas board, selected so that the texture of the weave will soften and blur the brushstrokes. The outer edges of the snowbanks are drawn more simply. The outer and inner shapes of the stream are drawn carefully, although these will change somewhat in the process of painting. Then the darks of the trees are painted in pure black, with a round softhair brush. The idea is to make these very important shapes dark enough so that they won't disappear as colors are applied behind and around them.

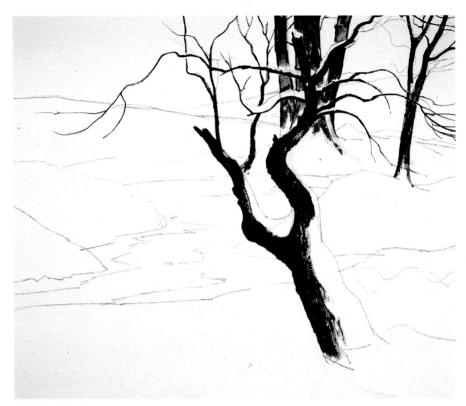

Step 2. The sky is painted with broad strokes of a bristle brush. The color is a mixture of ultramarine blue, cadmium red, yellow ochre, and white. Since water most often reflects the color of the sky—and ice is just another form of water—the sky mixture reappears along the edges of the frozen stream. The sky color runs over the darks of the distant trees, but the trees are still there. The muted tones of the trees along the horizon are now scrubbed in with burnt umber, ultramarine blue, and white.

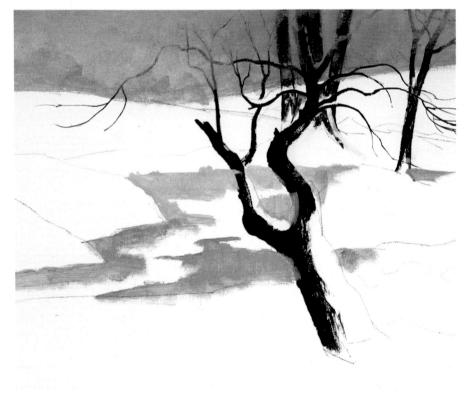

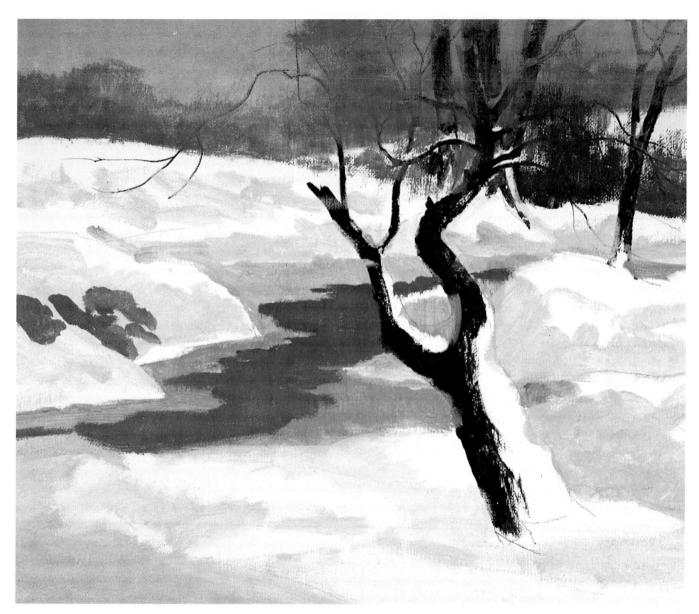

Step 3. The trees at the horizon are extended upward with scumbling strokes of the sky mixture-containing much less white. Then the warmer tree tones-below the horizon and to the right-are scumbled in with burnt sienna and black. For both these operations, the paint is fairly thick and a bristle brush is used. You can see where the texture of the canvas breaks through the strokes. An even darker version of the sky mixture is painted across the center of the stream. And a paler version of that mixture - with more white and more water-is used to block in the shadow sides of snowdrifts. Snow, like ice, is just water, reflecting the color of the sky.

When Painting Snow

- **1.** Remember that snow is water—which reflects the surrounding colors.
- **2.** Observe snowdrifts carefully and look for the planes of light and shadow.
- **3.** The lighted planes tend to reflect the color of the sunlight.
- **4.** The shadow planes tend to reflect the color of the sky.
- **5.** Thus, the lighted planes tend to be warmer in color and the shadow areas tend to be cooler.
- **6.** Look for other reflected colors—from nearby foliage, tree trunks, rocks, dead weeds, and other objects in the landscape.

CAPTURE THE SUBTLE COLORS OF WINTER

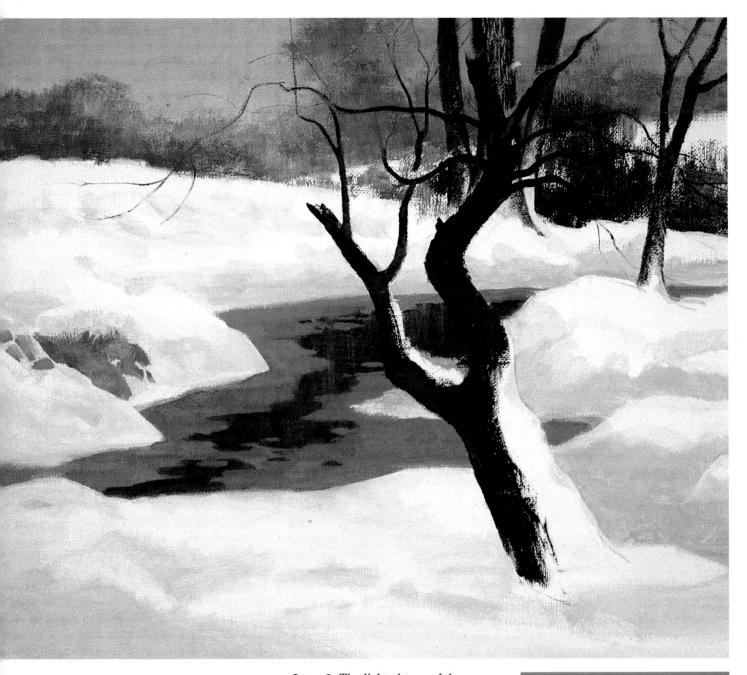

Step 4. The lighted tops of the snowdrifts are scumbled with fluid white, faintly tinted with naphthol crimson, yellow ochre, and ultramarine blue. These scumbled strokes seem to blend into the shadows. The artist uses a round softhair brush to define the dark shape within the frozen stream—an even darker mixture of the sky color. The darks of the trees are reinforced now with burnt umber, ultramarine blue, and white. A bit of white is drybrushed over the distant trunks.

Warning: Snow Isn't White

So never paint snow with pure white from the tube. Modify the white to match the color you actually see in the landscape. Add a whisper of yellow on a sunny day, red at sunrise or sunset, blue on an overcast day. Paint the colors of snow you see, not what you think you see.

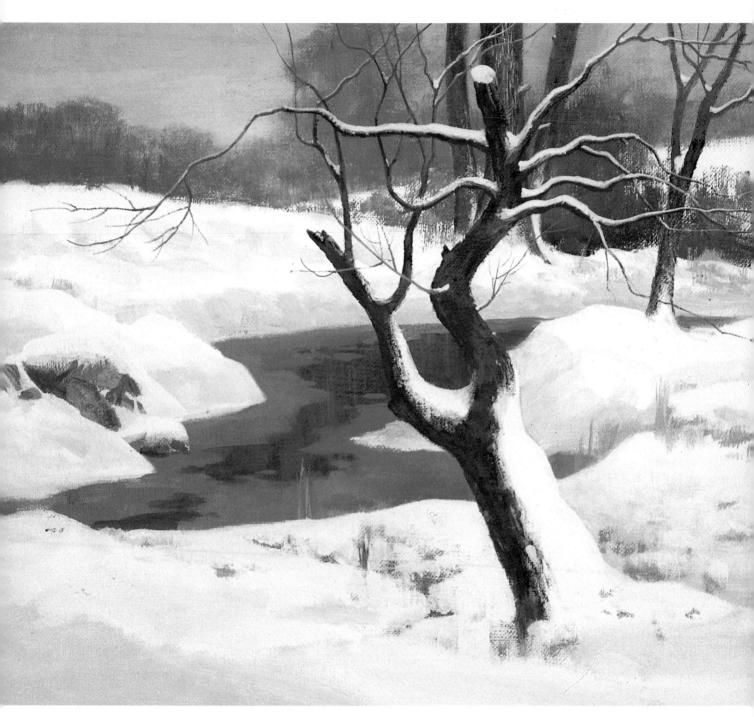

Step 5. The trunks and branches are completed with two drybrush operations. Over the dense black of Step 1, a slightly paler tone of burnt umber, ultramarine blue, and white is drybrushed to suggest the texture of the bark. Then the snow is drybrushed over the edges of the dark trunks and branches - mostly white, with just a tinge of the snow mixture used in Step 4. The canvas texture makes it easier to scumble and blend the smoky tones in the distance. And the weave also makes it easy to drybrush the bark textures on the trunks and branches.

Some warm horizontal strokes of naphthol crimson, yellow ochre, ultramarine blue, and white are added to the lower sky. All the dark trunks and branches are reinforced with burnt umber, ultramarine blue, and white. The lighted tops of the snowdrifts are reinforced by scumbling a bit more of the mixture used in Step 4. Some shadows are added to the rocks at the left-partly concealed by snow-with burnt umber and ultramarine blue. Here and there, the artist uses the point of a round brush to add some dead leaves with burnt sienna, a little black and white, and enough water to make the strokes more fluid. A winter landscape is not all dull gray and white. As you see here, winter is full of subtle color.

Snow Can Be Any Color

Don't paint snow shadows gray. They can be *any* color, depending upon light and weather: blue, violet, green, gold—whatever!

INTERPRETING THE MOOD OF THE COAST

Step 1. In this demonstration, you'll learn how to use acrylic in a fluid, transparent technique-the "wet-inwet" technique that's similar to watercolor. Like a watercolor, this entire picture is painted with only softhair brushes. The shapes of this rocky coastal scene are drawn with a pencil on cold-pressed watercolor paper. Brush the entire sky area with clear water – you can use a large flat brush or a sponge—and let the water sink in for just a moment. While the paper is still wet and shiny, the dark shapes of the clouds are brushed onto the wet surface with a mixture of ultramarine blue, naphthol crimson, and yellow ochre. The strokes spread and blur. If any color goes where you don't want it, you can blot it up with a paper towel or tissue.

Step 2. The cloud shapes are allowed to dry. Because acrylic is waterproof when it dries, the clouds won't dissolve when more color is brushed over them. Now the sky area is brushed with clear water once again. A pale mixture of ultramarine blue and phthalocyanine blue-with lots of water - is brushed over the entire sky area, right down to the horizon. The color is carried over the distant hills. While the sky is still very wet, a hint of yellow ochre is brushed between the horizon and the lower clouds to add a suggestion of warmth. Notice that no white is used to make the colors lighter. It's all done with water; thus the colors remain transparent like watercolor.

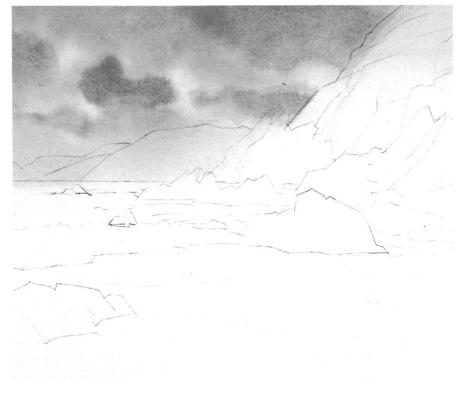

Step 3. When the sky is bone dry, the distant hills are painted over it with the same mixture that was used for the clouds. The paler hills are painted first, then allowed to dry. The darker tones of the cliff and the foreground rocks are begun with the sky mixture, containing more blue—and with burnt umber added. The dark side of the big rock is carefully painted around the shape of the gull.

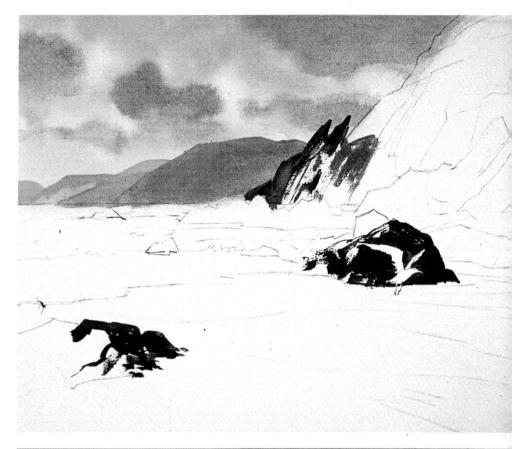

Step 4. More darks, plus some details of cracks and crevices, are added to the cliffs and rocks with the same mixture that was used in Step 3. Notice how drybrush strokes accentuate the craggy texture of the rocks. The details of the rocks are painted with great care and allowed to dry. They're now waterproof, so wet tones can be washed over them.

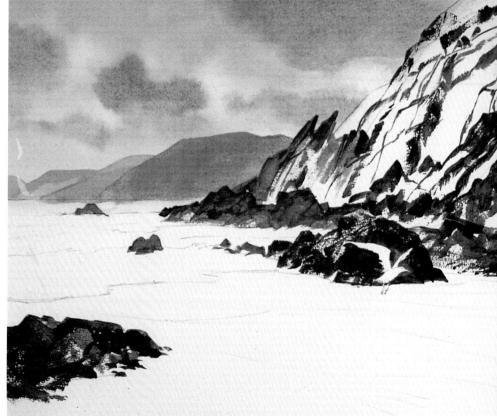

Playing It Safe

Remember that your color is transparent—so you can't cover up your mistakes. Play it safe by applying light colors first. You can always darken them if they're too light.

INTERPRETING THE MOOD OF THE COAST

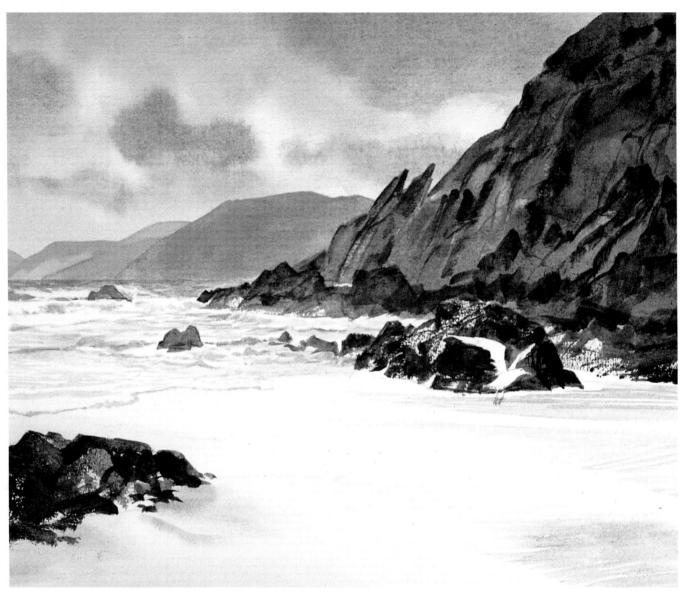

It Just Looks Like Watercolor . . .

Acrylic dries insoluble—unlike normal watercolor—so you can't scrub off a mistake with a wet brush. Plan each step before you touch brush to paper. But if an acrylic "watercolor" does fail, don't tear it up. Repaint it in the opaque technique.

Step 5. A fluid wash of ultramarine blue and burnt sienna is brushed over the entire cliff area. While this tone is still wet and shiny, the dark rock mixture is blended in at the top of the cliff; thus, this looming rock formation becomes more shadowy. The tip of a round brush carries slender, curving strokes of the cloud mixture across

the water. This same brush draws slender lines of burnt sienna and ultramarine blue across the beach to suggest ripples in the sand. The beach in the immediate foreground is first sponged with clear water and then the ripples are painted onto the wet surface, where they tend to blur.

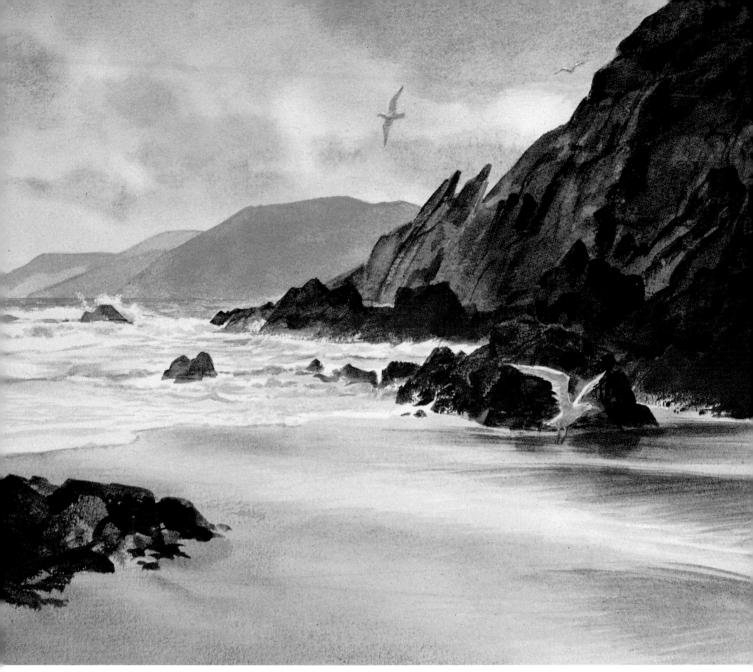

Step 6. In the final stage, the rocks at the foot of the cliff are darkened with a wash of burnt sienna and ultramarine blue. The lower edges of the rocks are drybrushed so they seem to disappear into the foam of the breaking waves. Drybrush strokes also suggest the rough texture of the rocks in the lower right. The dark flecks in the distant hill are a phenomenon called granulation, which adds to the atmospheric feeling: a very wet wash of acrylic color, diluted with lots of water, settles into the valleys of the textured paper.

The delicate ripples on the beach are allowed to dry. Darker strokes are added on the right to accentuate the ripples—a mixture of burnt umber and ultramarine blue. This same mixture adds reflections beneath the rocks and the cliff at the right. And a paler version of this mixture adds the shadows under the wings and body of the gull. When this detailed work is dry, the entire beach is brushed with clear water once again. While the surface is wet, a mixture of burnt sienna, ultramarine blue, and yellow ochre is brushed over the foreground, fading

away into the distance. Before the beach loses its shine, a paper towel blots up a light path from the lower right to the edge of the water, suggesting sunlight reflecting on the wet beach. For drybrush strokes like those on the rocks, one good trick is to work with the *side* of a round softhair brush, not with the tip. The side will make a more ragged stroke.

PAINTING A PORTRAIT

Step 1. This head is first drawn on tracing paper and then transferred to canvas. First he establishes the strongest darks in the head. The shadows around the eyes are painted with a dark mixture of raw umber, black. and white, applied with a bristle brush. The major dark notes of the head are now completed with the same mixture. The edges of the face and shoulders - where they meet the background—are also defined with dark lines. As the shapes of the face. shoulders, and background are filled with color in later stages, these dark lines will disappear. The broad shadow under the chin contains just a bit more white.

A Review of Underpainting and Glazing

- **1.** Begin with a careful pencil drawing that defines the forms.
- 2. Paint the pattern of lights and shadows in monochrome, which can be a cool or warm gray.
- **3.** Block in the shadow areas of the underpainting *first*.
- **4.** Block in the middletones and the lights, adding more and more white to the basic gray mixture working from dark to light.
- 5. When the underpainting is bone dry, thin your tube color with gloss medium and begin to glaze transparent color over the monochrome foundation.
- **6.** Work from light to dark, brushing one glaze over another until you reach the final density.
- **7.** Scumble the lighted areas with semitransparent color, diluted with medium once again, but also containing a touch of white.

Step 2. More white is added to the same mixture to paint the middletones—the tones that are lighter than the shadows but darker than the lights. You can see where these middletones are added between the darks on the forehead, eyes, nose, ears, cheeks, chin, jaw, and neck. Gaps of bare canvas are left for the lightest tones, which will come next. More dark strokes are added along the right side of the forehead and jaw. The shadows of the features are reinforced with more darks too. And the shoulders are painted with flat tones.

Step 3. The lightest tones are scumbled in with the same mixture, which now contains much more white. You can see these tones where there was just bare canvas before: the left side of the forehead, cheek, nose, upper lip, jaw, neck, and Adam's apple. The shapes of the ear are more clearly defined with this light tone too. A dark version of this mixture covers the hair. The background is painted with various tones of this mixture darkest at the top, lighter at the middle, then darker again at the bottom blended by scumbling. The broad tones are all painted with a bristle brush. Then a round softhair brush adds a few more details, such as wrinkles around the eyes.

Step 4. Small bristle brushes strengthen the lights and darks, still working with lighter and darker versions of the same mixture used in all the preceding steps. You can see where strong highlights are added to the brow, nose, and chin, while the darks are strengthened on the right side of the face and neck. The shadow inside the collar is strengthened too. The background is lightened with more scumbling strokes to make the head stand out more boldly. Then the tip of a small, round softhair brush sharpens the details of the eyes and evebrows, defines the mouth more clearly, and adds light and dark lines to the hair. At this point, the picture is completely painted in monochrome, like the kettle you saw in Step 3 of the underpainting and glazing demonstration.

Draw Lots of Heads

The secret of painting successful portraits is to do a lot of drawing. Don't draw from photographs. Draw from life. Make lots of line drawings that teach you about the contours of faces and features. Observe the shapes of the shadows and block them in boldly and simply. Draw different views of the head. Change the lighting on the head so you learn how to draw lights and shadows.

Step 5. The lights and shadows of the head are completely defined. The portrait is already a convincing likeness—like a black-and-white photograph. Now the color is added in transparent glazes that reveal the underlying pattern of lights and shadows. The glazing begins on the face with very pale tones of burnt sienna and yellow ochre, plus a lot of gloss medium—

paler in the light areas, darker in the shadow areas. The background is slightly toned with a glaze of naphthol crimson, ultramarine blue, yellow ochre, and gloss medium. The glazing operation is performed with flat softhair brushes. The whole idea is to build up the color *very gradually*, so it doesn't obscure the monochrome underpainting.

Step 6. When the first glazes are dry, the middletones and shadow areas of the face are darkened with more of the same mixture. The glaze is heavily applied in the shadow areas, a bit more thinly in the middletones, and very lightly over the more brightly lit areas. The lines in the face are darkened with the same mixture, applied with a round softhair brush. The back-

ground is darkened with a glaze of alizarin crimson, yellow ochre, and black, which is carried over the shoulders.

The darker tones of the face are strengthened with a mixture of black, burnt sienna, and yellow ochre. A bit more burnt sienna and yellow ochre are glazed over the lighter areas. Now the face begins to glow with the colors

of life. The whites of the eyes are lightened with a whisper of white and ultramarine blue, diluted with a lot of medium, while highlights are added to the eyes with the same mixture, diluted with much less medium. The background is darkened with a glaze of ultramarine blue and a little yellow ochre.

Step 7. In the final stage, a flat soft-hair brush picks up just a bit of white and yellow ochre—diluted with gloss medium—and lightly scumbles over the lighted areas of the face, gradually softening the edges and blending them into the darks. All the lines and contours are softened and made more luminous. Compare Step 7 with Step 6, looking carefully at the lighter sides of the brow, cheek, nose, chin, and neck. This scumbled golden white is quite thin and transparent, softening

the darks, but never concealing them. The scumbled strokes are built up very gradually—stopping before there's any danger of covering the darks that were so carefully painted in monochrome. Notice how small touches of white, tinted with yellow ochre, are added to the wrinkles on the brow and eyes, to the nose, and to the lips. In the same way, an additional glaze of black, burnt sienna, and yellow ochre—diluted with a lot of gloss medium—is scumbled over the

shadow side of the face, which becomes darker, and contrasts more strongly with the light background. A great deal of gloss medium is added to all these glazes and scumbles to make sure that they're thin and transparent. They must never be allowed to obscure the monochrome foundation on which the entire painting is built. The luminosity of the flesh tones is the result of this transparency.

SECTION THREE

LANDSCAPE SUBJECTS

SELECTING LANDSCAPE SUBJECTS

Potential Pictures. One way to tell the difference between an experienced painter and a beginner-without even looking at their work—is to watch how they find a subject to paint. The experienced artist walks for ten or fifteen minutes (maybe less), then quickly sets up his gear and gets to work. The beginner often wanders for an hour or more, looking for "just the right subject," and finally gets to work when the experienced painter is half finished. Why does the "veteran" find his subject so much more quickly? Does he just have a better eve, so he spots the "right subject" more quickly? On the contrary, he knows that he won't find perfect pictures, so he doesn't waste his time looking for them. He seizes on a subject that seems to have *potential*. The elements of the picture may be out there, but they're usually scattered, the wrong size, the wrong shape, or just too far away. They become a picture because the artist sees how they might be reassembled into a satisfying pictorial design. The experienced artist spends his time creating the painting, while the beginner wastes his time looking for it.

Looking for Potential. There are many ways to spot a potential picture. The most obvious way is to look for some big shape that appeals to you, such as a clump of trees, the reflections in a lake, a rock formation, or a mountain peak. You organize the other parts of the landscape around this center of interest, deciding how much foreground, background, and sky to include, then bring in various "supporting actors" such as smaller trees, rocks, and more distant mountains. Still another approach is to look for some interesting color contrast, such as dark blue-green evergreens against the brown trees of an autumn landscape, or the hot colors of desert rock formations against a brilliant blue sky. You might also be intrigued by a contrast of light and shadow, like a flash of sunlight illuminating the edges of tree trunks in dark woods.

Orchestrating the Picture. Having decided on a focal point, you still have to decide how to organize the various elements that make a picture. You can't just stick that clump of trees or that rock formation in the middle of the painting, include a little sky and a little background, and then go to work. Just as a famous star needs a supporting cast, the focal point of your picture needs some secondary elements. If the dominant shape in your picture is a big tree, place it a bit off center and balance it against some smaller trees-which will make the big tree look that much bigger. A mountain peak will look more imposing with a meadow and some low hills in the foreground, plus some paler, more distant peaks beyond. If those smaller trees, that meadow and hills, or those distant peaks aren't exactly where you want them, you can move them to the right spot in the picture. If they're too big or too small, don't hesitate to change their scale.

Keep It Simple. Just as you decide what to put into the picture, you must also decide what to leave out. You may actually see dozens of trees, but a big one (or a big clump) and a few smaller ones are enough to make a picture. Don't try to paint every pebble scattered at the foot of that rock formation; just a few pebbles are enough to make the big rocks look bigger by contrast. A sky is often filled with clouds, all roughly the same size and shape. They look beautiful in nature, but they make a dull picture, so enlarge one, reduce two or three others, and leave out the rest.

Make a Viewfinder. Many painters use a simple device that helps them

isolate pictures within the landscape. To make a viewfinder, as it's called, take a piece of white or gray cardboard about the size of the page you're now reading. In the center of the cardboard, cut a "window" that's about 5"×7" (125 mm×175 mm). Hold this viewfinder at a convenient distance from your eye—not too close—and you'll see lots of pictorial possibilities that you might not spot with the naked eye. You can also make a viewfinder by making a rectangular window with the fingers of both hands, like a motion picture director might do.

Try Again. An unpromising subject often turns into a winner with a slight change in the light, the weather, or your vantage point. If you want to capture the blue of a lake at its most brilliant, the color will be strongest at midday, when the sun is brightest. But later in the afternoon, as the sun drops low in the sky, the shoreline of the lake may have a dark, mysterious silhouette, and dark ripples will appear on the surface of the water-giving you a second picture of the same subject. It's also a good idea to walk around the subject and look at it from different angles. From one vantage point, those distant hills may be framed by trees, while the hills may have a more interesting shape from another angle. One view may interest you more than the other—or you may want to paint both. Some subjects look more paintable when you move closer, such as the gnarled texture of an old tree stump, which you can't see so easily from a distance. At other times, it's best to step back: that cluster of wildflowers may merge into an interesting, irregular shape if you paint it from farther away. Keep watching. Keep moving. There are more pictures out there than you think.

MIXING COLORS FOR LANDSCAPES

Plan Your Mixtures. There are two main secrets to successful color mixing. First, try to visualize the components of the mixture before you start to mix them - don't just pick up colors at random and scrub them together on the palette, hoping that the mixture will turn out right. Second, add colors to the mixture very gradually. Look carefully at the subject and try to decide which two or three tube colors will come closest to the right mixture. (You'll probably need some white too.) Start out by mixing small quantities of just two colors. Then add a small quantity of the third, if you need it. Keep adding color in small amounts until you have the exact hue.

Procedure. Let's see how this would work with a typical mixture. You need a rich, deep green for a clump of trees; naturally, you start with blue and yellow. You blend a small quantity of phthalocvanine blue with some cadmium yellow light. These two brilliant colors produce a brilliant green, but it seems too blue. Now you add a bit more cadmium yellow to make a "greener" green. Finally, you've got the right balance of blue and yellow to give you a satisfactory green. But it's too bright. You pick up some burnt umber to create a more subdued flavor. Not quite enough umber, so vou add a bit more. The mixture finally looks right, and you add more of the three components to get the quantity of color you need. For the paler, more distant trees, you use the same mixture, but you add some white.

Mixing Greens. It's hard to imagine painting landscapes without painting trees, shrubs, and grasses. So it's essential for the landscape painter to learn how to mix the greatest possible variety of greens. Just the two blues and two yellows on your palette will

give you quite a range. The most brilliant mixture will be phthalocyanine blue and cadmium vellow light. Ultramarine blue and cadmium yellow light, or phthalocyanine blue and vellow ochre, will give you more subdued mixtures. And the most muted greens will combine ultramarine blue and vellow ochre. Black and cadmium vellow will give you another rich green, while black and yellow ochre will give you a very subtle brownish green. These hues will change radically as you vary the proportions of blue and vellow or black and yellow. Major changes will also take place when you add a slight touch of red or brown. You also have two ready-made greens on your palette: the brilliant phthalocyanine and the subdued chromium oxide. Don't merely use these straight from the tube. Learn to modify them with blue to produce blue-greens, with yellow to produce yellow-greens, and with browns and reds to produce brownish greens. If you decide to add Hooker's green to the palette, try the same combinations.

Mixing Browns. In outdoor subjects. browns are as widespread as greens. Your palette gives you just as many interesting possibilities. Any blue-redyellow combination will produce an interesting variety of browns, which will change radically as you adjust the proportions of the three components. More blue will give you a darker, grayer brown. More red will push the mixture toward copper. And more yellow will give you a golden brown. Try substituting black for blue. You can also create interesting browns with red-green combinations such as cadmium red light and phthalocyanine green, or naphthol crimson and chromium oxide green. You do have two browns on your palette-burnt umber and burnt sienna - which can be modified in all sorts of ways. Touches of blue will give you grayish browns. You can add any other color on the palette to give you reddish, greenish, blackish, and yellowish browns.

Adding White. Buy the largest available tube of titanium white, since you'll use more white than any other color. It's a rare mixture that doesn't include some white. In fact, many colors look rather drab as they come straight from the tube, not revealing their true richness until you add some white. The blues and greens, in particular, often look blackish as they come from the tube and need a touch of white to reveal their true color.

Color Schemes. The need to plan the overall color scheme of a landscape is just as important as planning the individual color mixtures. What you may actually see is a uniformly green landscape in midsummer. But a solid green landscape can be terribly monotonous, so now you've got to find some way to relieve the uniformity. A few brownish or yellowish trees will help, even if you have to paint them from memory or from sketches. When you find yourself looking at a monotonous gray winter landscape, the solution may be to add some evergreens or some brownish tree trunks. Try to orchestrate your bright and subdued colors to direct the viewer's eye. It's good strategy to save your strongest colors or your strongest contrasts for the center of interest, where you want the viewer's eye to go. Those bright yellow wildflowers will look most vivid against a gray, fallen tree trunk. If you're painting a rocky landscape and you want one rock formation to stand out, exaggerate the contrast between the sunlit and shadow sides of the boulders.

MIXING COLORS FOR LANDSCAPES

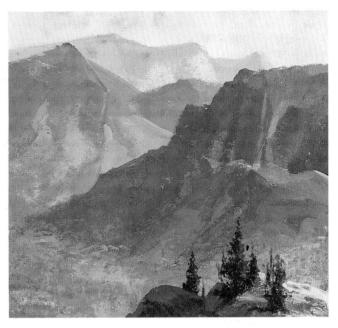

Mountains. The stony forms of mountains are far more colorful than you might believe at first glance. The darkest mountain is a blend of burnt umber, ultramarine blue, yellow ochre, and white—with more white and yellow ochre in the lighter areas, more blue and brown in the shadows. The more distant mountains are mixtures of burnt sienna, ultramarine blue, white, and yellow ochre—with lots of white in the lighted areas and lots of blue in the shadows.

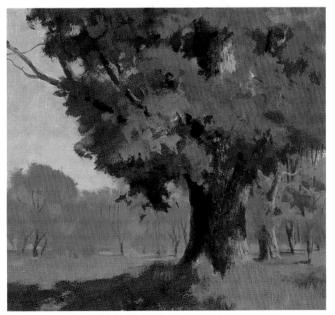

Tree in Full Leaf. Paint the *masses* of leaves with broad strokes. The sunlit sides are ultramarine blue and cadmium yellow, plus a little white, while the shadowy areas are ultramarine blue, yellow ochre, and burnt sienna. These mixtures reappear in the paler tones of the distant trees, which obviously contain much more white. The trunk of the big tree is ultramarine blue, burnt sienna, yellow ochre, and white—with more white on the sunlit side.

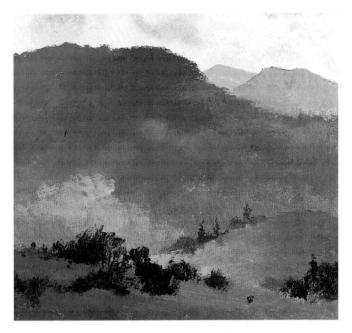

Hills. When you paint hills covered with trees and underbrush, try to emphasize the variety of color within the green. This green hill is a subtle patchwork of various green mixtures: ultramarine blue and cadmium yellow; ultramarine blue and yellow ochre; phthalocyanine blue and yellow ochre; phthalocyanine blue, cadmium yellow, and a touch of burnt umber to soften this brilliant mixture; phthalocyanine green and burnt sienna; Mars black and yellow ochre for the most muted greens of all.

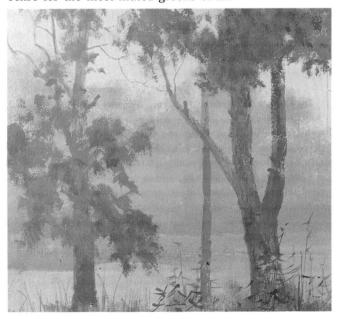

Trees in Mist. On a misty day, trees lose their brilliant colors, but new, equally interesting colors emerge. You can mix lovely, muted greens, like the foliage in the foreground, with ultramarine blue, yellow ochre, white, and perhaps a touch of burnt umber or burnt sienna. You can also use just a little phthalocyanine blue or phthalocyanine green, burnt umber or burnt sienna, yellow ochre, and white—or Mars black, cadmium yellow, and white.

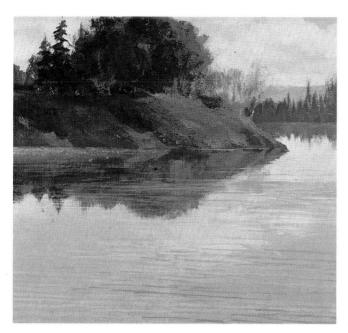

Pond Under Open Sky. Water has no color of its own, but takes its color from its surroundings. This pond repeats the blues and whites of the sky and clouds above. Along the shoreline, it reflects the tones of trees and grass—not only the sunny greens, but also the shadow tones. To produce delicate blues, add plenty of white to ultramarine or phthalocyanine blue, then the slightest touch of burnt umber, burnt sienna, or yellow ochre.

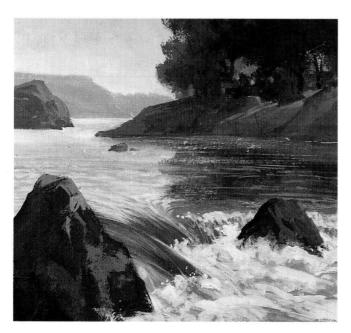

Stream. In moving water, the color effects are more complicated. Just above the rock in the lower left, the water reflects the colors of the sky. To the right of the sky tone, the water picks up the colors of the trees and rocks on the distant shore—with sky colors appearing among the pale ripples. Where the water rushes over the rocks, you can see the darkness of the concealed rocks. As the rushing water bursts into foam, it turns white, but then the shadows beneath the foam pick up the sky color once again.

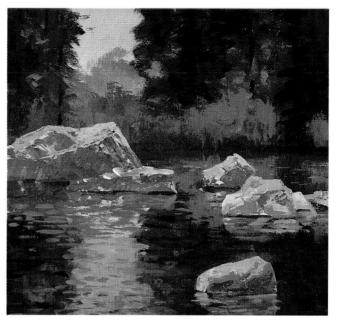

Pond in Deep Woods. This pond is dominated by the dark tones of the surrounding landscape, reflecting just a small patch of pale sky that breaks through the trees. These trees and rocks—and their reflections—are mixtures of burnt umber, ultramarine blue, yellow ochre, and white. You can also produce mysterious, shadowy mixtures with Mars black, yellow ochre, and white; with phthalocyanine green, burnt umber, and white; or with Hooker's green, burnt sienna, and white.

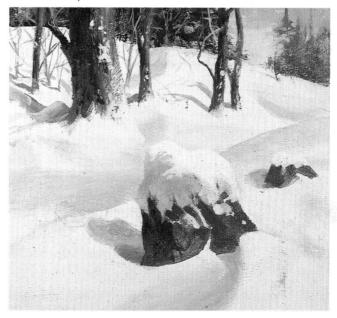

Snow. When you paint snow, remember snow has no special color of its own, but reflects the colors of its surroundings. On a sunny day, the lighted tops of snowbanks reflect the warm glow of the sunlight, while the shadows pick up the cooler tones of the sky. Within the shadows cast by these tree trunks you can also see a subtle reflection of the dark tone of bark. Snow, like foam, should never be painted pure white: on a bright day, add a hint of sunlight; on an overcast day, add a hint of gray.

RENDERING THE TEXTURES OF A TREE

Step 1. This demonstration painting of a tree begins with a pencil drawing that defines the contours of the trunk and branches, the curves of the meadow, the shapes of the three rocks beneath the tree, and the clusters of leaves against the sky. The lines of the tree and rocks will be followed carefully in the final painting. But the shapes of the leafy clusters and the landscape will disappear under rough, impulsive brushwork, so a precise drawing isn't really essential. The main thing is to establish the locations and the general shapes of the leafy masses and the horizon.

Learning More About Trees

Painting landscapes means painting lots of trees. Fill your sketchbook with drawings of trees so you learn about the shapes, texture, and details of all the different varieties of trees in your part of the

- 1. Start by focusing on the overall shape of the foliage mass and the main trunk—not on individual branches or clusters of leaves.
- 2. When you've drawn the big shapes with lines that define the contours, then block in the shadows. Look for a few simple shadow shapes in the leafy mass and draw those shapes boldly.
- **3.** When you've drawn the big shapes and blocked in the big shadows, then you can add some smaller branches and some smaller clusters of leaves. But not too many!

Step 2. A mixture of white, a touch of ultramarine blue, and lots of water is brushed over the entire surface of the illustration board, casting a semiopaque veil over the pencil drawing, which is now almost invisible - just a faint "ghost" of the lines remains. A flat bristle brush covers the top half of the picture with a sky tone: ultramarine blue and white at the top, and ultramarine blue, phthalocyanine blue, yellow ochre, and white for the paler tone that approaches the horizon. When this sky tone is dry, the tree can be painted right over it without disturbing the underlying color.

Step 3. The foliage along the horizon and against the sky is painted with short, scrubby strokes of thick color not too much water-containing ultramarine blue, yellow ochre, and white. Now it's getting too hard to see the faint lines of the tree trunk and branches, so they're redrawn in pencil over the dried color of the sky and the distant foliage. The grassy tones of the meadow are painted with the same short, scumbling strokes of a bristle brush, carrying dark and light mixtures of ultramarine blue, yellow ochre, cadmium yellow, and white. There's more yellow in the light mixture at the left and more blue in the shadowy area at the lower right.

Step 4. A small bristle brush scrubs a thin mixture of burnt umber, chromium oxide green, and white over the trunk and branches. (The grayish tone of the bark would be a lot less interesting if it were merely a mixture of black and white!) Then a painting knife picks up a thick mixture of white, yellow ochre, and gel medium. This pasty color is roughly stroked over the shapes of the three rocks, leaving a ragged, irregular texture. It's important to let this *impasto* passage dry thoroughly before going back to work on the rocks.

A Quick Review of the Impasto Technique

Impasto technique is used to create a rough texture. Blend your paints into a thick mixture that stands up in a mound on your palette. Your strokes should show on your painting, whether you're working with knife or brush. Always let the surface dry completely before applying any more color.

RENDERING THE TEXTURES OF A TREE

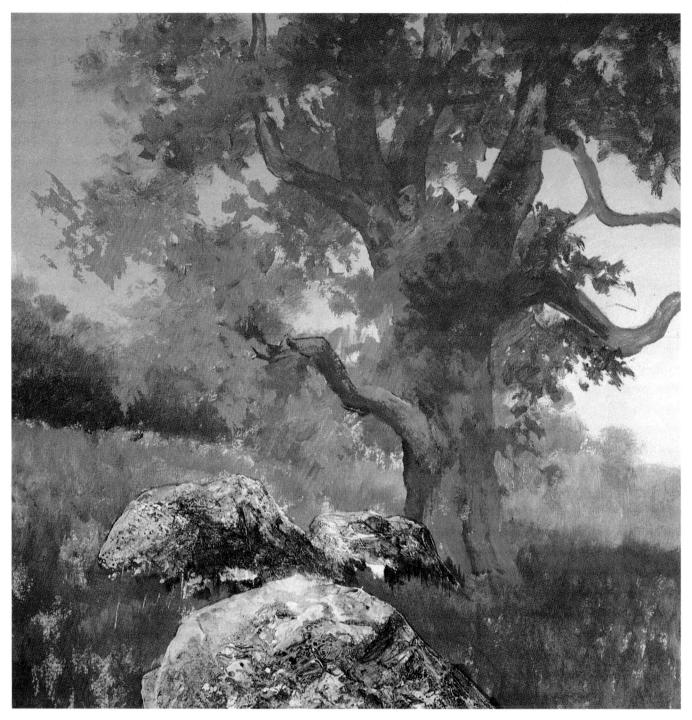

Step 5. When the rocks are bone dry, they're glazed with a transparent mixture of cadmium red, yellow ochre, ultramarine blue, and gloss painting medium, applied with a softhair brush. This glaze settles into all the cracks and crevices left by the painting knife at the end of Step 4. Then the foliage

on the tree is begun with quick taps of the tip of a bristle brush, carrying two different mixtures: ultramarine blue, cadmium yellow, and white for the sunlit leaves; phthalocyanine blue, yellow ochre, cadmium yellow, and white for the darker clusters of leaves.

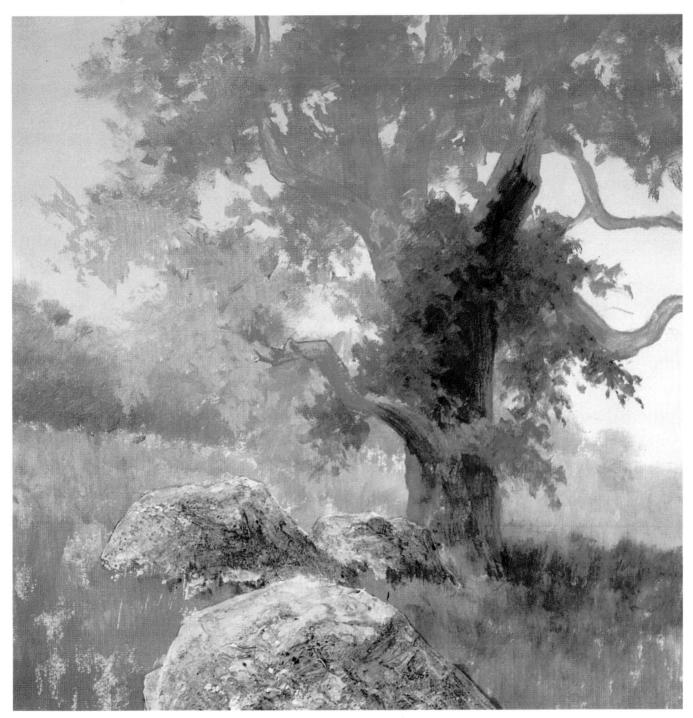

Step 6. The shadows on the trunk and the branches are begun with ultramarine blue and burnt sienna—the strokes follow the upward curves of the tree. The shadow to the right of the tree is painted with short, scrubby strokes of a bristle brush that suggest the texture of the grass with a mixture of Hooker's green and burnt sienna. Then, with the same tapping motion that first appeared in Step 5,

the rich, dark greens of the lower leaves are added with Hooker's green, burnt sienna, cadmium yellow, and just a little white. The color used to paint the foliage is fairly thick—not diluted with too much water or painting medium—so it retains the marks of the bristles, suggesting leaves. Notice that a pale, greenish wash of this leaf mixture, containing lots of water, is carried over the rocks.

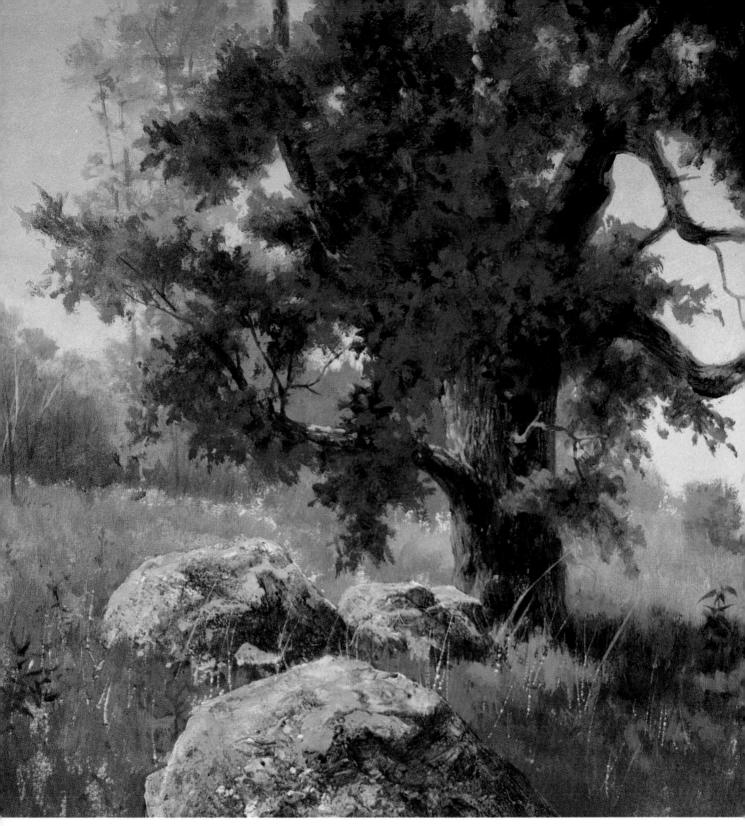

Step 7. Quick, tapping strokes of this mixture of Hooker's green, burnt sienna, cadmium yellow, and a touch of white are carried upward to cover all the deep green shadows of the foliage. Amid these shadowy clusters of leaves, you can see even deeper tones: mixtures of ultramarine blue, Hooker's green, and burnt sienna. More light and dark strokes of Hooker's green, burnt sienna, cadmium yellow, and white are scrubbed over

the grass in the foreground. The shadows and dark lines on the trunk and branches are completed with slender strokes of ultramarine blue and burnt sienna, made with the tip of a round softhair brush. More twigs are added to the big tree, and trunks are added to the distant trees in the upper left with a pale mixture of ultramarine blue, burnt sienna, yellow ochre, and white. Some pale strokes of this same mixture—containing lots of white—

are dragged over the tops of the rocks to strengthen the contrast of light and shadow. Then the shadow sides of the rocks are deepened with the same mixture used on the trunk. Final details are added with the sharp corner of a razor blade and the pointed tip of a small, round softhair brush. The blade scratches weeds and blades of grass in the meadow. The round brush picks up some of the tree mixtures to add some leafy weeds.

PAINT AN ATMOSPHERIC LANDSCAPE OF EVERGREENS

Step 1. Like the deciduous tree in the preceding demonstration, this painting of a group of evergreens begins with a precise pencil drawing of the trunks and branches, but a much more casual indication of the masses of foliage. It's important to visualize foliage as big, simple shapes. Just draw the general outlines of these shapes in pencil, but don't follow the drawing too closely when you start to paint. Foliage must be painted with free, ragged strokes, which will soon cover up these pencil lines.

Step 2. The pencil drawing is partly concealed by a very thin wash of white, a little ultramarine blue, and a lot of water, so the lines are almost invisible. Then the sky is painted in two operations. First, the sky is brushed with clear water. While the surface of the illustration board is still wet and slightly shiny, a mixture of ultramarine blue and phthalocyanine blue is carried from the top of the picture down to the horizon, gradually adding more water as the brush approaches the horizon, so the sky is dark at the top and pale below. This graded wash, as it's called, is allowed to dry. Then the sky is again wetted with clear water and the same type of graded wash is carried upward from the horizon; this time, the mixture is simply naphthol crimson and water, with more color at the horizon and more water at the top.

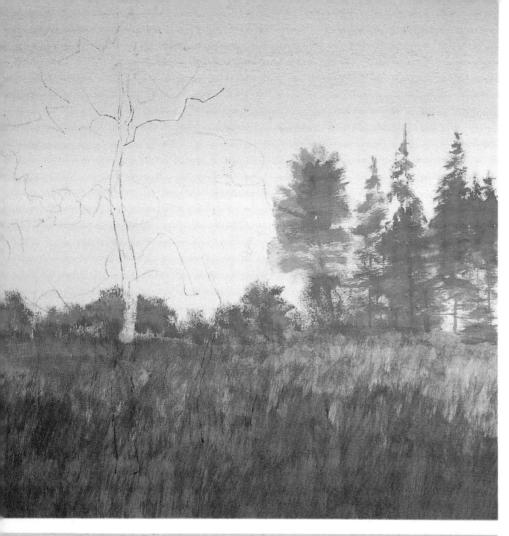

Step 3. The grassy area is scribbled with up-and-down strokes of a flat bristle brush, dampened with burnt sienna and water. Because the brush carries so little color, the marks of the bristles are clearly seen and give the distinct impression of blades of grass. When this scrubby passage dries, it's covered with a fluid, transparent glaze of yellow ochre and water, applied with a large softhair brush. When the yellow ochre dries, the strokes of burnt sienna shine through.

The distant trees along the horizon are painted with short, scrubby strokes of ultramarine blue, cadmium red, yellow ochre, and white, applied with a bristle brush. This same tone, containing more water and more white, is carried over the upper half of the meadow, just beneath the trees—the color is a thin scumble. The immediate foreground is glazed with a transparent wash of chromium oxide green and ultramarine blue, applied with a large softhair brush. It's getting hard to see the lines of the trees, so they're lightly redrawn in pencil.

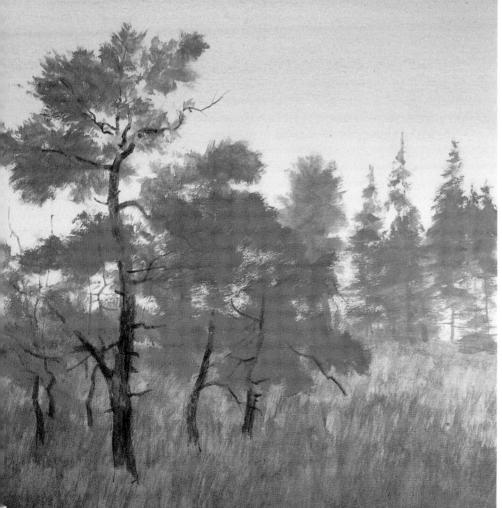

Step 4. A bristle brush scrubs a mixture of Hooker's green and yellow ochre over the foliage areas of the pines in the foreground. The color on the brush is damp, not really wet, so the strokes have a ragged quality that suggests clusters of pine needles. The tip of a small, round softhair brush builds up the trunks and branches with many little lines of Hooker's green and burnt sienna. Look closely at the trunks and you can see that they're not one solid tone, but are composed of many parallel lines that suggest the texture of the bark.

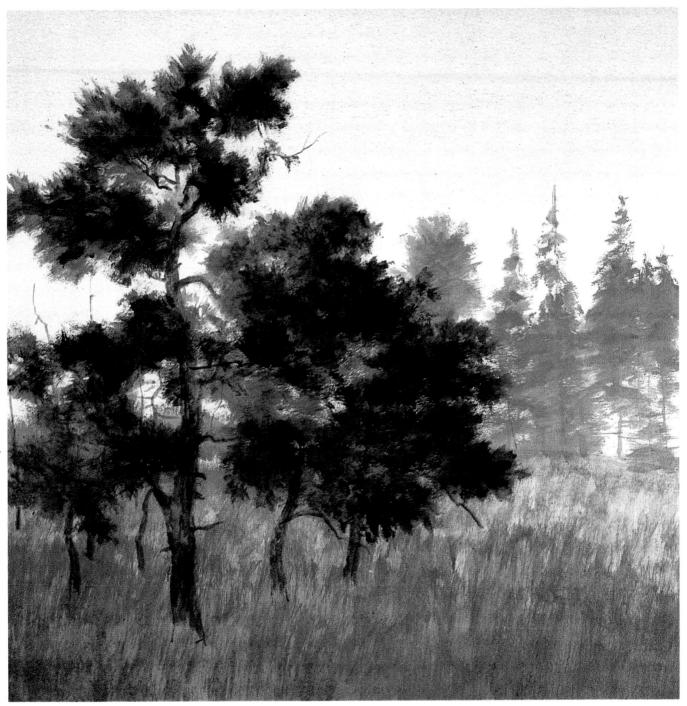

Step 5. The shadow tones on the foreground pines are painted with the same brush and the same type of brushwork, but the colors are a bit more fluid and "juicy." These darks are a mixture of Hooker's green and burnt sienna, thinned with water to the consistency of watercolor, containing no white. The bristles of the brush now leave a very distinct mark that suggests pine needles even more clearly. These dark strokes are allowed to dry, and then more scrubs of this dark mixture are added to areas where the shadows are particularly dense.

Big Shapes Come First!

At this stage, the painting still contains a minimum of detail, but you can already see the picture clearly because the artist has blocked in the main shapes simply and boldly. Here's what he's done.

- **1.** He's visualized the main masses of foliage in the foreground trees and brushed them in with broad, loose strokes.
- 2. He's visualized the main shapes

- of the pale, distant trees and brushed them in roughly—emphasizing their silhouettes.
- **3.** He's brushed in the ground colors, paying particular attention to the subtle contrast between the darker foreground and the paler middle ground.
- **4.** With the big shapes in place, all the picture needs for completion are selective touches of texture and detail.

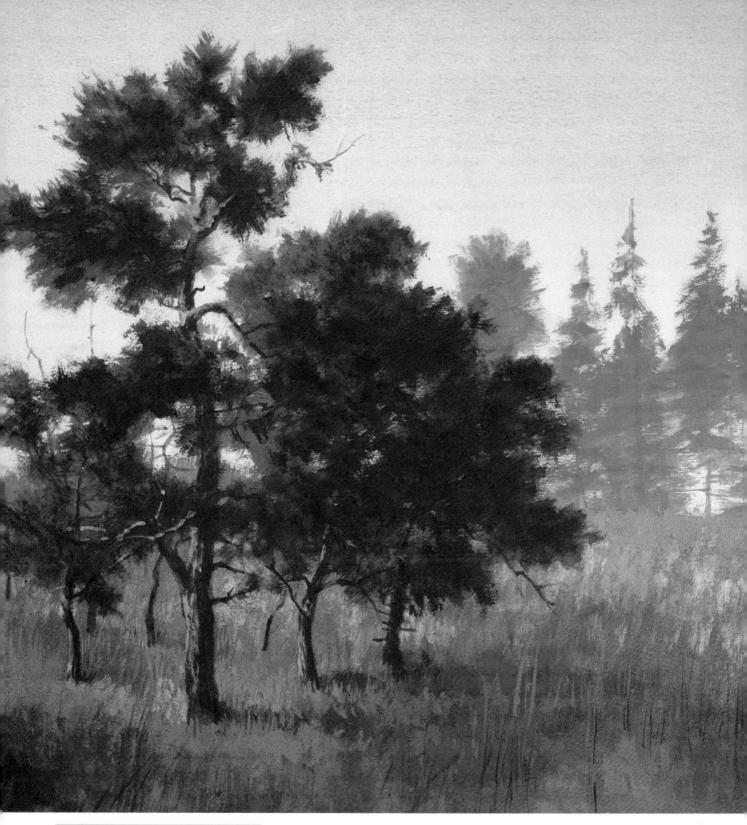

Creating Atmospheric Landscapes

This painting is an interesting combination of transparent and opaque color—a combination that's particularly effective for painting atmospheric landscapes. The sky is completely transparent. The meadow begins with transparent color and is completed with more opaque color. Conversely, the trees begin with opaque color and are finished with transparent color that gives you the sensation of luminous shadows.

Step 6. The foreground of the meadow is enriched with scumbling strokes of thick color: burnt sienna, cadmium yellow, a touch of Hooker's green, and lots of white in the sunlit areas; ultramarine blue, burnt sienna, yellow ochre, and a touch of white in the shadows. The broad tones are painted with a flat bristle brush. Notice how the tip of a small, round softhair brush carries blades of sunlit

grass up over the shadows. The same brush strikes in darker blades of grass with a mixture of ultramarine blue, Hooker's green, and burnt sienna. This small brush strengthens the shadow sides of the trunks and branches with the same mixture, then blends white into this mixture and adds a few strokes of sunlight to the left sides of the trunks and branches.

SIMPLIFYING THE DETAIL OF A FOREST

Step 1. There's so much detail in a forest that it's important to be highly selective about just how much to include. All that foliage can become just one big blur, so it's critical to focus on just a few tree trunks of various sizes and make them the dominant shapes in the picture. In the pencil drawing, it's obvious that the picture will be dominated by one thick trunk to the left, played off against some smaller trunks to the right and some really slender trunks in the distance. Once again, the tree trunks and branches are drawn precisely, while the clusters of foliage are merely indicated with casual lines. The drawing also defines the shape of the shadow at the foot of the large tree.

Step 2. The final painting will have a patch of bright sunlight breaking through the dense foliage. This sunlit break is indicated with a pale wash of cadmium vellow and vellow ochre, thinned with water to the consistency of watercolor. When this yellow shape dries, it's surrounded by a warmer, darker tone that suggests the overall color of the surrounding woods: a mixture of naphthol crimson, yellow ochre, ultramarine blue, and lots of water. You've probably noticed that the original pencil lines are almost invisible once again, having been covered with a very thin wash of white, ultramarine blue, and water, which is allowed to dry before the painting operation begins.

SIMPLIFYING THE DETAIL OF A FOREST

Step 3. The sunlit patch of ground is scumbled with a mixture of cadmium yellow, yellow ochre, and burnt sienna. The dark tones above this and to the right are mixtures of naphthol crimson, ultramarine blue, yellow ochre, and white. And the rich tone in the lower left is cadmium red, cadmium yellow, and burnt umber. All these tones are scumbled in with the short, stiff bristles of the brush known as a *bright*. The color is thick and opaque.

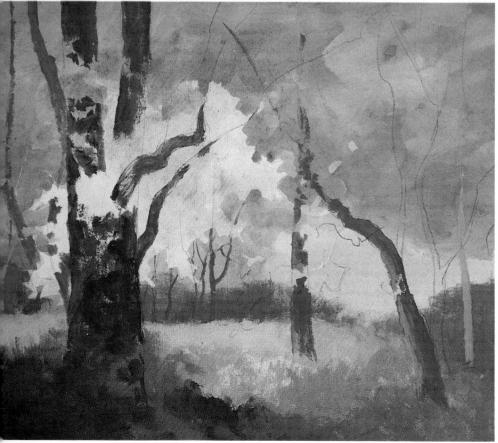

Step 4. The trunks and branches are redrawn with light pencil lines. De Reyna begins the thick trunk with a small, flat bristle brush carrying a much darker version of the mixture used in Step 3: ultramarine blue, naphthol crimson, yellow ochre, and white. He uses the same mixture in the shadowy tone to the right of the tree. Then he adds more white to the mixture and, with the point of a round softhair brush, begins to trace the slender shapes of the smaller trunks.

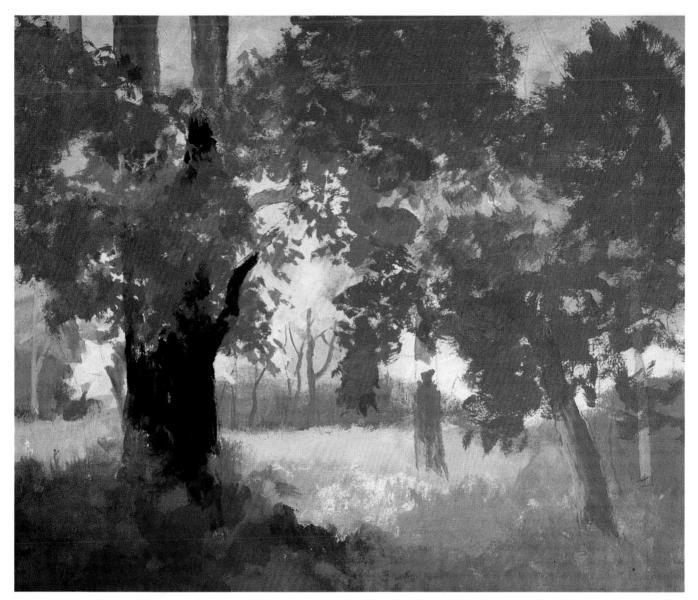

Step 5. The glowing colors of the foliage are tapped in with the tip of a bristle bright, carrying a mixture of cadmium red, cadmium yellow, yellow ochre, and white. The dark note on the side of the tree—naphthol crimson, yellow ochre, and ultramarine blue—is scrubbed in with the longer, more flexible bristles of a *flat*. At this point, all the color is thick and opaque, gradually covering most of the transparent sky tones.

Learning to Simplify

- 1. Include only the major shapes in your preliminary drawing.
- 2. When you plan your composition, remember that you need only one star and just a few supporting actors.
- **3.** Paint with big brushes and broad strokes until you reach the final stage of the picture.
- **4.** Don't paint every detail: suggest more detail than you actually paint.
- **5.** As you finish the painting, see if there are any details you can paint *out*.

SIMPLIFYING THE DETAIL OF A FOREST

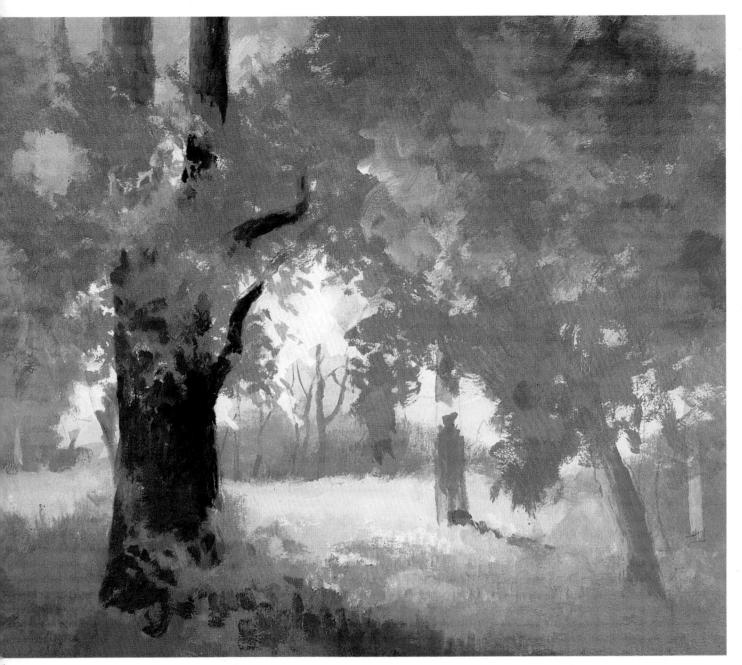

Step 6. The artist carries the dark mixture of naphthol crimson, yellow ochre, and ultramarine blue up over the main trunk and branches, leaving the paler undertone uncovered here and there to suggest lighter patches. Short strokes of the same dark mixture are scattered at the foot of the tree to suggest shadows in the underbrush. He uses a large bristle brush

to add darker tones to the foliage: various mixtures of naphthol crimson, cadmium red, cadmium yellow, yellow ochre, ultramarine blue, and white—never more than three colors (plus white) to a mixture. For example, the darks in the upper right corner are cadmium red, ultramarine blue, yellow ochre, and a little white.

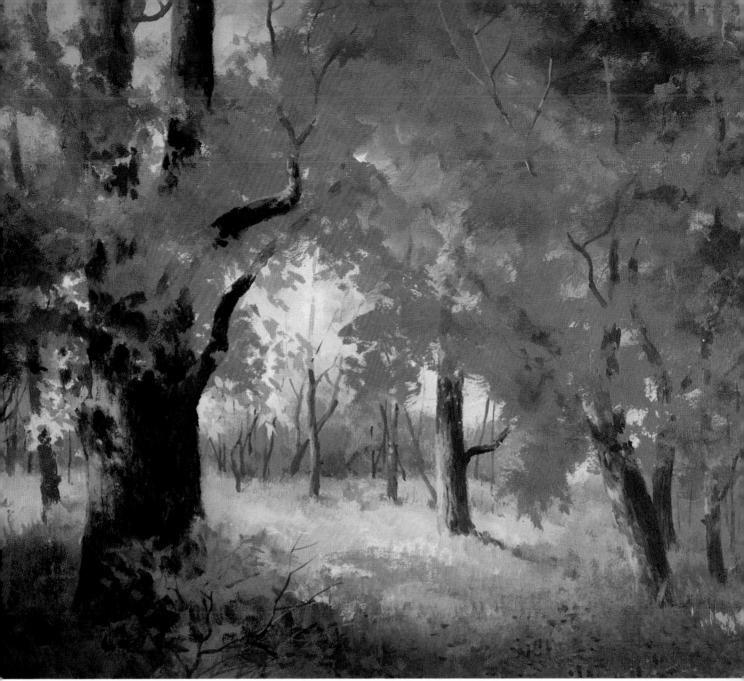

Step 7. The foliage is completed by alternating strokes of the gold and coppery mixtures introduced in Steps 5 and 6. Darks are added to the sides of the smaller trees with ultramarine blue, burnt sienna, yellow ochre, and white. More white is added to this mixture to strengthen the lighted sides of the small trunks and also the big trunk to the left. This same mixture is used to add more trunks and branches in the distance. All this work is done with the tip of a small, round

softhair brush that also picks up more of the foliage mixtures to suggest the dried leaves of a bush at the foot of the large tree. A few strokes of this coppery tone are drybrushed over the shadow to the left of the big tree. And the tip of the brush adds a few flecks of this color to the right foreground, suggesting fallen leaves. Here and there among the foliage, a thick, pale mixture of ultramarine blue, white, and a little naphthol crimson appears to suggest pale sky breaking through

the dense forest. The texture of the bark on the big tree is completed with dark, slender lines of ultramarine blue and burnt umber, drawn with the smallest round brush. By the time the picture is finished, it's almost entirely covered with opaque color. Only the glow of golden light breaking through the forest to the right of the big tree is the original transparent wash. And this remains the most luminous spot of color in the painting.

MODELING MOUNTAINS

Step 1. The pencil drawing—on a sheet of illustration board-defines the shapes of the various peaks and the complicated pattern of light and dark shapes that will appear in later steps. Then the sky is roughly covered with a mixture of phthalocyanine blue, ultramarine blue, white, and just enough water to make a mixture that's milky and semiopaque, so the pencil lines will shine through. The darker tones of the distant mountains in the upper right are painted with a blend of burnt sienna, ultramarine blue, and white. The strokes are made with a flat softhair brush, pulled downward and quickly lifted to leave an effect something like drybrush. Then a touch of this mixture is added to a great deal of white to paint the snowy peak with the point of a round softhair brush.

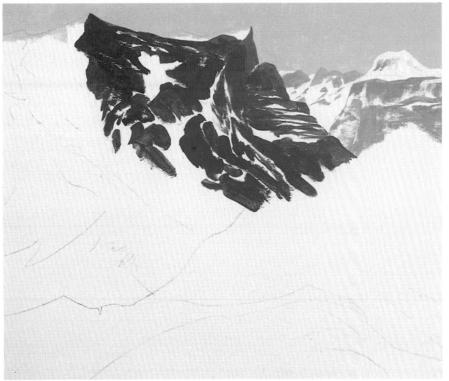

Step 2. The darks of the tallest mountain are brushed in with a mixture of burnt umber, ultramarine blue, a little cadmium red, and some white. The paint is thinned with water and a little gloss medium to a creamy consistency; thus, the flat nylon brush carries the paint across the board in smooth, solid strokes. Between the strokes, strips and patches of bare paper are left to suggest the snow. Now you can see why the preliminary pencil drawing is so important: the beauty of the mountain depends on that intricate design of lights and darks, which must be followed carefully with the brush.

Mixing Blues for Skies

This combination of the two blues is worth remembering. Phthalocyanine blue may be too bright for the sky, while ultramarine blue can be too subdued. When you mix them and add white, you get the perfect compromise.

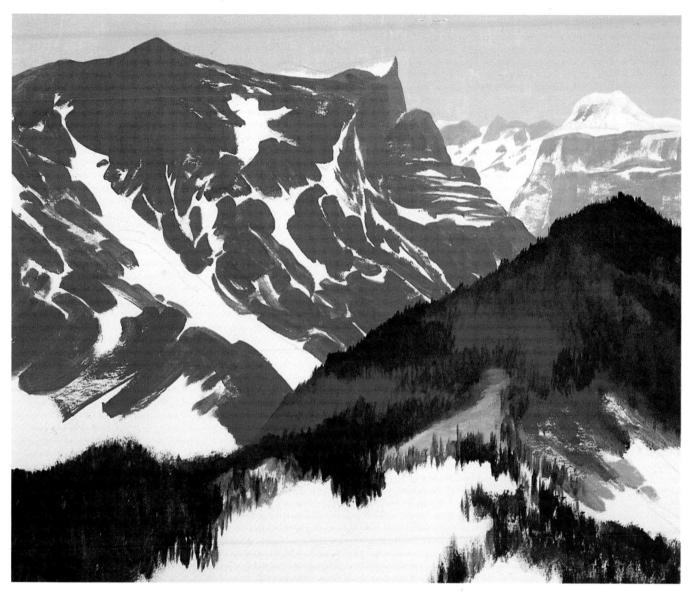

Step 3. The remaining slopes of the high mountain are painted with the same mixture used in Step 2: burnt umber, ultramarine blue, a little cadmium red, and white. Throughout, the paint is kept thick and creamy. Then the dark shape of the tree-covered mountain in the foreground is brushed in with that same mixture, containing less white. When the dark tone dries, a small, flat nylon brush scribbles in the suggestion of trees with up-anddown strokes of burnt umber, ultramarine blue, cadmium red, and yellow ochre. The shadows on the snow are the same mixture used for the distant mountains, but with more white. And the sunlit patches of snow are still the bare painting surface.

Tips for Painting Mountains

- **1.** Avoid painting the whole panorama of mountain peaks. Two or three peaks will do.
- **2.** Remember aerial perspective (see page 17) and make the near mountains darker than the far ones.
- **3.** Give the viewer some idea of scale. A few small trees will make the peaks look taller.
- **4.** Look for patterns on the mountains: the dark-light pattern of snow and rocks; the pattern of trees on the lower slopes.
- **5.** Simplify! Don't paint every crack in the rocks. The more detail you paint, the less imposing the mountains will look.

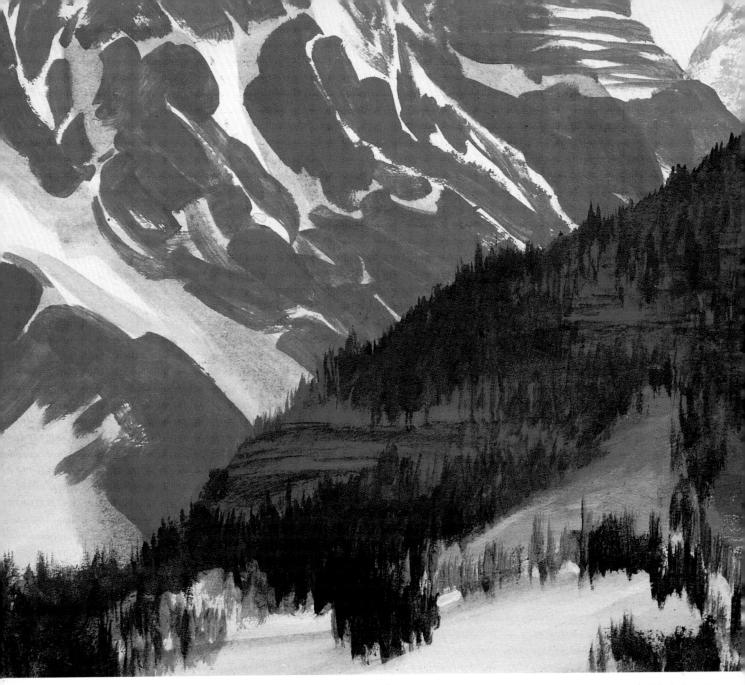

Step 4 (detail). This life-size section of the finished painting shows the various kinds of brushwork used to paint the mountains, snow, and trees. The dark shapes of the rocks, peeking through the snow on the slopes, are painted with straight and curving strokes of a flat brush. The strokes follow the diagonal contours of the mountainside. The layered rock formations in the upper right are painted with horizontal strokes. The pine forest on the shadowy slope of the mountain in the foreground is painted with

the point of a round softhair brush that moves up and down with a scribbling movement. You can't really pick out the form of any single tree, but the scribbling strokes cluster together to suggest hundreds of evergreens. The shadows on the snow are also painted with form-following strokes that move up the steep, diagonal slopes of the rocky mountainside, but move in a more horizontal direction on the snowy slopes of the mountain in the foreground, which is less steep.

MODELING MOUNTAINS

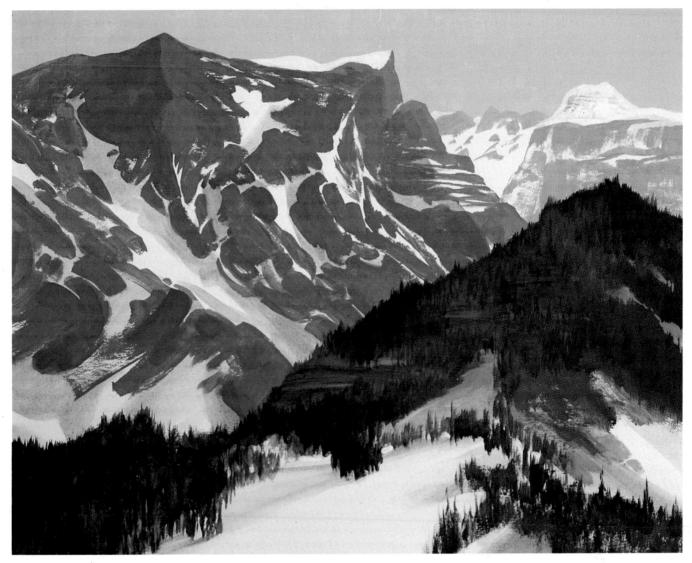

Step 4. The shadows on the snow are giazed with a transparent tone of ultramarine blue and cadmium red, plus a good deal of water and a little painting medium. The job is done with a flat softhair brush. It makes sense to use transparent color to paint the transparent shadows on the snow. Among the trees of the dark mountain in the foreground, a small, round softhair brush paints some traces of shadow with ultramarine blue, cadmium red light, and white. This brush picks up some pure white to paint a

snowy shape along the topmost edge of the tall mountain. Pure white is also used to "trim" the lower edges of some of the tree strokes in the foreground, giving the impression that the trunks are growing out of thick snow. Finally, the tip of a small, round softhair brush adds tiny strokes of dark color—burnt umber, ultramarine blue, yellow ochre, and a whisper of white—to the silhouette of the pine forest, suggesting individual trees that stand up clearly against the paler mountains beyond.

HILLS: TAPESTRIES OF COLOR AND LIGHT

Step 1. The hills will be covered with dense foliage, but there's not much point in trying to draw all those little trees. The pencil drawing defines the overall shapes of the hills and the land beneath, which will be divided into strips of light and dark. The blues between the clouds are first brushed in with a mixture of ultramarine blue, phthalocyanine blue, and white. While this blue tone is still moist, a touch of burnt sienna is added to this mixture—and then the shadows of the clouds are brushed in. The thick, creamy, opaque color of the shadows tends to merge slightly with the opaque color of the undertone. The effect is a soft, lovely fusion of the two colors.

Step 2. At the end of Step 1, the sunlit areas of the clouds remain bare white. Now de Reyna uses a flat nylon brush to scumble in the whites of the clouds with a mixture of white plus the slightest touch of burnt umber and phthalocyanine blue. As he blocks in the whites, he reshapes the clouds, the shadows, and the patches of blue sky. Now it's easier to see the forms of the clouds. The entire landscape is covered with a transparent mixture of phthalocyanine green and a little burnt sienna, plus plenty of water. (Even more water is added for the lighter area at the foot of the hills.) The color is painted with a big flat brush, leaving obvious strokes. These will soon be covered with opaque color.

Step 3. The dark areas of the hills are scrubbed in with a bristle bright that carries an opaque mixture of ultramarine blue, Hooker's green, yellow ochre, naphthol crimson, and white. (Notice that this is one of those rare times when four colors are needed to get exactly the right mixture.) This same color, minus the white and the yellow ochre, is used to brush in some rough strokes for dark trees at the crests of the hills and on the landscape below. The light patches toward the tops of the hills are the same mixture as the shadows, but with more white and yellow ochre—scumbled with a bristle bright to blend into the edges of the shadows.

Avoid Muddy Colors

Remember that more than three colors plus white are apt to produce mud! So, plan your mixtures in your head before you start to mix color on the palette. Try to produce the right mixture with just two colors plus white. Try to stick to no more than three colors plus white. Add a fourth color only if there's no possible way to get what you want with three colors (plus, white, of course). If you do end up with mud, don't try to rescue the mixture by adding even more colors. Start again from scratch and keep trying new combinations until you ring the bell.

Step 4. Now it's time to scumble in all the subtle gradations on the hillsides with bristle brushes. Stronger darks are added with ultramarine blue. Hooker's green, burnt sienna, and a hint of white. Stronger lights are added with Hooker's green, burnt sienna, plus a lot of yellow ochre and white. To create the glowing area at the foot of the hills, just left of center, the artist adds cadmium yellow to the same mixture. Rich, cool notes are added with phthalocyanine green, burnt sienna, and vellow ochre. And the darks of the foreground are added with phthalocyanine green and burnt sienna.

Step 5. When you look at the complete painting, the small, scribbly strokes of the dark trees merge and melt away into the shadow sides of the hills. These tree strokes are a mixture of ultramarine blue, naphthol crimson, yellow ochre, and a hint of white. In some of the sunlit areas of the hills-particularly to the rightsunstruck foliage is suggested with the same kind of brushwork. But these strokes are light mixtures of chromium oxide green, cadmium vellow, and white, with the warm undertone still shining between them. The light and dark mixtures on the hillsides are also scumbled over the fields in the foreground. The forms of the trees at the foot of the hill, as well as the hedges between the fields, are sharpened with small strokes of burnt sienna, Hooker's green, yellow ochre, and a little white. The tip of the brush adds some trunks to the trees. An occasional warm note appears among the trees to relieve all that green—a mixture of cadmium red, burnt sienna, and a little ultramarine blue. At the crest of the hill to the left, the trees poke too far up into the sky, so they're trimmed down with a few strokes of sky tone. The painting has come a long way from the uniform green of Step 2. These hills are now a rich tapestry of color—warm and cool, dark and light.

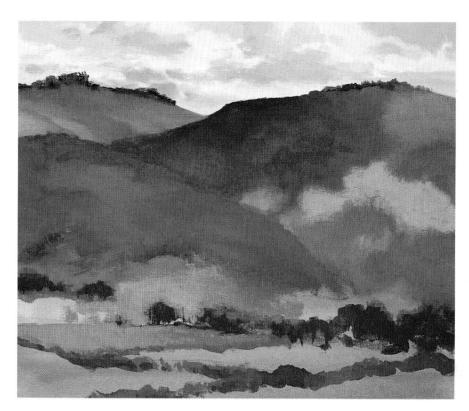

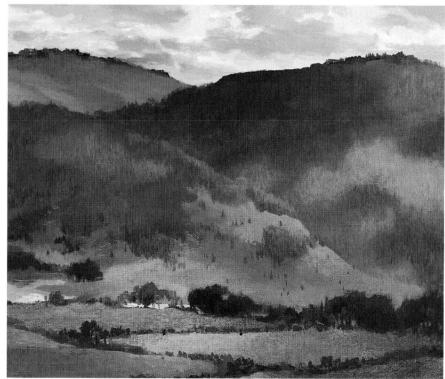

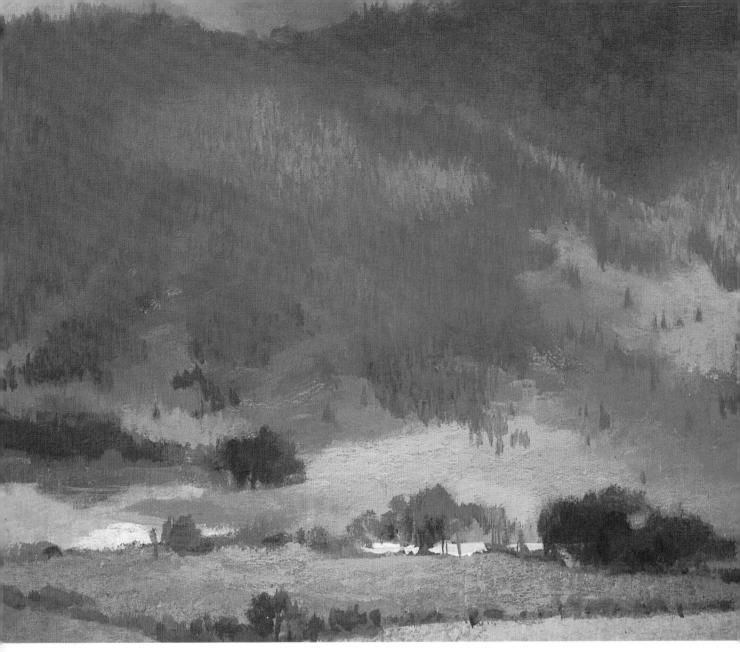

Step 5 (detail). Here's a close-up of a section of the finished painting, showing the variety of brushwork that suggests a lot of detail without every tree having been painted. The lights and shadows on the hillsides are all scumbled with thick, opaque color. Notice how the areas of sunlight and shadow in the lower right seem to blend softly together. That's the effect of that back-and-forth, scumbling motion, which softens the edges of the brushstrokes so they seem to melt away into the color alongside them. When these scumbles are dry and won't be disturbed by further brushwork, the tip of a round softhair brush suggests those masses of trees with the same up-and-down scribbling motion that is used to paint the pines in the mountain demonstration you saw earlier. In some areas, the tree strokes are close together, suggesting dense growth. At other points, the tree strokes are farther apart, suggesting sparse growth. But the tree strokes never completely cover the scumbled undertones-which render the lights and shadows on the hills and make the big, rounded forms look three dimensional. The triangular shapes of the individual evergreens, standing alone here and there, are painted with a single touch of the point of the round brush, pressing down slightly to make the brush spread at the bottom of the stroke.

Paint from Nature!

Some people are outdoor painters who love to brave the elements (and the insects) to record what they see on location. Others are indoor painters who like the leisure and comfort of home. Landscapes painted indoors can be just as exciting and just as authentic as those painted on the spot. But remember that the best landscape paintings always start outdoors, even if they're finished at home. Spend as much time as you can painting on location, even if those paintings are small, quick studies for larger paintings that you hope to develop in the studio. Working on location will strengthen your powers of observation and train your visual memory. The only way to learn about landscape is firsthand.

INTERPRETING THE HUES OF THE DESERT

Step 1. These desert rock formations and their sandy surroundings are painted on smooth watercolor paper. The rocky forms are complicated, so the pencil drawing records them as precisely as possible. The pencil traces not only the outer edges of the rock formations, but the planes of light and shadow that will make the forms look three dimensional. The cloud forms and the shapes of the sandy foreground are drawn more freely.

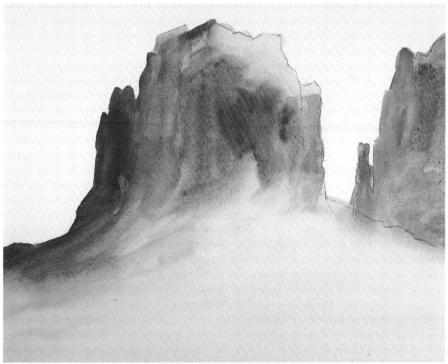

Step 2. The pencil lines are lightened with an eraser until they're practically invisible. They'll serve as a guide for your strokes, but won't show in the finished work. The sky is painted with a transparent wash of ultramarine blue, phthalocyanine blue, and water. carried around the rock formations. The shadow side of the big shape is painted with ultramarine blue, naphthol crimson, and water. Cadmium red, ultramarine blue, and water are freely brushed over the lighted side and blended into the wet shadow color. This same warm mixture is brushed over the rocky shape to the right. Then a little white and a lot of water are mixed with the shadow tone, which is brushed over the foreground and over the edge of the rocky shape.

INTERPRETING THE HUES OF THE DESERT

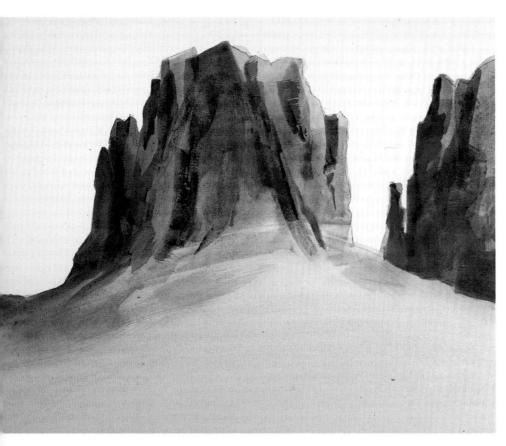

Step 3. When Step 2 is completely dry, the artist picks up the same shadow mixture—ultramarine blue, naphthol crimson, and less waterwith a flat softhair brush to paint the shadows with squarish strokes. When these strokes are dry, a darker wash—containing less water than the last – of cadmium red and ultramarine blue is carried over the rocks with the same brush. Now the planes of light and shadow on the two big rock formations are clearly defined, creating a feeling of strong sunlight striking the rocks from the right. The artist brushes a bit more of the original shadow mixture along the sand at the base of the biggest rock.

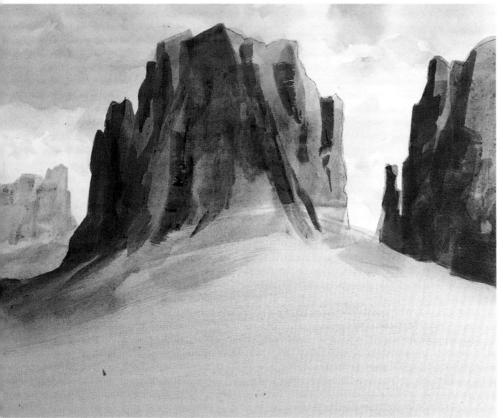

Step 4. At the end of Step 3, the sky is still the very pale blue that was applied at the beginning. Now deeper blues are added with a round softhair brush: ultramarine blue, plus a little naphthol crimson and yellow ochre, and a lot of water. Alongside these wet patches, the same brush brings in shadowy tones of the same mixture-with more crimson and less blue-to blend wet-in-wet with the blue shapes. Here and there, the brush softens the edges of the wet shapes with clear water, as you can see most clearly in the upper right. The distant rock formation at the left is painted with the shadowy sky mixture-with more water on the lighted side and less on the shadow side.

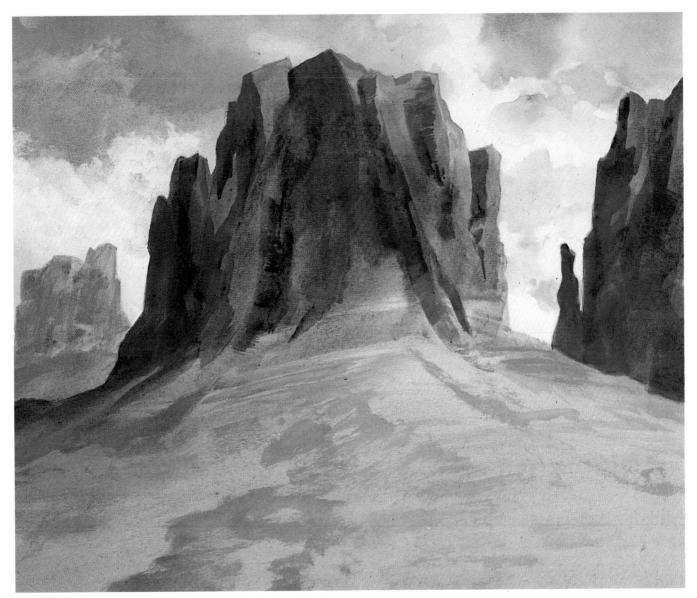

Step 5. A touch of white is added to each of the sky mixtures used in the last step—the blue and the shadow color-making them more opaque. Then these mixtures are scumbled over the sky area in the upper left, still leaving the sky in the upper right untouched. The cloud behind the small rock formation at the left is scumbled with white, tinted with just a little ultramarine blue and naphthol crimson. The curving contours of the sandy foreground are suggested with scrubby strokes of cadmium red, ultramarine blue, yellow ochre, and white. A few touches of this mixture are added to the sunlit planes of the biggest rock formation.

A Word of Caution About Scumbling

- **1.** Build up a scumbled passage gradually.
- 2. Don't add too much opaque color or you'll find that you've painted out the passage instead of scumbling it with a veil of color.
- 3. Scumbled color often looks

- more opaque when it's wet—and less opaque when it dries.
- **4.** To judge scumbled color accurately, let one layer (or one series of strokes) dry before you apply more color.
- **5.** Scumbled strokes tend to look blurry—so try to combine scumbles with areas of more precise brushwork, so the finished painting doesn't look fuzzy and indecisive.

INTERPRETING THE HUES OF THE DESERT

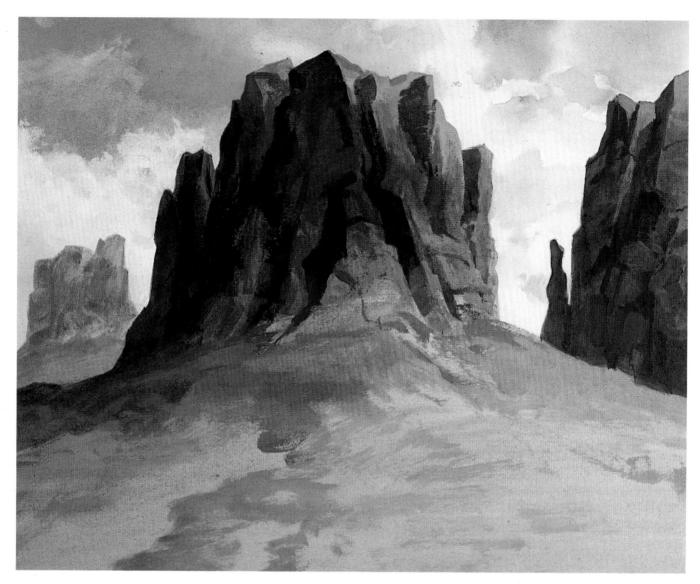

Step 6. Strong shadows are added to the bigger rock formation with square strokes made by a flat softhair brush. These darks are a mixture of ultramarine blue, cadmium red, and a little water. The point of a round softhair brush draws some crisp lines over the rocks to suggest cracks and crevices. A touch of white is added to this mixture for the shadow that's carried across the left. A few strokes of the sandy color—cadmium red, yellow ochre, and white—are carried up into the base of the center rock.

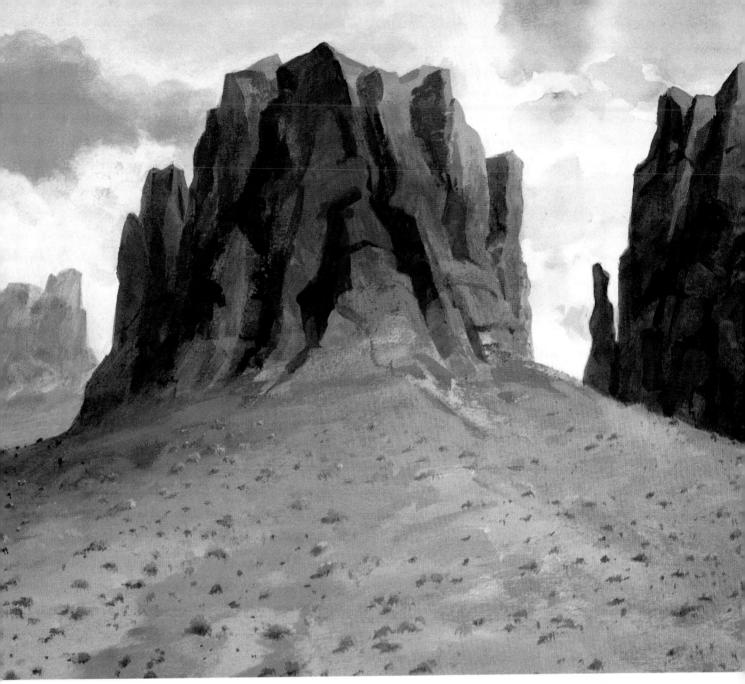

Step 7. Now is the time to simplify some of the major areas of the picture before going on to the final details. The sky behind the big rock formation looks a bit too dark; the rock will stand out more strongly against a lighter sky. So a pale, opaque mixture of ultramarine blue, naphthol crimson, phthalocyanine blue, and white is scumbled around the big, ruddy shape to make the sky drop back slightly. Too much seems to be happening in the sandy foreground, so this is scumbled with various mixtures of naphthol crimson, cadmium red light, yellow ochre, cadmium yellow, ultramarine blue, and white-never more than

three or four of these colors to a mixture. These sandy tones obliterate a lot of the distracting brushwork that you saw in Step 6, now producing a slightly smoother tone. The last details are those small touches of green that suggest the desert weeds. These are nothing more than little dabs made by the tip of a bristle brush, carrying a thick, not-too-fluid mixture of chromium oxide green, yellow ochre, and white. The touches of dark shadow under these weeds are the same mixture used for the shadows on the rocks: ultramarine blue, naphthol crimson, and a hint of white. These touches of shadow are often placed

slightly to the left of the green strokes, reinforcing the feeling that the strong sunlight comes from the right. One strong shadow remains in the foreground, just left of center, subtly leading the eye upward toward the central rock formation. Once again, this landscape is an effective combination of transparent and opaque color. The most brilliant, luminous colors on the rocks are transparent washes, thinned only with water. The softer colors of the foreground are opaque. The sky is painted in transparent color at the beginning, but opaque color is added for corrections.

SHOW THE MOVEMENT OF A STREAM

Step 1. The painting begins with a pencil drawing on a sheet of illustration board. Burnt sienna, ultramarine blue, and water are mixed on the palette to a very fluid consistency. A roughly textured, synthetic sponge is soaked in clear water; then most of the water is squeezed out, leaving the sponge moist. One flat side of the sponge is dipped into the pool of color on the palette. Then the sponge is carefully pressed against the surface of the illustration board and lifted away, leaving a mottled pattern that suggests the texture of the rocks in the stream. Just one area—in the upper right—is scrubbed in with a brush, since this is a reflection, not a rock.

Step 2. A large, flat softhair brush scribbles in the tones of the trees with a mixture of Hooker's green and burnt umber, diluted only with water, so that the color is transparent. More water is added for the lighter areas. The marks of the brush are left to suggest the texture of the leaves.

Step 3. Still working with very fluid, transparent color, the cool tones of the stream are brushed in with a mixture of ultramarine blue, burnt umber, and yellow ochre diluted only with water. (All the work in this step can be done with either round or flat softhair brushes.) Notice how the strokes seem to follow the movement of the water rushing between the rocks. Gaps of bare paper are left to suggest foam. Just below the distant shoreline, the artist scrubs in some of the tree mixture—the same colors used in Step 2—for reflections.

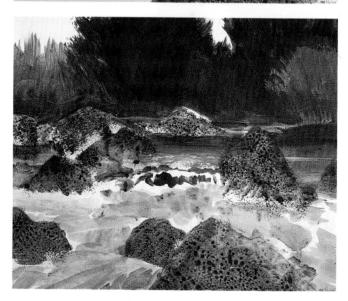

You Can Combine Different Kinds of Brushwork

This painting shows how different kinds of brushwork combine to create various textures. The shadow tones of the rocks clearly show the mottled marks of the sponge under short, thick strokes of opaque color. The foam is painted with short, thick dabs where it's most dense; small dots to suggest flecks of foam splashing upward; and slender lines where the foam trickles over the dark water.

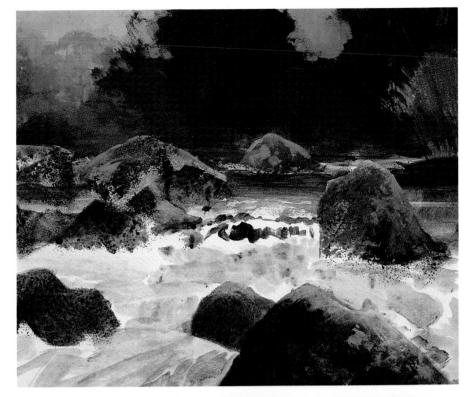

Step 4. Now the first opaque color appears. The sky is painted with rough strokes of ultramarine blue, burnt sienna, yellow ochre, and white. These strokes reshape the edges of the trees, enlarging the patches of sky. This same mixture, containing less white and a little more burnt sienna, is scumbled over the distant trees to the extreme left; now they seem farther away. The rocks are glazed with a transparent wash of burnt sienna, Hooker's green, water, and a little gloss medium, deepening their tone, while still allowing the underlying texture to come through. When this glaze is dry, the brush picks up some pale sky color and scumbles it over the lighted tops of the rocks.

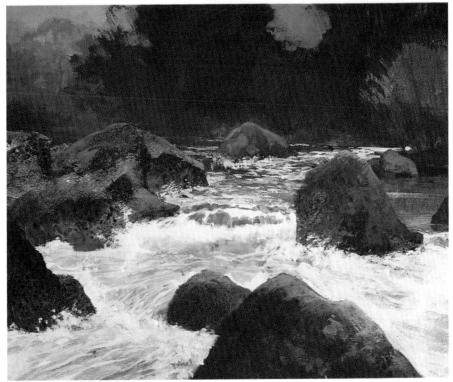

Step 5. The rocks at the left seem too scattered, so now they're pulled together. The dark tone of the rock in the lower left is extended upward with another sponge mark. The sky tone is scumbled over the other rocks at the left, making them one big rock formation and covering up the patch of water. Then the foam patterns are painted with white, tinted with a touch of sky tone. The broad strokes are made by a flat softhair brush, while the slender lines are made with the tip of a round brush. The lines follow the flow of the stream. The solid patches of foam are dense and opaque, but the other white strokes are semiopaque, revealing the cool undertones.

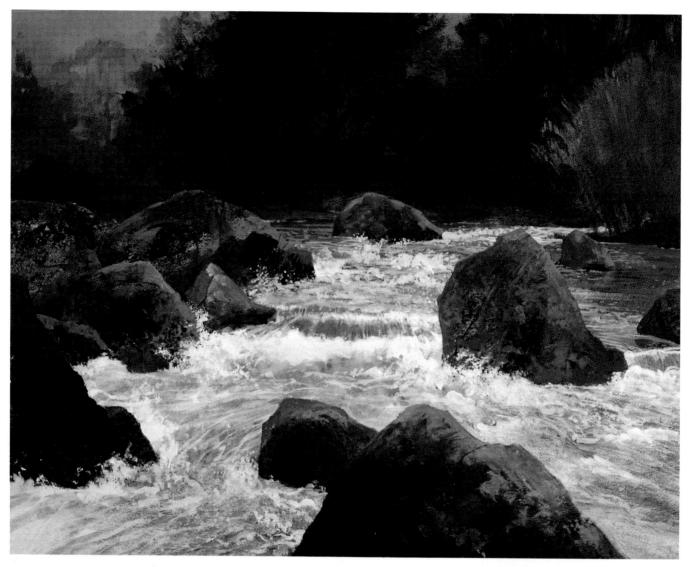

Step 6. The water is completed with many small, semiopaque lines of white—tinted with sky color—that methodically follow the flow of the stream around and between the rocks. The cool, underlying color applied in Step 3 is never completely covered; it's this combination of transparent color beneath and semiopaque color above that gives the water that special luminosity. A few more touches of sky tone are scumbled over the tops of the rocks and allowed to dry. Then the artist draws a few cracks on the

sides of trees with the point of a small, round softhair brush. A bit of opaque sky color is mixed with the original tree color—making the mixture more opaque—and the darks of the trees are extended to narrow the patch of sky that breaks through the trees just to the right of center. A little sky tone is scrubbed into the middle of the big tree at the center of the picture and allowed to dry; then the artist paints a trunk and some branches over this lighter tone.

One Good Way to Paint Landscapes

This painting follows a couple of "rules-of-thumb" that can be helpful, though they shouldn't be followed rigidly.

- 1. Start with transparent color and then finish with opaque color.
- **2.** When you combine transparent and opaque color, try to keep your shadows transparent, and save your opaque strokes for the lights.

CATCHING THE LIGHT ON SNOW

Step 1. The pencil drawing defines the outer edges of the big, snow-covered tree, the snow-covered rocks, and the frozen stream on a sheet of illustration board. Equally important, the pencil lines trace the shapes of the dark rocks that appear within the snow to the left. Then a bristle brush scrubs a thick, opaque mixture of ultramarine blue, burnt sienna, cadmium red, and white over the sky. The sky is dim and overcast, but some light comes through to the left of the big tree. This tone contains less ultramarine blue and more white.

Step 2. The dark patches of rock, so carefully drawn in Step 1, are now painted with a blend of ultramarine blue, burnt sienna, and white. The color isn't too thoroughly mixed on the palette. Nor are the strokes blended together on the painting surface. So these strokes have a ragged, irregular texture, like that of the rocks. The snow-covered branches on either side of the tree are painted with wavy strokes of white, tinted with a little sky tone.

CATCHING THE LIGHT ON SNOW

Step 3. The trunks and branches of the distant trees are painted with a mixture of ultramarine blue, cadmium red, yellow ochre, and white. The thicker trunks are painted with a flat softhair brush, while the thinner trunks and branches are painted with a round softhair brush. The paint is thick and creamy, so it doesn't flow too smoothly over the painting surface; the result is an effect something like drybrush, which you can see most clearly in the trunk of the dark tree. As the trunks grow more distant, more white is added to the mixture.

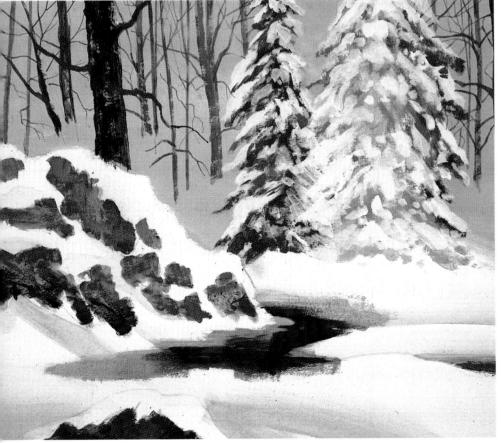

Step 4. The original sky mixture is thinned with more water to paint the shadows on the snowbanks with transparent color. The edges of these shadow strokes are softened with clear water. The rocks are darkened with a thick mixture of ultramarine blue, burnt sienna, yellow ochre, and white. This same mixture, with a little more white, is used to paint the pale edges of the frozen stream, while a darker version is used to paint the deepest tones. A few strokes of sky color divide the big tree shape in two. Strokes of rock tone suggest shadowy branches. Then strokes of white, tinted with sky color, represent the clumps of snow resting on these branches.

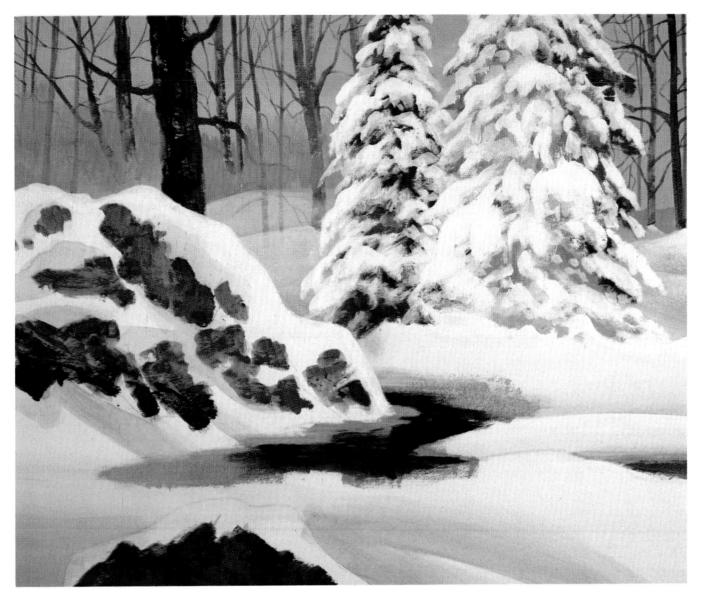

Step 5. More strokes of white, tinted with a little sky tone, are added to thicken the snow on the trees. The shadowy band of trees at the horizon is scumbled in with ultramarine blue, cadmium red, yellow ochre, and white, partially obscuring the bases of the tree trunks. Snowbanks are added beneath the horizon and between the trees with more sky mixture and white. The edges of the snowbank to the left are sharpened with pure white, toned with the faintest touch of sky color.

Experiment With a Limited Palette

- 1. Try painting a wintry scene like this one with a palette of three quiet colors—ultramarine blue, burnt sienna, and yellow ochre—plus white.
- 2. Then try another limited palette of *brilliant* colors—phthalocyanine blue, cadmium yellow, cadmium red, plus white—to learn how you
- can make muted mixtures with bright colors.
- **3.** Before you start to paint with either palette, test out your color mixtures on scraps of paper.
- **4.** See how many grays you can mix by combining all three subdued colors or all three bright colors—simply by varying the proportions of the colors in the mixture, then adding more or less white.

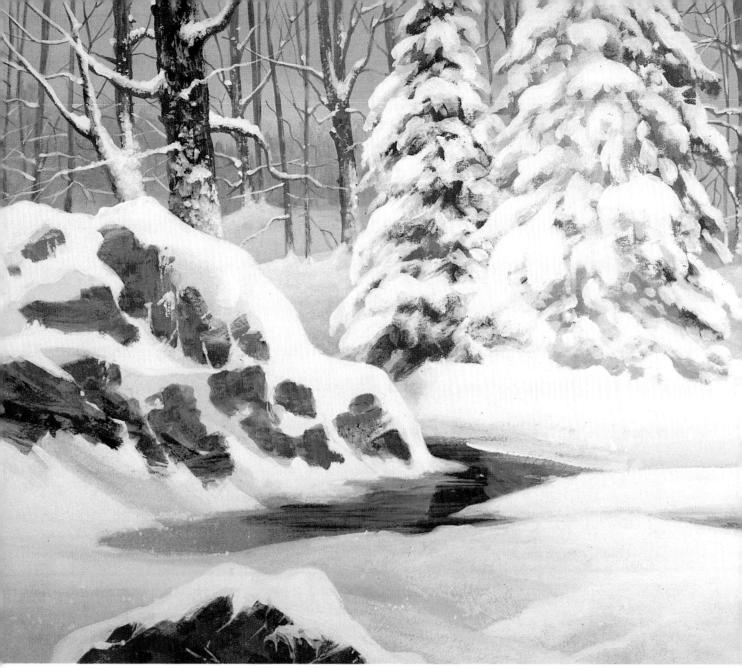

Step 6. The solid patches of snow on the rocks and branches are painted with thick strokes of creamy, opaque color. The darks of the rocks and branches, showing through the snow, are done with thinner, more fluid color. The dark tones of the frozen stream are painted in the same way. Then a bit of the snow color, tinted with sky tone, is scumbled over the dark strokes of the rocks and branches here and there. This same color is thinned with water to paint the reflection of the snowbank in the frozen stream; these semiopaque strokes allow the darkness of the stream to shine through.

The distant tree trunks are reinforced with thick strokes of burnt si-

enna, ultramarine blue, yellow ochre, and white. When these strokes are dry, snow is dabbed on the trunks and branches with thick white, tinted with a little ultramarine blue, and applied with the tip of a small bristle brush. The point of a round softhair brush draws snowy lines on the tops of the thinner branches. A large bristle brush scumbles this same bluishwhite mixture over the sunlit portions of all the snowbanks in the middle distance and the foreground. The back-and-forth scrubbing stroke blends the pale tops of the snowbanks into the darker shadow planes. Thick strokes of this snowy mixture are carried over the top of the dark rock in the left foreground. A few touches of snow are drybrushed over the dark shapes of the rocks. The tip of a round brush paints a few light lines on the rocks to suggest snow that's settled in the cracks. Pure white is mixed on the palette with lots of water. A big bristle brush - or perhaps a toothbrush—is dipped into this milky fluid. Then a stiff piece of wood, such as a brush handle or an ice cream stick, is drawn over the tips of the bristles to spatter a few snowflakes over the foreground. You can see them clearly in the lower left. Notice how the warm sky tone, which you first saw in Step 1, remains behind the trees, just above the horizon.

BUILD INTERESTING CLOUD SHAPES

Step 1. The preliminary pencil drawing - on a sheet of watercolor paper traces the outlines of the clouds, the shapes of the blue patches between the clouds, and the contours of the hills at the horizon. Although the contours of the clouds will change slightly, it's important to decide exactly where the clouds go. The sky tones are freely scrubbed in with a bristle brush. The blue shapes of the sky are painted with a mixture of ultramarine blue, phthalocyanine blue, and white at the very top of the picture. Just a little yellow ochre is added to this mixture at the center. The lower sky, right above the horizon, contains more white and yellow ochre. The clouds are just white paper at this point, but their shapes are becom-

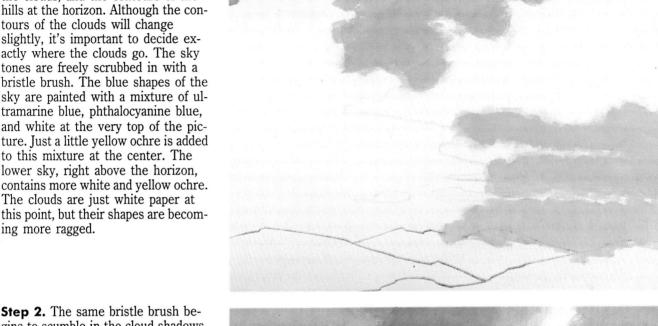

Step 2. The same bristle brush begins to scumble in the cloud shadows. This shadow tone is a mixture of ultramarine blue, cadmium red, yellow ochre, and white. Actually, you can see two distinct shadow tones. The lighter tone obviously contains more white; it's also slightly warmer, containing more cadmium red and yellow ochre. The darker, cooler tone contains more ultramarine blue. The scumbling stroke creates a soft edge where the shadow sides of the clouds seem to melt away into the blue of the sky.

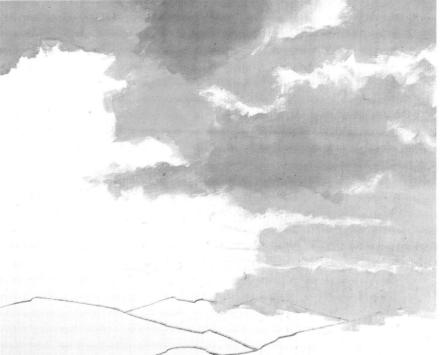

BUILD INTERESTING CLOUD SHAPES

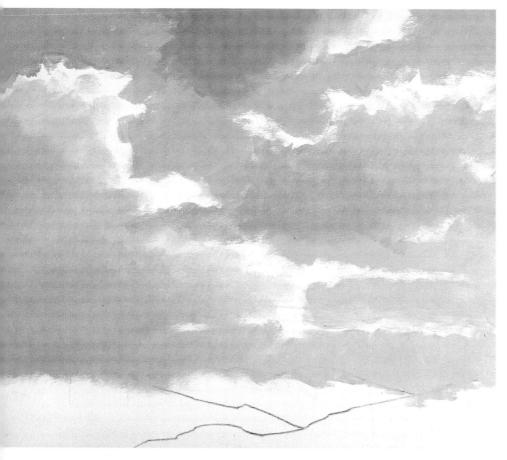

Step 3. The shadow side of the biggest cloud is painted with the same mixtures and the same scumbling strokes. The scrubbing motion of the brush creates a soft edge where the shadow side of the cloud ends and the sunlit side begins. All these sky tones are thick and opaque enough to cover most of the pencil lines. Notice how the clouds and the patches of sky form an interesting and varied design. The three main clouds are all different shapes and sizes. The strip of sky between the clouds is wide at some points, narrow at others; this design keeps the eve interested.

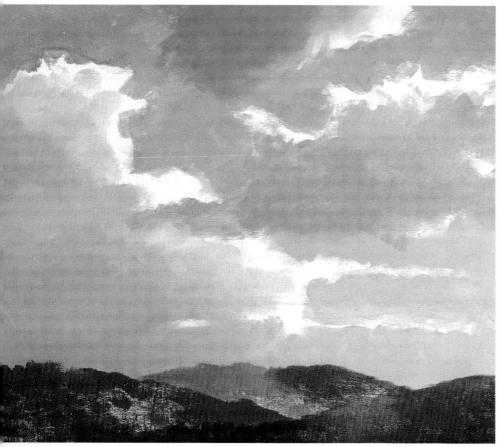

Step 4. The clouds cast strong shadows on portions of the land below. At other points, the sun breaks through the clouds and illuminates parts of the hills. The shadow on the distant hill is painted with ultramarine blue, vellow ochre, and white-with a little more white on the lighted portion of the hill. The shadow tones on the foreground hills are ultramarine blue, yellow ochre, cadmium yellow, and white. The sunlit hill to the right is painted with phthalocyanine blue, cadmium yellow, yellow ochre, and white. The bristle brush drags thick color over the textured painting surface, leaving some flecks of bare paper for a drybrush effect.

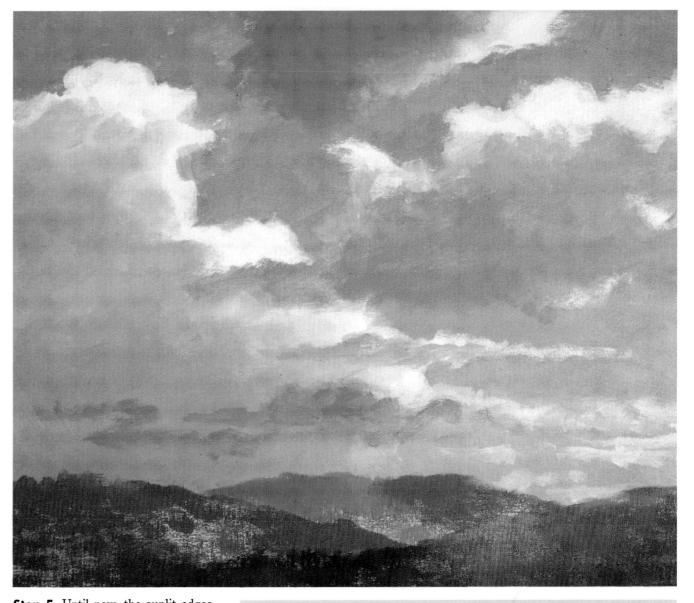

Step 5. Until now, the sunlit edges of the clouds are bare paper. Now these lights are scumbled with lots of white, faintly tinted with ultramarine blue, yellow ochre, and naphthol crimson. The shapes of the clouds grow rounder and fuller. The scumbling strokes blend the lights softly into the edges of the shadows. These same strokes soften the lighted edges so they don't look too harsh and mechanical against the blue sky. Just above the horizon, several long, slender, shadowy clouds are painted with the same mixture that's used to paint the shadows in Step 3: ultramarine blue, yellow ochre, cadmium red, and white.

When Painting Clouds, Remember:

- **1.** Make a quick preliminary study of the clouds in your sketchbook before you touch the actual painting.
- **2.** Don't worry if the clouds move and change: just choose the arrangement you like best and then "freeze" it in your sketchbook.
- **3.** Be sure to record the overall shapes of the clouds *and* the shapes of the shadow areas.
- **4.** Make a careful drawing on the painting surface, referring to your sketch and redesigning—or possibly simplifying—the shapes if you like
- **5.** Block in the shapes of the sky around the clouds.
- **6.** Block in the shadow areas of the clouds.
- **7.** Paint the lighted areas of the clouds, making final adjustments in the shapes as you work on the edges.

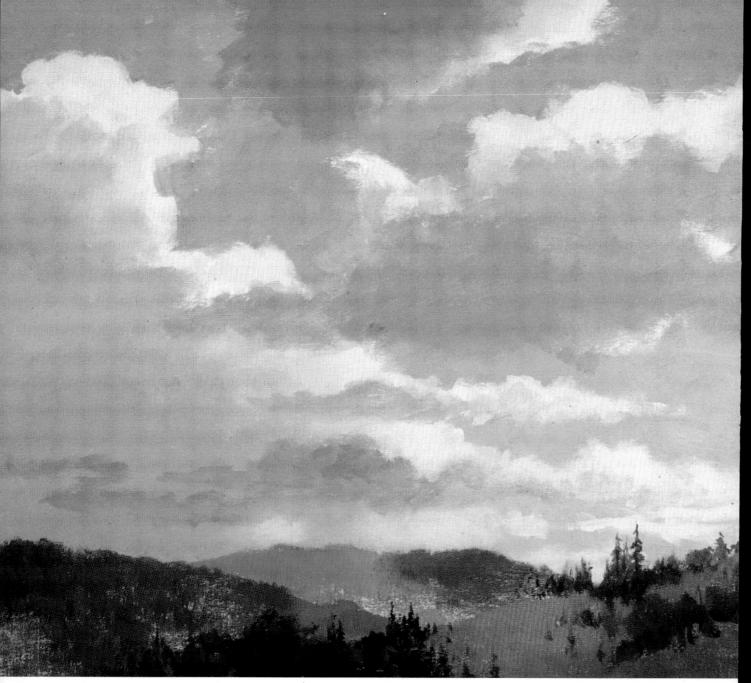

Step 6. The shadowy undersides of the clouds are strengthened and enriched with scumbled strokes of ultramarine blue, cadmium red, yellow ochre, and white. This isn't one consistent shadow tone. At some points you can see where it contains more red and yellow. At other points you can see where the shadow tone contains more blue. The individual strokes stand out more clearly than the strokes in Steps 2 and 3, when the shadow tones were first blocked in. The hill in the left foreground is darkened to strengthen the shadow cast by the clouds. A dark mixture of phthalocyanine blue, cadmium yellow, and burnt sienna is drybrushed over

the top of the hill. The shadow on the distant hill is also strengthened with this mixture, which now contains a bit more white. This same mixture-now mostly phthalocyanine blue and burnt sienna-is used to paint the trees on the hilltop with small touches of a round softhair brush. This is a good example of a picture painted almost entirely by scumbling. The soft shapes of the clouds are scumbled. The soft transitions between the light and dark areas of the hills are scumbled too. Just a bit of drybrush appears in the hills to suggest some texture. Only the trees are painted with precise touches of fluid color.

HOW TO CREATE COLORFUL SUNSETS

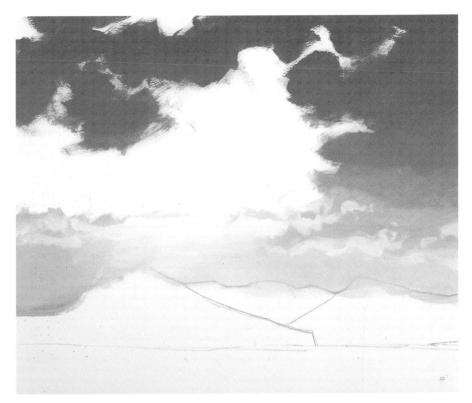

Step 1. This pencil drawing — on coldpressed watercolor paper—defines the outer edges of the clouds, the shapes of the landscape below, and the line of the water. Then the deep, cool tones of the sky are scumbled with a bristle bright, carrying a mixture of ultramarine blue, phthalocyanine blue, a touch of naphthol crimson, and white. More white is added to this mixture as the brush moves downward toward the horizon. The brush scrubs the darker and lighter strokes together to produce a subtle dark-to-light gradation. The big cloud at the center is bare paper. The smaller clouds above the horizon are strokes of white, tinted with a little sky mixture.

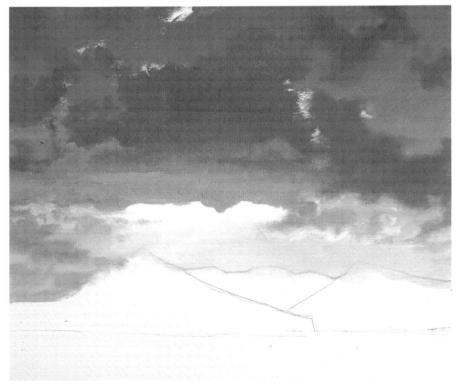

Step 2. When the sky is dry, the dark tones of the clouds are scumbled with a deep mixture of ultramarine blue, cadmium red, and just a hint of white. The back-and-forth scrubbing strokes produce soft edges where the clouds meet the sky. More white and blue are added to this mixture for the paler clouds in the lower sky. Along the bottom of the big, dark cloud, the bristle brush scumbles a mixture of cadmium red, yellow ochre, and white. The sky is palest directly under the sunlit edge of the big cloud; this suggests the intense light of the sun behind the cloud.

HOW TO CREATE COLORFUL SUNSETS

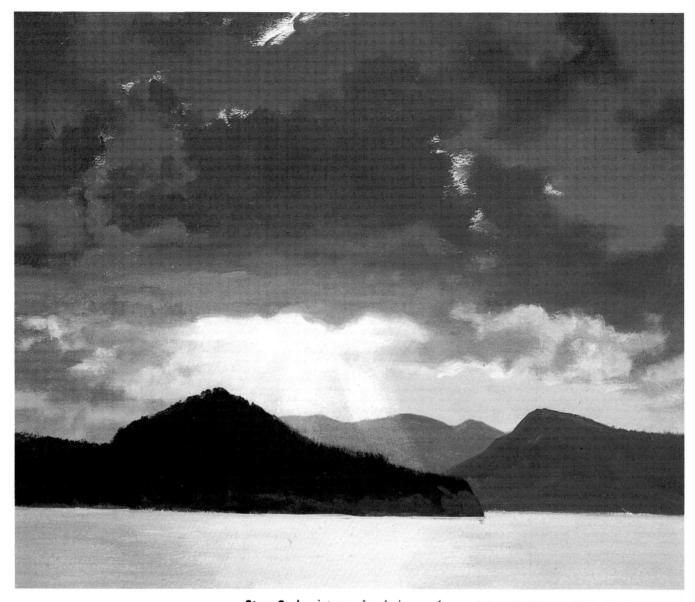

Step 3. A mixture of cadmium red, yellow ochre, ultramarine blue, and white—the consistency of cream—is brushed smoothly over the shapes of the island peaks. The most distant peak contains more white and blue; the nearest peak contains almost no white. This same mixture, containing more white and more water, is drybrushed over the band of water below the horizon, leaving some bare paper at the center to suggest the reflection of the sun. Sunlit edges are added to some of the lower clouds with strokes of thick white, tinted with a speck of cadmium red, ultramarine blue, and yellow ochre. This same mixture is drybrushed downward from the center of the sky to suggest rays of light.

Sunset Painting Tips

- 1. Don't fill the entire painting with hot color.
- **2.** Focus your most brilliant colors at the center of interest—which is usually the area of brightest light.
- **3.** Surround the brilliant colors with more subdued colors that *accentuate* the bright ones.
- **4.** Remember that most of the landscape (or seascape) is actually in shadow as the sun sets.
- **5.** Because the sun is *behind* the clouds and the landscape, emphasize silhouettes, as you see here.

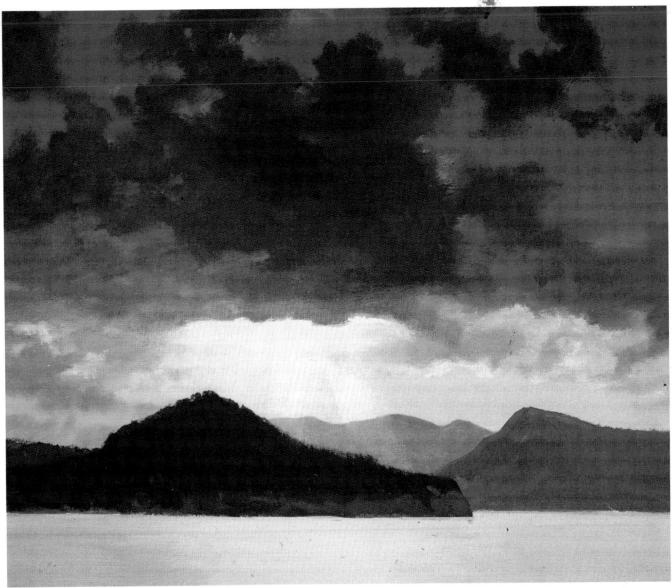

Look at the Light

Take a minute to look at where the light is coming from and how it makes the painting work. The light source—the sun—is behind the dark cloud and the mountains. Because of the sun's location, there are no light and shadow planes on the shapes. The big cloud and the mountains are seen as dark silhouettes. Some light spills over the lower edge of the cloud to create "rim lighting" (a strip of light around the edge of the subject). Light rays break through the gap in the clouds to spotlight a patch of water. The spotlit water reflects the light and color of the lower sky.

Step 4. The artist uses a big, flat softhair brush to glaze the upper sky with a transparent mixture of ultramarine blue, naphthol crimson, and Mars black, thinned with water and gloss painting medium. The dark clouds are reshaped and enlarged with scumbled strokes of ultramarine blue, cadmium red, and some white. Some of the dark color is carried over the ruddy band at the bottom of the central cloud, making the band narrower. The brilliant light of the lower sky is strengthened with pure white tinted with cadmium vellow to give a cooler tone to the water, and the artist adds much more water to the same transparent glaze mixture that he used on the upper sky.

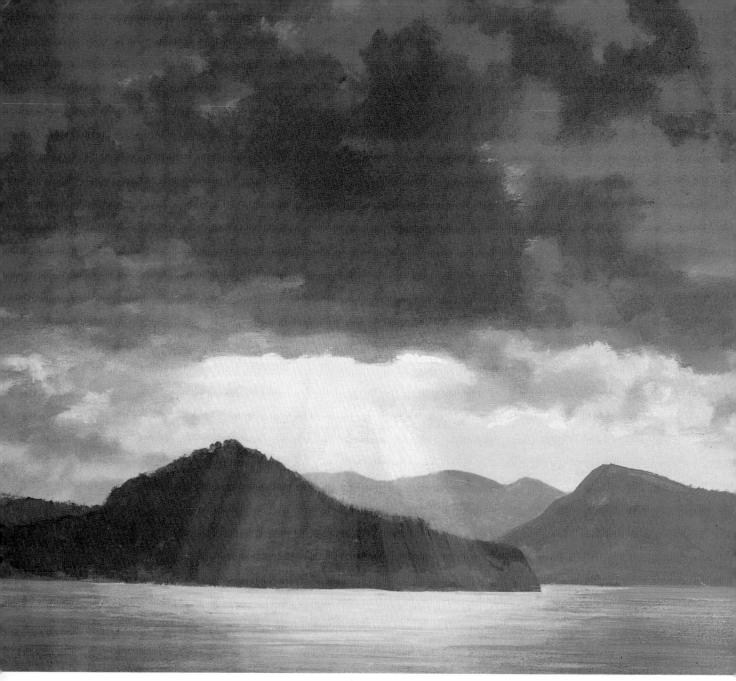

Step 5. The sky is now complete. In the final step, subtle touches are added to the islands and the water to make them harmonize with the sky. At the right and left, the water is darkened with drybrush strokes of cadmium red, yellow ochre, ultramarine blue, and white to suggest the reflections of the dark islands in the water. When these reflected tones are dry, a small softhair brush is used to drybrush thin, horizontal lines across the water. These strokes are the same combination as the dark reflections, but the proportions of the colors

change from stroke to stroke. The strokes at the edges contain more blue or red. The strokes at the center contain more yellow and white to suggest the brilliant sunlight shining on the water. This same pale mixture is drybrushed with diagonal strokes over the islands to carry the sun's rays all the way down to the water. This final landscape demonstration shows three different ways to apply color: scumbling in the sky; creamy, fluid color on the islands; and drybrush in the water.

Understanding Sunset Colors

- **1.** At sunset, the sky is normally paler at the horizon and darker at the zenith.
- **2.** The sky is also likely to be warmer—which means red, pink, orange, or yellow—at the horizon.
- **3.** The zenith tends to be cooler, which means blue, blue-violet, or violet.
- **4.** Because the light is behind the clouds, those clouds are apt to be darker than the sky, although there may be touches of lighter color on the edges of the clouds.
- **5.** Don't be surprised to see hints of unexpected color in a sunset sky. Green often appears in midsky. Don't say: "That's not supposed to be there!" If you see it, paint it.

SECTION FOUR

SEASCAPE SUBJECTS

SELECTING SEASCAPE SUBJECTS

Center of Interest. Painters love the coastline because it's so easy to find dramatic shapes to paint. Finding the focal point of your picture—a looming cliff, a jagged rock formation, a crashing wave—may not take very long. What usually takes more time and more thought is finding the right vantage point, the right light effect, and the right subsidiary elements.

Vantage Point. You can just set up your painting gear on the beach, look up at the cliff or look out at the waves. and start to paint. But it's usually worthwhile to walk around a bit to find the right vantage point or the right angle from which the subject looks most impressive. If you walk closer to the cliff and then look up at it from the shore below, the horizon seems lower and the cliff seems taller. If you walk farther away, you may have a more panoramic view of cliff. foreground rocks, and distant sea. Either view might make a good picture. Crashing waves are often too far away-and there are often too many of them. They're more dramatic if you get closer. But it's usually hard to get close enough without getting soaked. So the next best solution is to isolate some segment of the biggest wave, plus one or two more waves, and perhaps a few rocks, and paint the subject as if you're standing nearby. You'll also find that the picture can change dramatically when you change your eye level. First try sitting at the foot of a rock formation and looking out across the beach. Then climb to the top. See which vantage point you like best.

Lighting. Your vantage point or angle of view will also affect the lighting on your subject. At midday, the

sun is directly overhead, and the lighting tends to be uniform everywhere. with very little shadow. But throughout most of the morning and most of the afternoon, the sun is lower in the sky. This means that things like rocks, cliffs, dunes, and waves will have a lighted side and a shadow side. As you walk around your subject, you can decide how much light and how much shadow you want to see. From one angle, you'll see a lot of the sunlit side of the dune, with just a little shadow. Walk halfway around the dune, and you'll see mostly shadow and just a bit of sunlight. The dune (or rock or cliff) may also cast an interesting shadow, which enhances the picture when you stand at a certain spot. Any one of these light effects might make an interesting painting. But try to avoid a 50-50 balance of light and shadow: let the light or the shadow dominate. Especially interesting things happen to the light in early morning and late afternoon, when the sun is really low in the sky. That's when the light is literally behind the shapes of rocks, waves, surf, cliffs, headlands, and clouds. Now these shapes are seen as dark silhouettes—which many seascape painters love best.

Secondary Elements. Having found your center of interest, you then have to decide how many other elements you want to include. A crashing wave, throwing a mass of foam against a rock, may look even more violent with a calm stretch of beach in the foreground and peaceful, horizontal clouds in the distance. The curving shape of a big sand dune may look even more rhythmic if its curves are echoed in a couple of smaller dunes in the distance. And you can call attention to

the biggest dune by crowning it with beach grass. That headland may look taller and more jagged if you suggest some low, flat shoreline along the distant horizon. If you're lucky, these secondary elements may be in the picture or nearby. If not, you may have to rely on sketches or on your memory.

Working Indoors. All these suggestions are based on the assumption that you'll be painting outdoors—which isn't always true. Lack of time, changing weather, or just your personal preference may take you indoors more often than outdoors. It's also a lot easier to reorganize nature in the comfort and leisure of your home or studio. If you plan to do most of your painting indoors, the most practical solution is to treat the outdoors simply as a source of material. Go to the coastline with just the equipment you need to make pictorial notes, not to paint a finished picture. Use a sketchpad and a pencil to make quick drawings of ideas for pictures, just blocking in the shapes of waves, clouds, rocks, and dunes. Then turn the page and make more careful drawings of the most important elements in your future picture. Try to record the exact shape of the wave and the pattern of the foam trickling down its face. Or study the precise form of the rocks, with the pattern of light and shadow, and the texture of the cracks. To record colors, pack just enough painting equipment to make small, simple paintings on scraps of illustration board. Or paint on a pad of thick drawing paper or watercolor paper. An indoor painting does start on location. And a day of outdoor painting can give you enough material for many happy days of painting at home.

MIXING COLORS FOR SEASCAPES

Blues and Grays. Because the sky and the sea dominate most coastal subjects, blues and grays are the most common colors in seascape painting. For this reason, it's particularly important to learn how to amplify the two blues on your palette to produce the great variety of blues that actually appear in nature. And it's equally important to realize that gray isn't merely a drab mixture of black and white, but a family of colors so incredibly diverse that many seascape painters work primarily in grays-and create pictures of great variety and richness.

Modifying Blues. As the light changes throughout the day, the blue of the sky changes too. And since the sea mirrors the sky, the blue of the sea also changes from hour to hour. Both sea and sky change with the weather. So even on the sunniest day, you must learn to mix a variety of bright blues. But not all days are sunny, so you must be prepared to create blues for cloudy and hazy days, for foggy weather, and even for storms. You must learn all the different ways to transform the two blues on your palette - ultramarine blue and phthalocyanine blue - into many other hues. Both these blues are dark when they come from the tube, so they need white to bring out their full brillance. A minute touch of phthalocyanine green can make them look still more brilliant. A hint of yellow ochre will soften them without turning them green—but beware of adding the more powerful cadmium yellow light. A trace of burnt umber or burnt sienna will darken both blues, while a larger quantity of either brown (plus more white) will produce subtle, grayish blues. A speck of naphthol crimson will give you purplish blues. The brilliant phthalocyanine blue and the more muted, slightly purplish ultramarine blue will also modify one another, producing a lovely blue that's midway between the two.

Creating Grays. When the time comes to mix a gray, your first impulse will probably be to blend black and white, which will give you a steely gray that can be just right for stormy weather. But this is only one of many possible gray mixtures. The most interesting variety of grays will come from blending blue, brown, and white. You should certainly explore the various possibilities of mixing ultramarine blue or phthalocvanine blue with burnt umber or burnt sienna, plus white. When you change the proportions of blue and brown, these grays will change radically. When blue dominates, you get a cool gray; when the brown dominates, you get a warm gray. You can then enrich any of these blue-brown mixtures by adding any other color on your palette. The greens will give you greenish grays. Yellow ochre will give you a golden gray, though the more powerful cadmium yellow is unpredictable: add just a speck at a time or you may suddenly find that your gray turns green! Violet grays are more common in nature than you might think, so a touch of naphthol crimson may be just what you need. But add cadmium red with care—it pushes these grays toward brown, not toward violet.

Painting Skies. Even on the brightest day, skies are rarely a uniform color, so you've got to watch for subtle variations in the blue. The deepest, brightest blue is apt to be at the top, while the sky often grows paler and

warmer (with a hint of gold or pink) toward the horizon. On an overcast day, when the sky seems to be a uniform gray, you should also watch for gradual color changes from the zenith to the horizon. Also on an overcast day, the sun has a most unpredictable way of breaking through the gray at some point, producing an unexpected suggestion of gold. The colors of clouds are just as varied. Keep in mind that a cloud is a solid, threedimensional object, with a light side and a shadow side, just like a rock. The sunlit area of the cloud isn't just white, straight from the tube, but often has a hint of golden sunshine at midday, pink or orange at sunrise or sunset, gray or blue-gray on an overcast day. In the same way, the shadow side of the cloud can be a bluish gray, a brownish gray, or even a golden tone.

Painting Water. Although many poets talk of the glorious colors of the sea, water really has no color of its own. Like a mirror, water takes its color from its surroundings. A bright blue sky generally means bright blue water, while a gray sky usually means gray water. At sunrise or sunset, the water can be red, pink, orange, or violet. Of course, water is also influenced by the colors of the shoreline. The brilliant blue-green of tropical waters is a combination of the bright blue sky above and the golden sands beneath the water. The colors of tide pools are often combinations of sky color and the reflections of the surrounding rocks and sand. In short, don't simply decide that water is always blue, gray, or green. You've got to look carefully and paint what you actually see.

MIXING COLORS FOR SEASCAPES

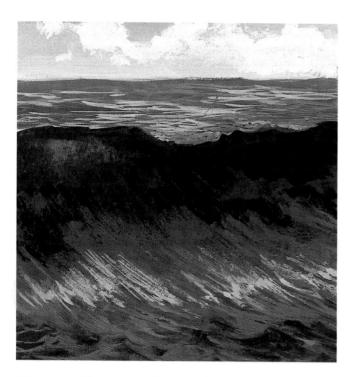

Wave on Clear Day. Because the sea is essentially a reflecting surface, its color is strongly influenced by the weather and by the prevailing light. On a clear day, you'll see blues and greens. The shadowy face of the wave, curving upward and tipping over slightly so it doesn't catch the direct sun, looks transparent and lets the light shine through.

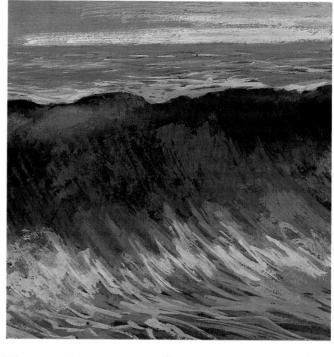

Wave on Overcast Day. On a gray, overcast day, that same wave looks quite different. The water picks up the grayish tone of the sky. The shadowy face of the wave seems less transparent. However, the water is far from a dead, uniform gray. It's still full of color, but much more subtle color than you see on a sunny day.

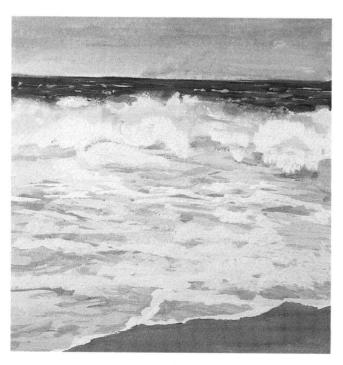

Foam on Clear Day. Foam is water in a different form, but it's still a reflecting surface, affected by light and weather. On a clear day, the foam reflects the warmth of the sun's rays. The sea beyond reflects the bright, cool tones of the sky. As the foam spills forward over the beach, the sandy tone shines through.

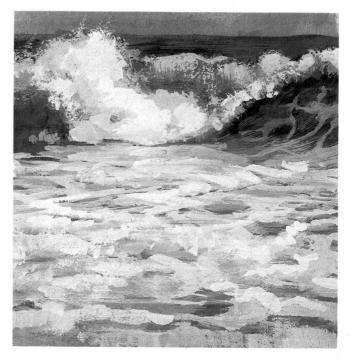

Foam on Overcast Day. When clouds cover the sky and block off the sun, the light loses its warm tone and turns grayish. The foam reflects this cool light, just as the water reflects the more somber tone of the sky. The beach looks grayer too, and these subdued sandy tones shine through the foam as it moves across the beach.

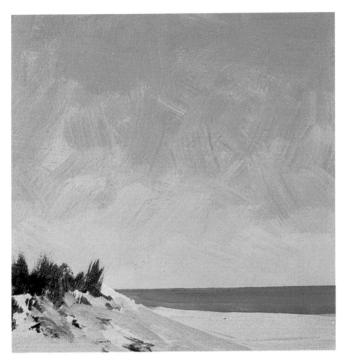

Clear Sky. On a sunny day, a cloudless sky is a deep, rich blue, but it's not a smooth, consistent tone from top to bottom. It's usually darkest at the zenith and grows lighter toward the horizon. Your two blues, phthalocyanine and ultramarine, plus white, will make a lovely sky tone. As you approach the horizon, you can add more white, plus yellow ochre for a hint of warmth.

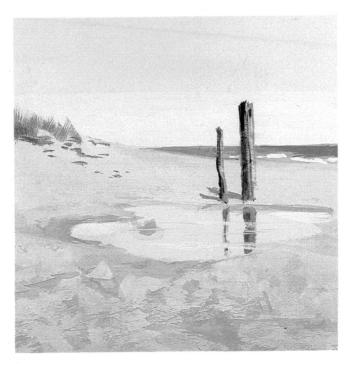

Tide Pool on Clear Day. A tide pool usually looks like a patch of sky dropped onto the beach. On a clear day, the pool mirrors the clear tones of the sky overhead. Notice that the pool also reflects nearby objects like these two weathered wooden posts. The wind produces light and dark ripples that interrupt the reflections.

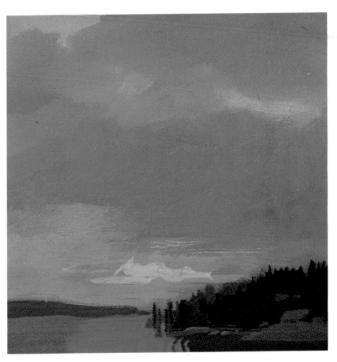

Overcast Sky. An overcast sky is actually full of subdued colors. Notice how these cloud layers are sometimes warm, sometimes cool. Try mixing blues and browns—ultramarine or phthalocyanine with burnt umber or burnt sienna—in different proportions to get blue-grays and brown-grays. Naturally, you'll need some white. And add yellow ochre for a more golden tone.

Tide Pool on Gray Day. On an overcast day, the sky is often darker than the beach—and so is the tide pool. The shadowy tones of the sky are mirrored in the water, where the reflections of the wooden posts look darker too. Where a little light breaks through the sky, as it does on the left, this light reappears in the pool.

MAKE YOUR WAVES SHINE WITH LIGHT

Step 1. For this painting demonstration, de Reyna has coated a sheet of hardboard with two layers of acrylic gesso diluted with water to the consistency of thin cream. One coat was brushed from top to bottom and allowed to dry. Then the other coat was brushed from side to side. This 'process gives the board a subtle crisscross pattern, something like canvas. On the dry board, he uses a pencil to draw the horizon line, the horizontal lines of the distant waves, the curving shapes of the closer waves and foam, and the low waves in the foreground.

Step 2. A kneaded rubber eraser lightens the pencil lines so that they're almost invisible here. Then a semitransparent mixture of chromium oxide green, phthalocyanine blue, and just a hint of white is freely brushed over the entire sea, starting from the horizon and working down to the bottom of the picture, leaving bare gesso only for the surf. This mixture is lightened with water at the top of the big wave. The brushstrokes in the immediate foreground are a bit darker, and they curve to suggest the wave action. Then the distant sea is darkened with horizontal strokes of ultramarine blue, Hooker's green, and a little white.

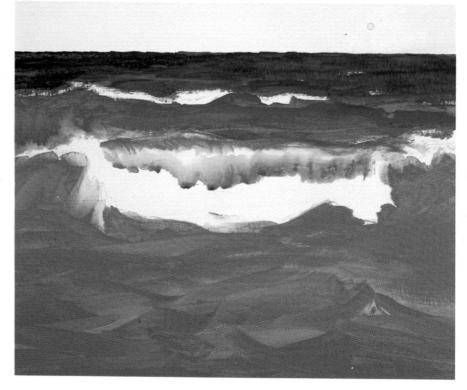

Step 3. The sky is brushed with a smooth mixture of phthalocyanine blue, naphthol crimson, yellow ochre, and white. The distant sea and the strip of water behind the near wave are darkened with horizontal strokes of phthalocyanine blue, chromium oxide green, burnt sienna, and white. A few whitecaps are added to the distant water with touches of white, tinted with sky tone. The shadow on the foam is painted with the sky mixture, and then the sunlit edge is painted with pure white, tinted with a little sky mixture and some more yellow ochre. The face of the oncoming wave is darkened at the left with the same mixture-but containing more white—that's used for the distant sea.

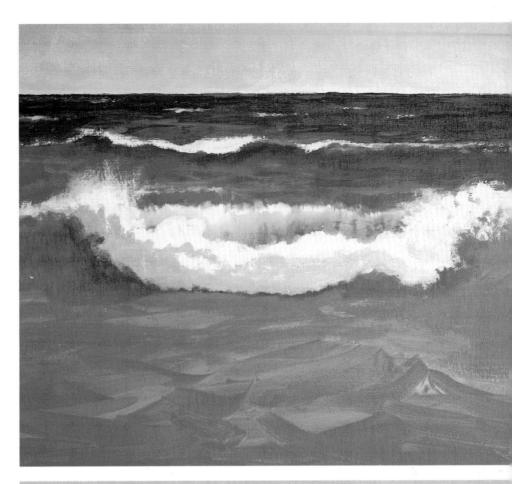

Step 4. Work now begins on the details of the rippling water in the foreground. Phthalocyanine blue, chromium oxide green, burnt sienna, and a little white are thinned with water to a fluid consistency that's necessary for precise brushwork. Then the tip of a round softhair brush strikes in short, curving strokes to suggest the dark faces of the ripples. The brush leaves spaces between these strokes, allowing the undertone to shine through. The face of the oncoming wave is darkened at the right with this fluid mixture.

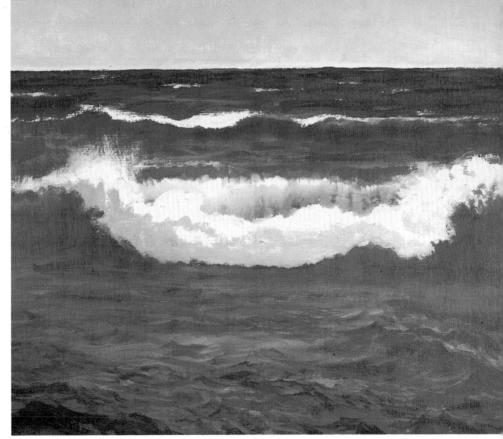

MAKE YOUR WAVES SHINE WITH LIGHT

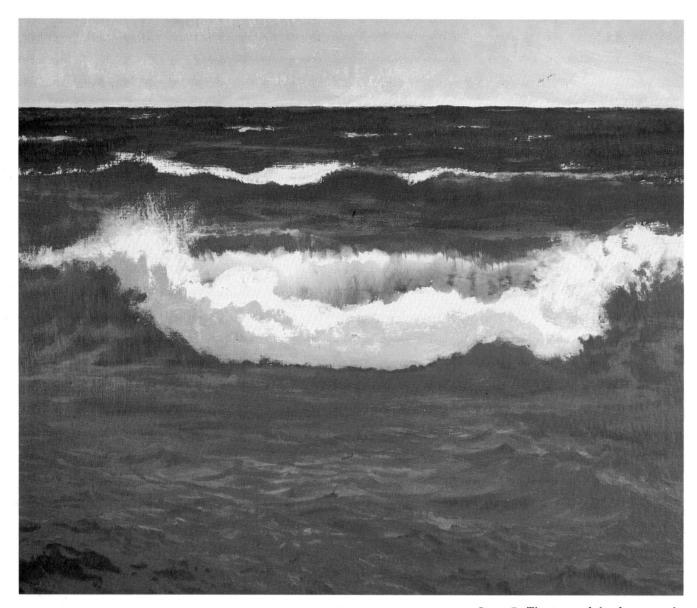

Step 5. The tops of the foreground ripples, which reflect the pale tone of the sky, are painted with a round softhair brush. This light tone is a mixture of phthalocyanine blue, chromium oxide green, yellow ochre, and white. The color is slightly thicker and more opaque than the dark undertone. Once again, the strokes are short curves, which you can see most clearly in the immediate foreground. These strokes don't cover the foreground completely, but leave gaps for the dark undertone to shine through. This mixture is carried upward over the face of the oncoming wave—to the right and left of the exploding surf-to suggest foam trickling over the clear water.

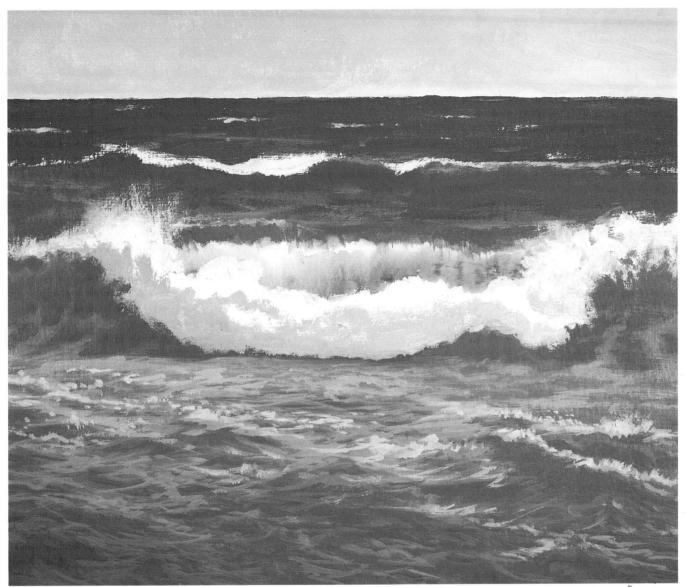

Step 6. Next the artist takes the same mixture he used in Step 5, but adds more white. Working with the tip of a small round brush, he uses this lighter mixture to fill in the details of the foreground. Curving strokes with this mixture suggest the light on the tops of the ripples. Then he picks up almost pure white, faintly tinted with sky tone, and adds touches of foam to the tops of the foreground waves. He also adds trails and flecks of foam that wander from left to right across the foreground. These strokes are placed so that they have gaps between them to allow the underlying darker strokes to come through. An intricate pattern of strokes suggests the sparkle and action of the water.

Before You Paint a Wave . . .

- **1.** Make a series of drawings of breaking waves in your sketchbook.
- **2.** In each sketch, define the shape of the surf.
- **3.** Be sure to define the shape of the shadow on the surf, so the surf

has a light plane and a shadow plane.

- **4.** Make several drawings of the pattern of foam that trickles down the face of the wave.
- **5.** Paint from the drawing that you like best—or make a new drawing that combines the best features of several drawings.

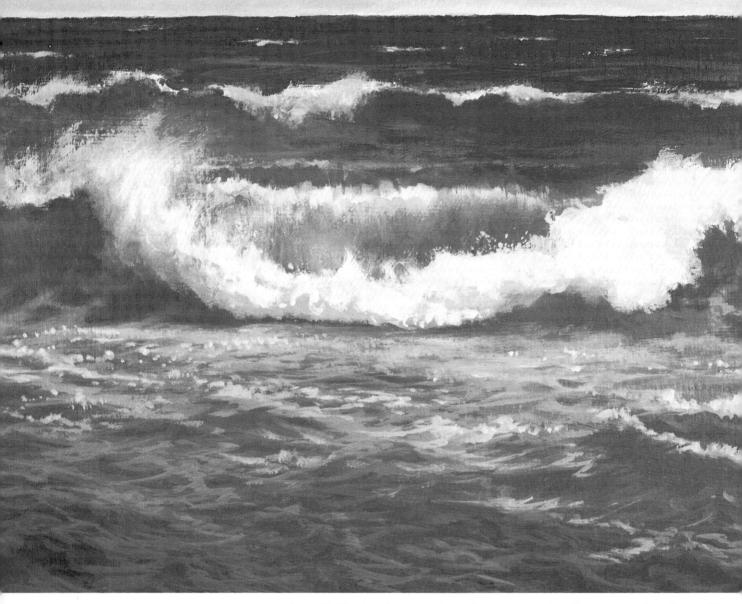

Step 7. The brush strengthens the tone of the wave that rolls downward behind the crashing foam. Darker tones of phthalocyanine blue, naphthol crimson, yellow ochre, and white are scumbled directly behind the foam to give the curving wave a more threedimensional, barrel shape. Pure white, tinted with a little sky tone, is scumbled along the top of the barrel. Now there's a clear gradation from light to middletone to shadow, giving the wave a distinctly round shape. A bristle brush scumbles a thick mixture of white, tinted with sky tone and a little more yellow ochre, over the sunlit edge of the surf. These scumbling strokes cover some of the shadow

tone that first appeared on the surf in Step 3. At the extreme left, the face of the big wave is scumbled with a pale mixture of phthalocyanine blue, Hooker's green, and white to suggest light breaking through the transparent water. More of the foam mixture is scumbled along the foamy edge of the more distant wave. A mixture of phthalocyanine blue, chromium oxide green, yellow ochre, and white is carried across the distant sea in horizontal drybrush strokes to suggest lighter tones on the water. Finally, the tip of a small brush adds some tiny dots of pure white to suggest foam flying upward from the crashing surf of the big wave.

EXPRESSING THE POWER OF SURF

Step 1. This study of surf and rocks will be painted on canvas whose texture is a bit too rough for pencil drawing. So the preliminary drawing is done on a sheet of transparent tracing paper. (This smooth paper allows you to erase easily, which means that you can change your mind and redraw the lines until you get them right.) When the drawing seems accurate, a second sheet of tracing paper is scribbled with soft pencil or charcoal. This transfer paper, as it's called, is laid over the canvas, and the drawing is laid on top. A sharp pencil goes over the most important lines of the drawing, which are then imprinted on the canvas via the transfer paper.

Step 2. The lines registered by the tracing paper are thinner, lighter, and simpler than the original drawing. Ultramarine blue, burnt sienna, yellow ochre, and white-straight from the tube-are mixed on the palette with the painting knife. The colors aren't smoothly blended. The mixture is lighter in some areas, darker in others. The knife picks up some dark tone on the underside of the blade and spreads this thick paste over the canvas with short, decisive strokes to suggest the shadows of the rocks. Then the knife picks up some lighter tones and spreads them over the darks to suggest the sunlit tops.

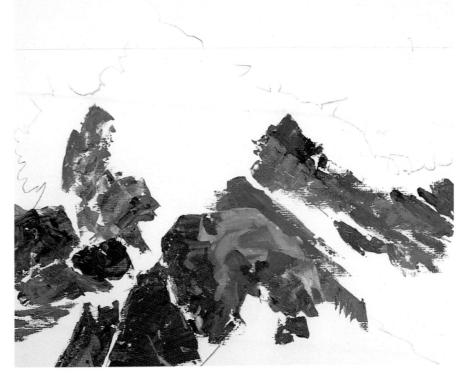

EXPRESSING THE POWER OF SURF

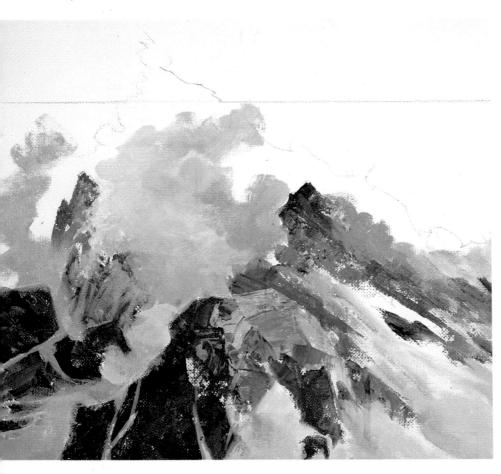

Step 3. The shadows of the crashing foam are scumbled with a stiff bristle brush that carries a mixture of ultramarine blue, naphthol crimson, yellow ochre, and white. The color is thick and creamy. One wet stroke is scrubbed into and over another, so they merge slightly, although you can still see the individual strokes. By now, the knife strokes are dry and brushstrokes of this foamy mixture are carried over and between the rocks to suggest foam splashing and running over the dark, blocky shapes. Notice the lines of foam running through the cracks in the rocks at the lower left.

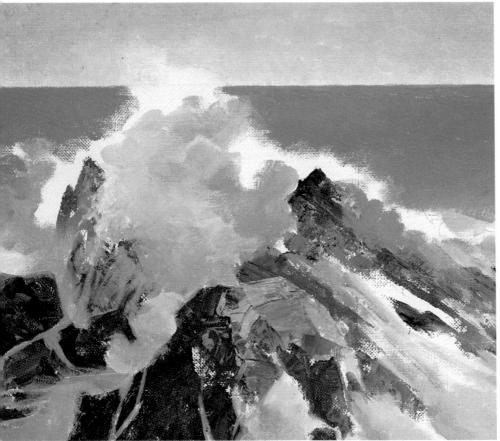

Step 4. The sky tone is painted with a smooth, fluid mixture of ultramarine blue, naphthol crimson, yellow ochre, and white, carried down to the horizon line. A darker mixture of the sky tone—ultramarine blue, naphthol crimson, yellow ochre, and whitecovers the sea, leaving a ragged strip of bare canvas for the sunlit edge of the foam. This mixture is darkest at the horizon and grows slightly lighter - containing more white - as it moves forward toward the rocks. The color is smooth and fluid enough to paint a crisp horizon line. Yet the color is thick enough to scumble around the edge of the foam, which is soft and ragged.

Don't Use Just One Painting Tool

This seascape shows the importance of finding the right tool for the subject: the painting knife for the rocks; the bristle brush for the waves and surf; and the softhair brush for the final details.

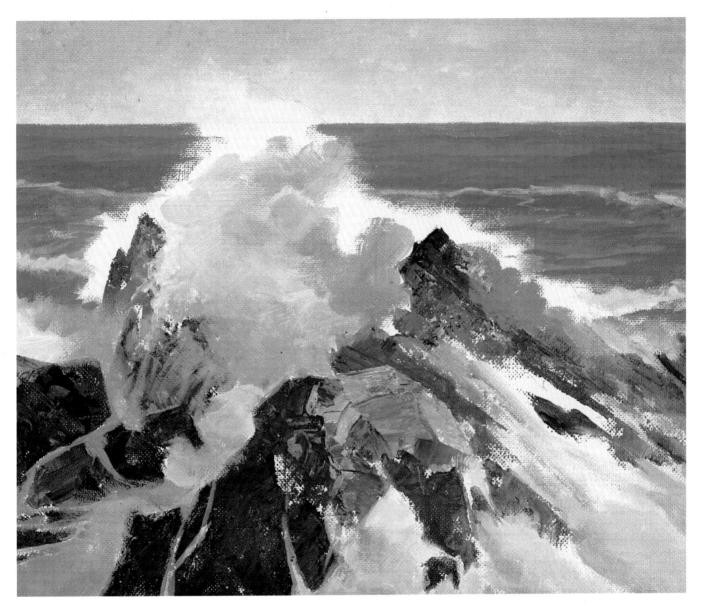

Step 5. When the underlying tone of the sea is dry, the point of a round softhair brush defines the darks and lights of the distant waves. The dark, horizontal lines are a mixture of ultramarine blue, a little naphthol crimson, some yellow ochre, and less white than the undertone. These strokes eliminate some of the foam at the extreme left. Then a lot of white is added to this mixture to paint the line of foam on the distant wave, just below the horizon, as well as the line of foam just above the rocks at the left. Now the canvas is almost completely covered with color, except for the sunlit edge of the exploding foam and some strips of sunlight on the foam that runs over the rocks.

Study the Brushwork

The secret of expressive brushwork is to make the brush follow the movement or the direction of the form you're painting. Where the surf explodes against the rocks, the strokes are short, decisive dabs and scrubs; the brush actually pulls the strokes upward and outward, moving as the foam moves. Then, as the foam spills over the rocks, the brush carries the foam across

the flat tops of the rock formation with long, diagonal strokes that move from left to right. The rocks are painted with short, squarish, decisive knife strokes that correspond to the light and shadow planes of the form. Later, in Steps 5 and 6, the rhythmic swell of the distant waves is painted with slender, horizontal, rhythmic strokes of the tip of the brush, which actually moves over the water with a wavelike motion.

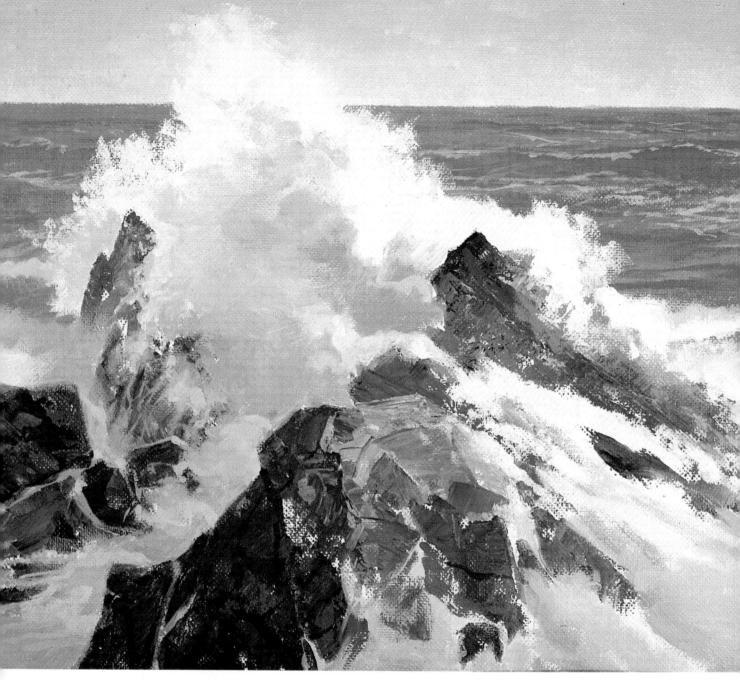

Step 6. Thick, pure white is tinted with a touch of the sky mixture and scumbled over the bare canvas around the edge of the foam that leaps up from the rocks. The brush scrubs back and forth to create a soft transition where the sunlit area melts into the shadow. Where the foam stands out against the dark sea beyond, the tip of the bristle brush applies the pale color in quick dabs that are broken up by the texture of the canvas. (Canvas is particularly receptive to scumbling because the fibers of the woven cloth have a lovely way of softening the stroke.) The bristle brush drags this thick, sunny mixture downward to the right, suggesting sunlight shining on the foam that runs over the rock formation. Then this pale mixture is darkened with a bit more sky tone and diluted with enough water for precise brushwork. So far, everything has been done with bristle brushes; but now a round softhair brush picks up this pale, fluid mixture and traces the lines of the foam on the distant sea with slender strokes. Moving into the foreground, the brush draws more trickles and streaks of foam over the rocks that are disappearing under the mass of surf. These trickles of foam are carried between the rocks and down into the lower left corner.

CAPTURE THE MAGIC OF MOONLIGHT

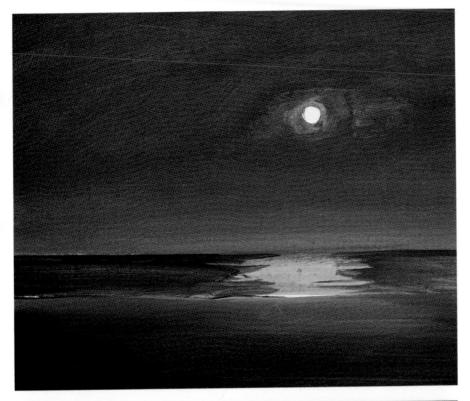

Step 1. The effects of moonlight are so subtle that it's very difficult to capture them with pencil lines. All the pencil can do is draw the line of the horizon, the line of the beach, the silhouette of the distant shore, the jagged shape of the reflection on the water, plus the circle of the moon all of which disappears under the firs application of color. On a sheet of illustration board, the picture is painted from dark to light, starting with the most somber tones. The entire painting surface is covered with smooth, fluid strokes of ultramarine blue, burnt sienna, vellow ochre, and a touch of white for opacity. A little more white and some more water area added at the lower edge of the sky to suggest the glow at the horizon. Only the moon and its reflection remain bare paper. Then the reflection is slightly tinted with the sky mixture and lots of water.

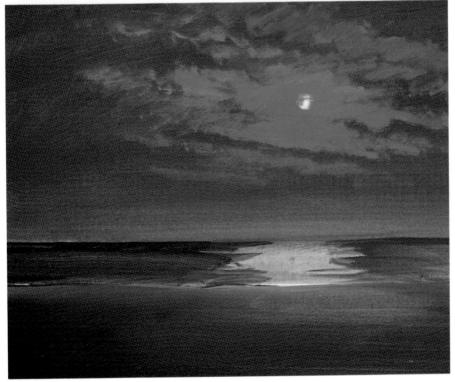

Step 2. The moonlit clouds are scumbled over the sky with phthalocyanine blue, naphthol crimson, yellow ochre, and white. Look closely and you'll see that the clouds are all painted with short, straight, parallel strokes that move diagonally downward from the upper right. The moon is partly covered by these strokes, but will be reestablished later on.

Keep the Light in Moonlight

- 1. Moonlit landscapes and seascapes are lighter than you think. Don't make them too dark.
- 2. The sky is usually lighter than the land below.
- **3.** Even at night, the sea reflects the sky—so the water is usually lighter than the land.

CAPTURE THE MAGIC OF MOONLIGHT

Step 3. To intensify the glow in the lower sky, a hint of this cloud mixture is scumbled upward from the horizon. The dark shape of the distant shore is painted with a smooth mixture of ultramarine blue, burnt sienna, and a touch of white. The cloud mixture, containing a little more blue, is scumbled downward from the horizon to cover most of the moon's reflection in the water. On each side of this reflection, the water is darkened with horizontal, scumbled strokes of the original sky mixture: ultramarine blue, naphthol crimson, and yellow ochre. A bit of the cloud mixture is scumbled over the edge of the beach at the left to suggest moonlight on wet sand.

Step 4. The original tone of the sky is darkened and solidified with a dense, creamy, opaque mixture of ultramarine blue, naphthol crimson, and yellow ochre, smoothly brushed with a flat softhair brush. This mixture covers some of the clouds and provides a dark background for more luminous tones that will be added to the sky in the final step. The moon's reflection is now re-established with a mixture that consists mainly of white, plus some sky color. The reflection actually consists of small touches of color, applied in rows with the tip of a bristle brush. These touches give the feeling that the moon is shining on the tops of waves that are moving into shore.

Step 5. The moonlit tops of the rocks on the beach are painted with short, smooth strokes of ultramarine blue, naphthol crimson, yellow ochre, and enough white to make them stand out in the darkness. The shadow sides of the rocks are scumbled with this same mixture, but containing no white. Then a little white is added to the mixture, which is scumbled over the beach to give the sand a dark, unified tone. The moonlight mixture (from Step 4) is scumbled along the edge of the beach to suggest light reflecting on the wet sand.

Moonlight Is Colorful . . .

... so keep black off your palette when you paint moonlight. Moonlight is full of color—so use *colors* to mix your darks. Don't assume that moonlight is always blue. It can be green, violet, gold-brown. Paint the colors you see!

Step 6. The clouds, which seemed too insistent, were cut back in Step 4. Now they're painted in a much darker, more subdued tone and carried across most of the sky. This is a dark mixture of ultramarine blue, naphthol crimson, yellow ochre, and just enough white to make them stand out against the dark background. As you saw in Step 2, the clouds are painted with short, straight, parallel strokes that move diagonally downward from right to left. Now more white, naphthol crimson, and yellow ochre are added to this mixture and scumbled over the edges of the clouds that are closest to the moon. The same mixture is used to scumble the halo around the moon. The circle of the moon is repainted with almost

pure white, tinted with a touch of this mixture. On either side of the reflection in the water, the dark patches of sea are enlivened with slender, horizontal strokes of the dark cloud mixture, painted with the tip of a round brush. When you paint a moonlit seascape – or a moonlit landscape for that matter-keep several "lessons" in mind. First, remember that a moonlit sky is lighter than the dark shapes of the land below. Second, the colors, lights, and shadows of the sea reflect the sky, just as they do in daylight. Finally, don't overdo the moonlight on the clouds and water, scattering touches of white all over the picture; concentrate these light touches at the focal point of your composition.

PAINTING FOG AS VEILS OF COLOR

Step 1. De Reyna chose cold-pressed watercolor paper for this painting because it will be done entirely in thin fluid washes, very much like watercolor. First, he draws in the shapes of the rocky coast with a pencil. Then these lines are lightened with a kneaded rubber eraser so they're almost invisible. To avoid abrading the surface of the paper, the eraser is pressed against the pencil lines and lifted away, rather than scrubbed back and forth.

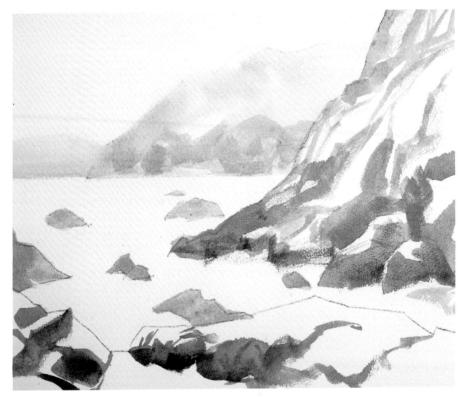

Step 2. The shadow planes and the cracks between the rocks are painted with a flat softhair brush, carrying a fluid mixture of ultramarine blue, naphthol crimson, yellow ochre, and water. More water is added for the paler strokes. The color is transparent. Before painting the blurred top of the two distant cliffs, the sky is painted with a very pale wash of the same mixture used to paint the rocks in the foreground; while this wash is still moist and slightly shiny, the tops of the cliffs are painted with darker strokes that blur into the wetness. The lights of the foreground rocks and sea remain bare paper.

PAINTING FOG AS VEILS OF COLOR

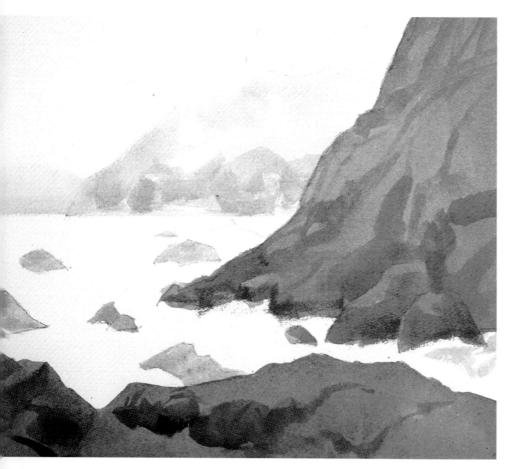

Step 3. When the shadow strokes are dry, a flat softhair brush covers the foreground rocks with a transparent wash of ultramarine blue, naphthol crimson, burnt sienna, and water. Now these shapes are distinctly darker—and therefore look nearer—than the paler shapes in the distance.

It's Still There!

Fog makes the landscape paler and more remote, but the shapes of the land are still there. Define the shapes carefully. Don't turn them to mush! Fog minimizes the contrast between light and shadow—but the lights and shadows may still be visible. Don't ignore them.

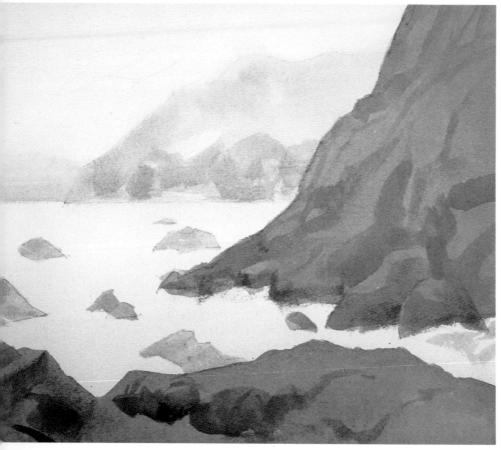

Step 4. A pale wash of phthalocyanine blue, naphthol crimson, yellow ochre, and lots of water is carried over the entire picture—the first step in creating a veil of fog that will gradually become denser in succeeding steps. Now the picture has a slightly cooler, more unified tone.

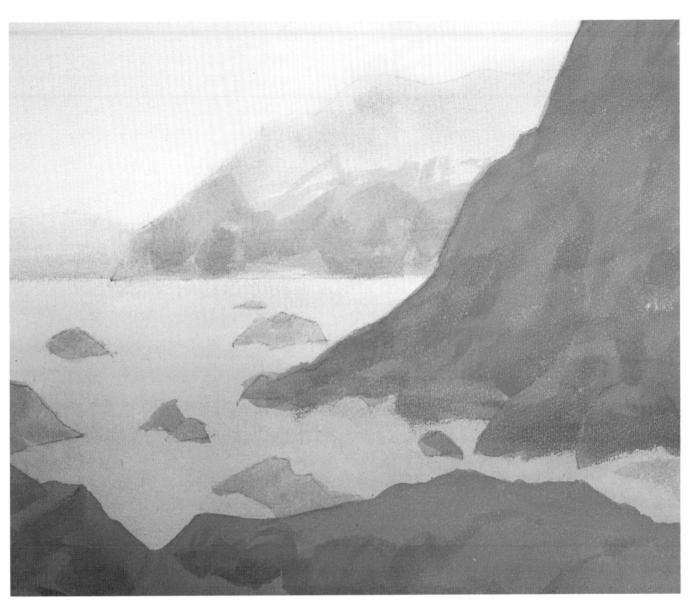

Step 5. When Step 4 is dry, a touch of white is added to the mixture of phthalocyanine blue, naphthol crimson, and yellow ochre. Diluted with a great deal of water, this misty tone is washed over the entire surface of the painting with a large, flat softhair brush. Now the fog is beginning to thicken as a slight veil appears over the rocks, both near and far.

Fog Isn't Just Gray

Fog is not just a dull mixture of black and white—it can be many different grays. Depending on the time of day and the color of the sunlight behind the fog, you can see golden grays, greenish grays, bluish grays, and grays with hints of warm color like pink or orange.

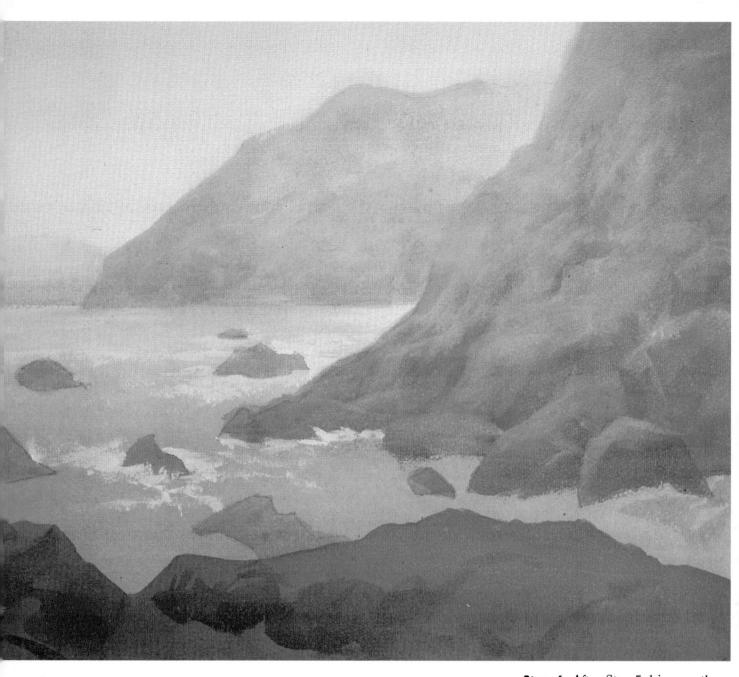

Step 6. After Step 5 dries, another wash of this misty mixture is brushed over the rocks in the immediate foreground. Then a little more white is added—though not enough to make the mixture opaque—and this misty tone is carried over the sea, the cliff to the right, the distant cliffs, and the sky. Now each successive rock formation seems farther away. A little more white is added to the mixture, and the tip of a round brush adds lines of foam around the rocks.

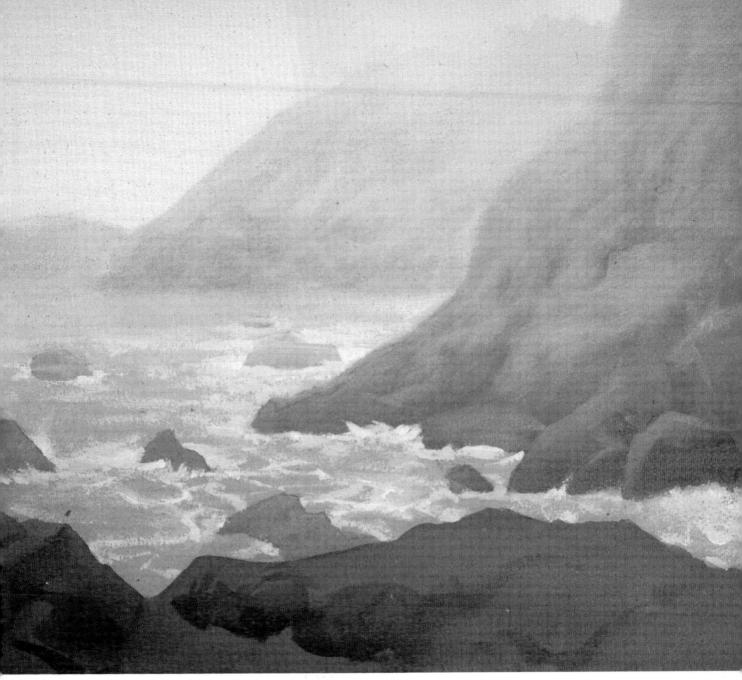

Step 7. When the surface is dry once more, another touch of white is added to the foggy mixture. This semiopaque tone is brushed over the upper half of the picture and scumbled over the edges of the cliffs to blur their outlines. A round brush draws more lines of foam along the bases of the cliffs, around the rocks, and in the churning water. The completed painting is a dramatic example of the way acrylic color can be used in varying degrees of transparency and opacity to create atmospheric effects. Starting with transparent color, the painting is completed with veils of semitransparent color, each a little more misty than the preceding veil.

Don't Add Too Much White

Proceed in very gradual stages, always adding a little *less* white than you think you need—so you don't risk covering all the careful work underneath.

CREATING THE TEXTURES OF A ROCKY BEACH

Step 1. A sturdy sheet of watercolor board—cold-pressed watercolor paper mounted on stiff cardboard by the manufacturer - is brushed with a thin coat of acrylic gesso. The gesso is diluted with water to a consistency of thin cream so that the white paint settles evenly over the paper, showing no brushstrokes. The texture of the watercolor paper is unchanged, but now the surface is slightly tougher and less absorbent than the bare watercolor paper. The gesso coating provides a particularly receptive surface for the opaque technique. Then the shapes of the rocks, the distant sea, and the coastline are drawn in pencil on the gesso surface. A kneaded rubber eraser moves over the painting surface, removing all superfluous lines and lightening the few lines that remain. Then a flat nylon brush covers the rocks with transparent strokes of burnt sienna, ultramarine blue, and yellow ochre, diluted with water. On the gesso surface, these strokes stand out clearly instead of melting together, as they'd be inclined to do on bare watercolor paper.

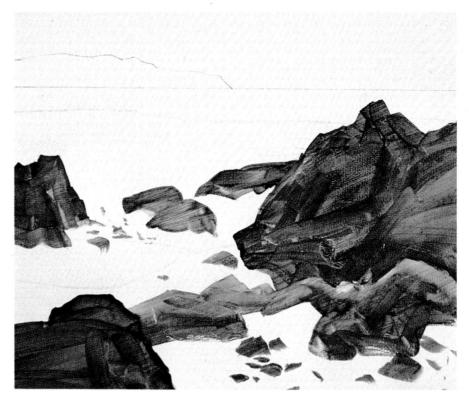

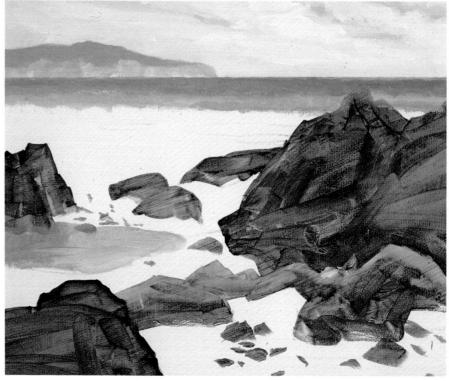

Step 3. The sand is covered with a smooth, opaque, but fairly fluid mixture of phthalocyanine blue, naphthol crimson, yellow ochre, and lots of white. Over this smooth undercoat, a small bristle brush adds individual touches and dabs of this same mixture-containing less white-to indicate pebbles and the irregular texture of the sand. Some of the sea tone is scumbled in at the edge of the beach to suggest the wetness of the sand. You can see that the surrounding colors are beginning to obscure the edges of the rocks, but this will be corrected when the rocks are repainted in thicker, more opaque tones.

The Sea "Defies" Aerial Perspective

On a clear day, the sea often defies the "laws" of aerial perspective (see page 17). You may be surprised to find that the sea is actually darkest at the horizon, growing paler in the foreground, as you see here. This is probably because the more distant waves show us their shadowy faces—rather than their sunlit tops—and these strips of shadow seem to blend together on the distant water. As the waves approach us, we can see more of their sunlit tops.

Step 4. The lighted planes of the rocks are brushed in with a small bristle bright, carrying thick, opaque color. This is a dense mixture of ultramarine blue, burnt sienna, yellow ochre, and white. The paint is the consistency of thick cream, and the brushstrokes are roughened by the texture of the watercolor board. The brush also touches the tops of some of the pebbles scattered between the larger rocks.

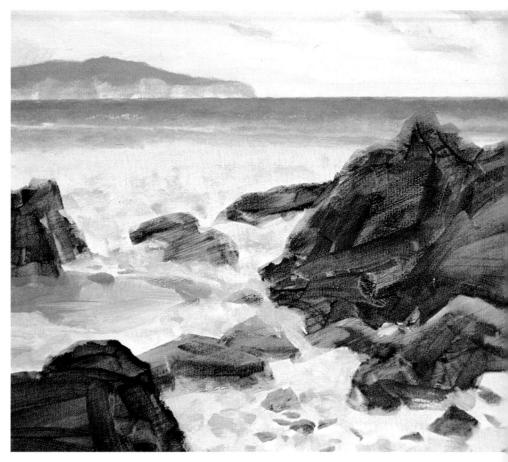

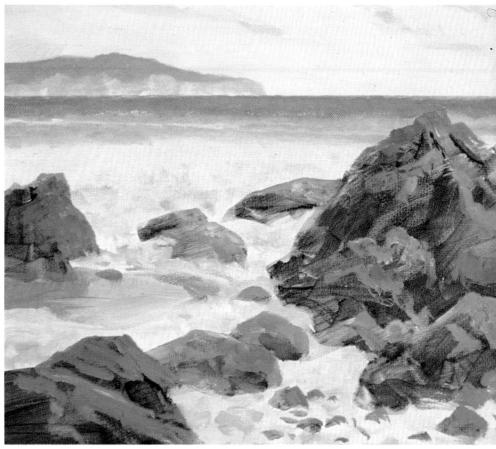

CREATING THE TEXTURES OF A ROCKY BEACH

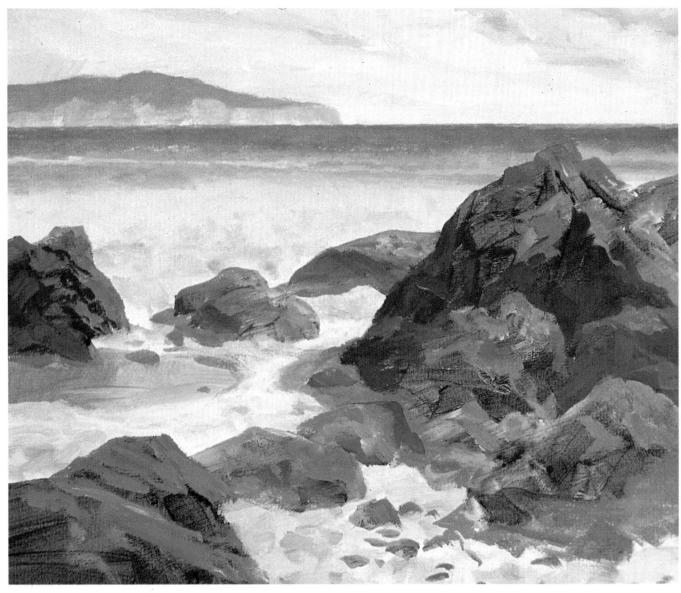

A Lesson in Composition

By the end of Step 4, the basic pictorial design has emerged. Study how the composition works.

- 1. The center of interest—the big rock at the right—is off-center.
- **2.** This big shape is balanced by the smaller shapes of the rocks at the left.
- **3.** The rocks are varied in size and shape.

- **4.** The horizon line is high—not dead center.
- **5.** The shape of the headland on the horizon also balances the shape of the big rock.
- **6.** The horizontal lines of the sea accentuate the diagonal lines of the big rock.
- **7.** The sand in the foreground creates a path that leads your eye into the picture.

Step 5. The dark sides of the rocks are painted with a flat nylon brush, carrying ultramarine blue, cadmium red, yellow ochre, and just a hint of white. Look carefully at the big rock on the right, and you'll see how the shapes of the shadows are painted with great care, slightly overlapping the edges of the lighted planes that were painted in Step 4. Thus, the planes change their shapes. The shadow sides of the foreground rocks aren't completed yet. More white is added to this shadow mixture, and this lighter tone is brushed over the sand to suggest the shadows cast by the big rocks.

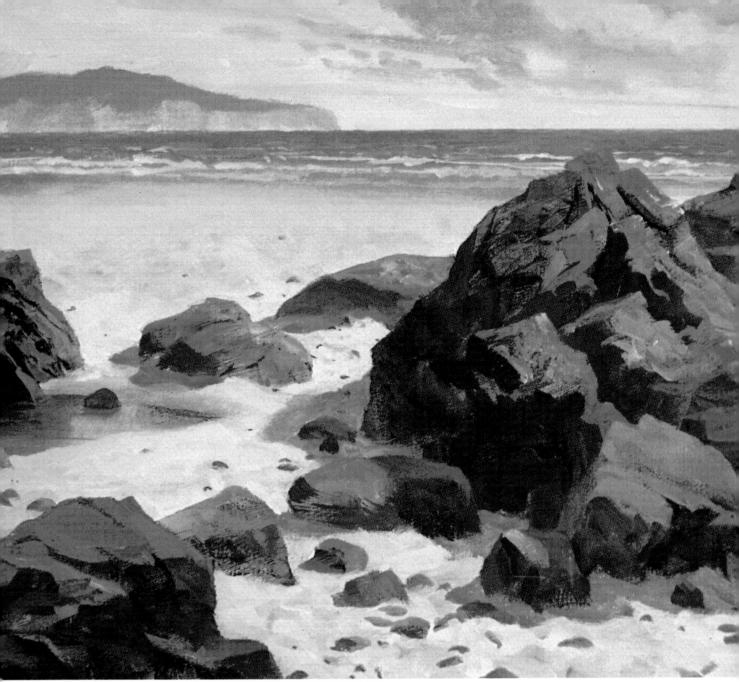

Step 6. The shadow sides of all the rocks are now darkened with a mixture of ultramarine blue, cadmium red, vellow ochre, and a little white. On a bristle brush, de Reyna picks up more of the original mixture that was used to paint the lighted planes: ultramarine blue, burnt sienna, yellow ochre, and white, diluted with just a little water so that the paint is thick and pasty. Strokes of this mixture define the lighted planes of the rocks more clearly and give them a rougher texture. Some final dark touches are added to the shadow sides of the rocks with ultramarine blue, cadmium red, yellow ochre, and a hint of white. In the process of reinforcing the lights

and darks, their shapes have changed to form a more satisfying design; compare the completed rocks in this step with those in the previous step. The artist picks up the fluid shadow mixture with the tip of a round softhair brush to add some cracks and details among the big forms of the rocks. With the same brush, he adds a dark reflection in the pool at the left. He switches to a bristle brush to go back over the sand with a slightly thicker version of the original mixture: phthalocyanine blue, naphthol crimson, yellow ochre, and lots of white. The sand in the distance is simplified and looks smoother. He eliminates some of the darker touches and some of the peb-

bles from the foreground. Then he uses a small bristle brush to add some other pebbles with the same light and shadow mixtures used to paint the rocks. Most of the pebbles are now concentrated in the center foreground—a big, distracting pebble at the lower right has been painted over with sand color. The sky needs more blue to harmonize with the water; a big patch of phthalocyanine blue, naphthol crimson, yellow ochre, and white is scumbled in to create a break in the clouds. The tip of a round brush draws wavy lines of white-tinted with some sky color-over the water to suggest the foamy tops of waves rolling toward shore.

MODELING THE RHYTHMIC FORMS OF DUNES

Step 1. The curving, rhythmic shapes of dunes are extremely subtle, and they can be difficult to draw. Draw them first on a separate sheet of paper that's tough enough to withstand repeated erasures. You can then blacken the back of the sheet with charcoal or soft pencil, place the sheet on top of the painting surface, and transfer the drawing by going over the lines with a hard pencil.

The sky is first covered with a fluid, semiopaque wash of phthalocyanine blue, yellow ochre, and white. Ultramarine blue and white are brushed across the top and blended into the wet undertone. Now the sky is darker and cooler at the top, paler and warmer at the horizon. When the sky dries, a single, dark stroke of the sky tone—now combining ultramarine blue, phthalocyanine blue, yellow ochre, and a little white—is carried across the sea. While this stroke is still wet, the lower edge is softened with a stroke of clear water.

Step 2. Just beneath the dark line of the water, the small triangular forms of the distant beach are scumbled with a thin, just slightly opaque mixture of ultramarine blue, naphthol crimson, cadmium yellow, and white. More white is added to this mixture, which is painted along the sunlit edge of the big dune. Before this patch of color is completely dry, the artist uses a darker version of this same mixture now containing less white—to paint the shadow of the dune. The shadow tone gradually changes from warm to cool. The warm strokes toward the top contain more crimson and vellow. The darker strokes toward the bottom contain more blue.

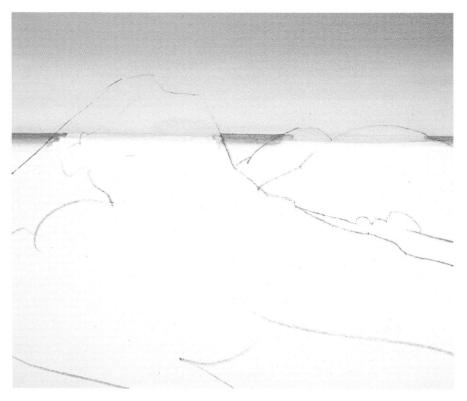

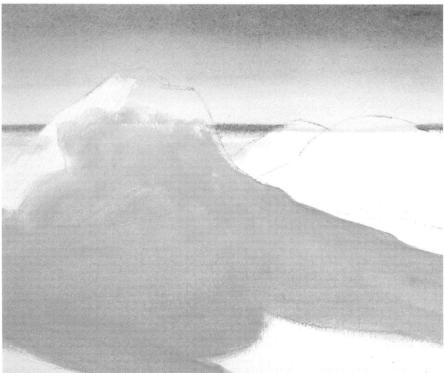

Step 3. The sunlit sides of the two smaller dunes, as well as the sunlit patches on the flat sand, are painted with the same mixture that was used for the lighted side of the big dune in Step 2: ultramarine blue, naphthol crimson, cadmium yellow, and a lot of white. While the sunlit planes of the small dunes are still damp, the shadow sides are scumbled with a darker version of this same mixture—containing less white-so that the light and shadow blend softly together. This blending gives a rounded shape to the dunes. The texture of the watercolor paper softens the brushstrokes and makes the blending easier.

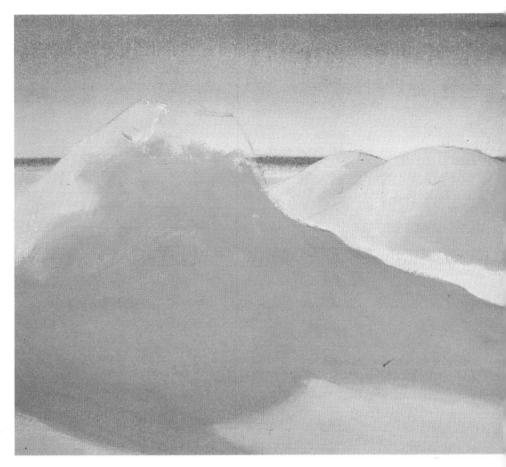

Step 4. Over the blue sky, a flat nylon brush scumbles some clouds with diagonal strokes. These clouds are the same mixture used for the lighted sides of the dunes: ultramarine blue, naphthol crimson, yellow ochre, white, and enough water to make the paint flow smoothly. Then a small, flat bristle brush adds the first dark vegetation to the top of the dune with drybrush strokes. This is a thick mixture of ultramarine blue, burnt sienna, yellow ochre, a little white-and not much water. The drybrush strokes are particularly ragged because the brush is held almost parallel to the paper. The flat side of the brush does most of the work.

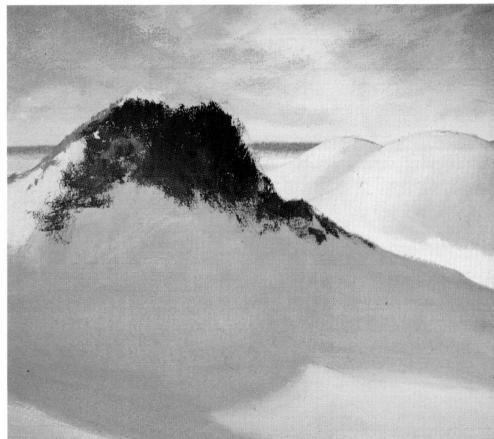

MODELING THE RHYTHMIC FORMS OF DUNES

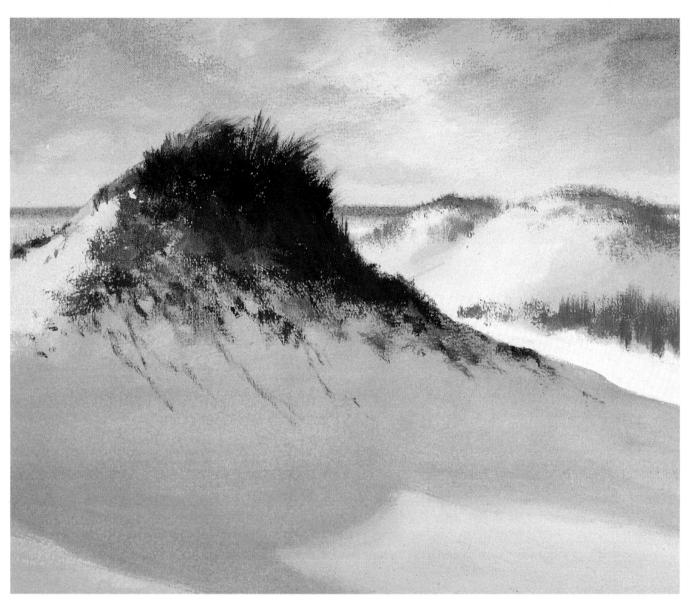

High Key and Low Key

The term *key* refers to the overall lightness or darkness of the subject. A high key painting—like this study of dunes—is generally light. Except for the grass, even the darks are fairly pale, like the shadows on these dunes. But this same scene *could* be low key—which means generally dark—under different lighting conditions, such as

early morning or late afternoon, when the sun is low. Before you start to paint any landscape subject, try to determine whether it's high key, low key, or somewhere in between. And remember two guidelines: in a high key landscape, even the darks are pale; and in a low key landscape (like the demonstration painting of moonlight), even the lights are fairly dark.

Step 5. The distant grass is drybrushed with the tip of a small bristle brush, carrying the same mixture plus more white - that was introduced in Step 4. The brush is pulled upward to make a ragged, vertical stroke that suggests individual blades and stalks. The tip of a small, round softhair brush adds a little water to the dark mixture to make it more fluid and more suitable for precise brushwork. This brush carries some slender lines of grass down the side of the big dune and brings some individual blades from the top of the dune into the sky. The flat side of the bristle brush adds more dark smudges to the side of the big dune.

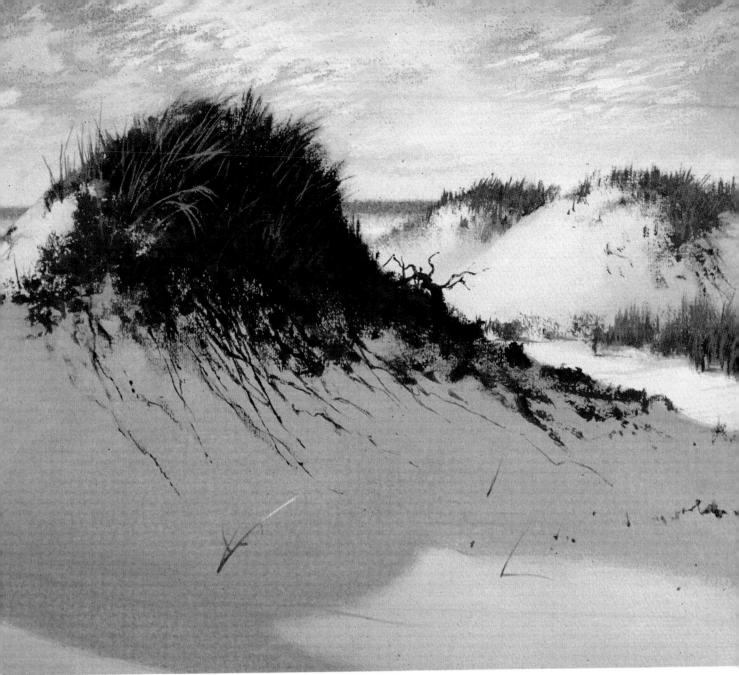

Step 6. The clouds are more precisely defined with short, parallel, diagonal strokes of white, tinted with the slightest touch of phthalocyanine blue, naphthol crimson, and cadmium yellow. The brush skims lightly over the paper so that the texture of the painting surface roughens the stroke. The sharp point of a small softhair brush adds more vertical drybrush strokes to thicken the growth on the distant dunes: a mixture of ultramarine blue, cadmium yellow, cadmium red, and white. More water is added to this mixture for precise brushwork.

Then the point of the brush adds pale blades of grass with straight and curving strokes against the darkness of the big dune at the left. Not too many strokes are added—just enough to suggest more detail than you actually see. The small brush picks up the original dark mixture of ultramarine blue, burnt sienna, and yellow ochre to draw more lines of vegetation that wander down the side of the dune. The bit of driftwood on the right side of the dune is painted with that brush too. The tip of the brush adds a few dark blades to the immediate fore-

ground. The blade just left of center catches a glint of light: it's the same mixture used for the lighted sides of the dunes. Finally, a transparent wash of yellow ochre, diluted with a lot of water, is carried over the entire sand area, adding a hint of sunny warmth. As you look back at the various steps in this demonstration, you'll notice that the picture is painted mainly with semiopaque color, containing just a little white and enough water to make the paint flow smoothly.

SHAPE TIDE POOLS WITH LIGHT AND SHADOW

Step 1. The artist drew the scene on tracing paper, then transferred it to the surface of a sheet of cold-pressed watercolor board. The sky is painted with ultramarine blue, phthalocyanine blue, yellow ochre, and whiteapplied with a flat nylon brush. The brushstrokes at the top contain more ultramarine blue and less white. The warmer, paler tone above the horizon contains more yellow ochre and white. The narrow strip of sea is painted with ultramarine blue, yellow ochre. and white - applied in horizontal strokes; the bristle brush skims lightly over the painting surface, leaving some streaks of bare paper to suggest foam. Ultramarine blue, burnt sienna, and yellow ochre are thinned only with water to produce a transparent wash that's brushed over the tide pools on the beach.

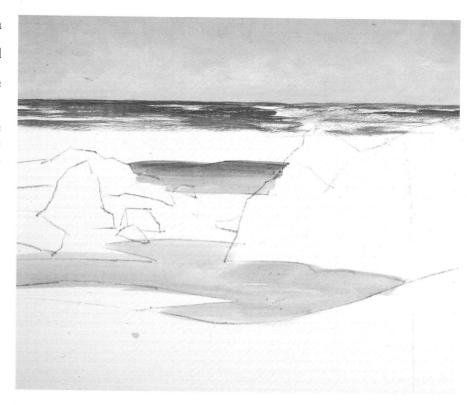

Step 2. Naphthol crimson, ultramarine blue, yellow ochre, and white are diluted with plenty of water to produce a thin, fluid mixture that's just slightly opaque. This mixture is brushed over the sand and it also overlaps the tide pools in the foreground. (Although this color runs over the pencil lines, the mixture is thin enough to reveal them.) When this tone is dry, a flat softhair brush mixes a wash of ultramarine blue, burnt sienna, yellow ochre, and a whisper of white. This semitransparent mixture is brushed over both tide pools and the foreground sand, which now has a cooler, more subdued tone than the distant sand.

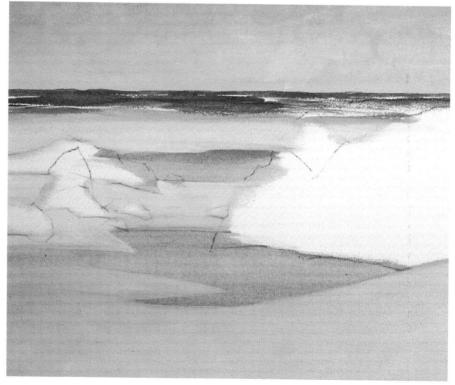

Step 3. The rocks are textured with thick, pasty color, undiluted with water or medium. The sunlit tops of the rocks are white, tinted with naphthol crimson, ultramarine blue, and yellow ochre. The shadow planes are ultramarine blue, burnt sienna, yellow ochre, and white in varying proportions: some strokes contain more burnt sienna, while others contain more ultramarine blue or yellow ochre. But at this stage, texture is more important than color. The rough, thick strokes of the bristle brush leave a craggy, impasto surface.

You Can Change Your Mind

With acrylics it's simple to change your mind or to make corrections, since it dries so rapidly and covers the underlying color so easily.

Step 4. The rough texture of the rocks is allowed to dry thoroughly. Then the rocks are glazed with a transparent mixture of ultramarine blue, burnt sienna, yellow ochre, water, and gloss medium. This fluid mixture sinks into the rough, impasto brush marks of Step 3 to produce a rocky texture. Less water is added to this glaze for the shadow planes of the rocks. This tone is carried downward into the pool beneath the big rock, where horizontal strokes render the reflection. When the reflection is dry, both tide pools are darkened with a transparent mixture that's mainly ultramarine blue and water, with a little burnt sienna and yellow ochre.

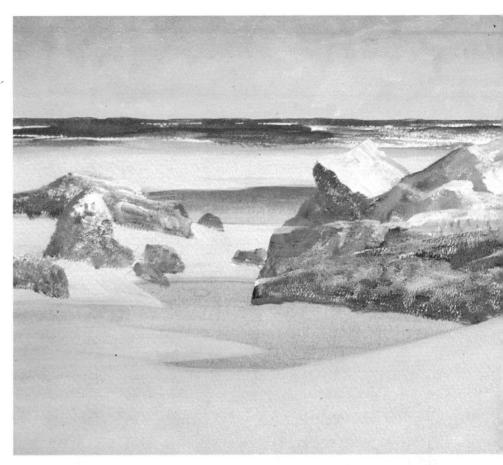

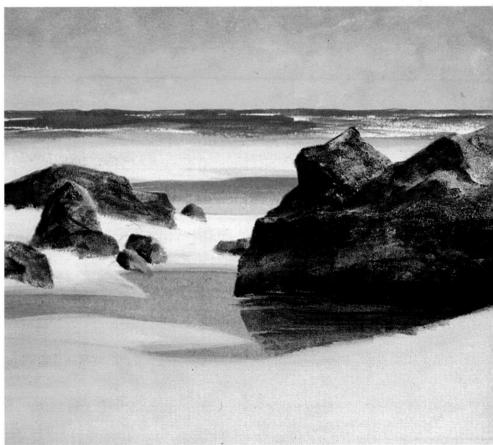

SHAPE TIDE POOLS WITH LIGHT AND SHADOW

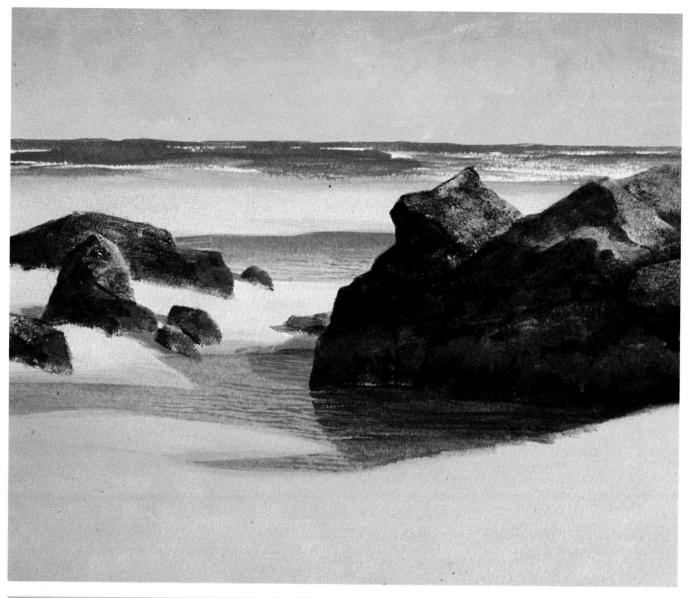

Tips for Painting Rocks

- 1. Before you start to paint, make rock studies in your sketchbook to analyze the forms.
- 2. Think geometry! Ask yourself: "Are the rocks like cubes, cylinders, cones, pyramids, spheres?"
- **3.** Draw the light and shadow planes carefully.
- 4. Analyze the direction of the light

and see how the light molds the forms (see page 16).

- **5.** Simplify. Don't include every crack. Decide what to leave out.
- **6.** Paint with expressive strokes that follow the form: straight, flat strokes for blocky rocks; curving strokes for rounded rocks.
- **7.** Don't paint all rocks brown or gray. Rocks can be blue, green, violet, pink, orange—any color.

Step 5. The shadow sides of the rocks are darkened with drybrush strokes of the same mixture that was used to glaze the rocks in Step 4: ultramarine blue, burnt sienna, yellow ochre, water, and gloss medium. (The gloss medium thickens the glaze slightly and adds luminosity.) A pointed softhair brush draws cracks in the rocks with a dark mixture of ultramarine blue and burnt sienna. Some smudges of moss are added to the smaller rocks at the left. These are drybrush strokes of phthalocyanine blue, cadmium yellow, and a little burnt umber. Some sky tone and ripples are added to the tide pools with horizontal strokes of ultramarine blue, yellow ochre, and white.

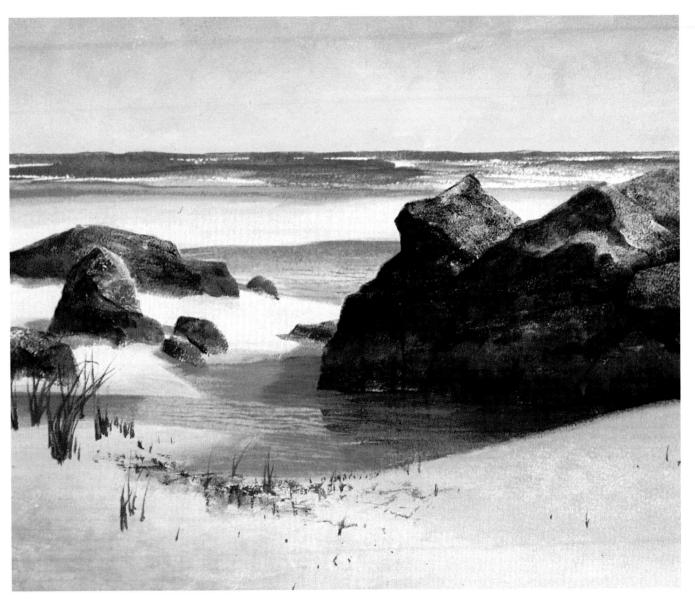

Step 6. More sky tone—phthalocyanine blue, ultramarine blue, yellow ochre, and white-is scumbled into the pools, which reflect the sunny sky overhead. Thin, horizontal lines of this mixture are carried across the pools with the point of a round brush to suggest ripples. A thicker, creamier sand tone is produced by mixing ultramarine blue, naphthol crimson, yellow ochre, and white; this is brushed over the sand in the foreground with short, scrubby strokes that allow the lighter undertone to come through. This brushwork suggests the irregular texture of the sand. With the round brush the artist begins to add some blades of beach grass with a fluid mixture of burnt umber, Hooker's green, yellow ochre, and water.

Analyze the Brushwork

The varied textures of this subject are reflected in the brushwork. The sand is painted with soft, smooth strokes of fluid color. In contrast, the rough texture of the rocks is rendered with drybrush strokes. The distant waves and the ripples in the tide pools are painted with wavy, rhythmic, horizontal strokes that suggest the movement of the water. The blades of beach grass are painted with slender strokes that start at the base of each blade and then curve upward, following the direction of the grass. The grass casts wavy shadows on the sand; these shadows are painted with wavy strokes.

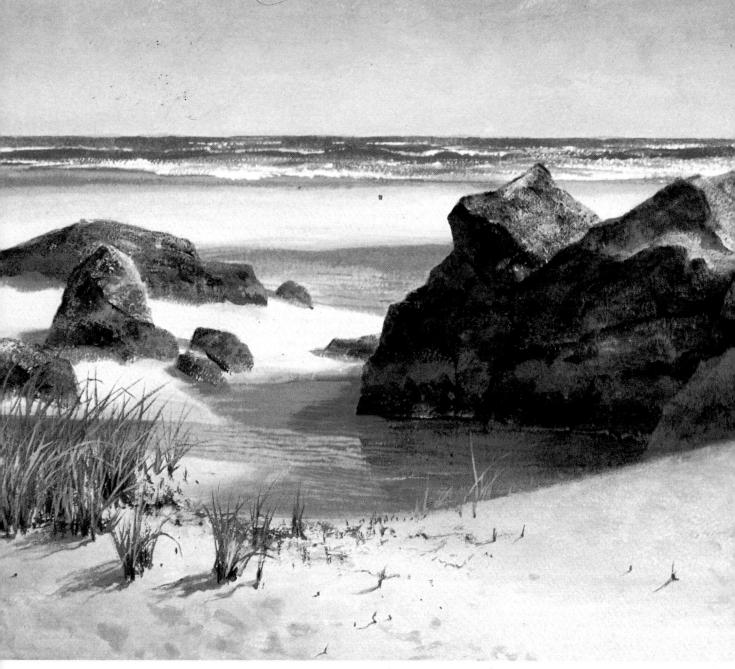

Step 7. The finishing touches are added to the rocks. The flat side of a bristle brush is used to drybrush some burnt sienna and ultramarine blue over the lighted tops of the rocks to produce a speckled texture. This drybrush work is then carried down over the shadowy sides. The moss on the rocks is strengthened with a mixture of phthalocyanine blue and yellow ochre. Additional drybrush strokes of sky tone are carried across the distant pool: a mixture of phthalocyanine

blue, yellow ochre, and white. The cluster of beach grass is painted in two operations, very much like the grass on the dune in an earlier demonstration. Some dark tones of Hooker's green and burnt umber are drybrushed. When these tones are dry, the point of a round brush adds individual blades with Hooker's green, yellow ochre, burnt sienna, and white. Some blades, caught in sunlight, contain more yellow ochre and white. The curving beach in the immediate

foreground is darkened with short, scumbling strokes of ultramarine blue naphthol crimson, yellow ochre, and white—particularly at the extreme right and left. Some darker smudges of this color suggest footprints in the lower left. The shadows of the beach grass are drawn with thin, wavy strokes of burnt sienna, ultramarine blue, yellow ochre, and white. Finally the sand is warmed with an almost invisible, transparent glaze of yellow ochre, dissolved in pure water.

BIBLIOGRAPHY

To build on what you've learned so far, here are some other books that are worth tracking down and reading. Unfortunately, there aren't a lot of books on acrylic painting-and many of the best ones are currently out of print. You'll have to go to the library to find some of these books. It's also worthwhile to try secondhand bookstores, which often have out-of-print art books. And you should certainly keep in touch with your local bookseller and your local art supply store, so you'll know when any of these outof-print books are republished - since publishers do sometimes reissue books that were once popular.

Betts, Edward, Master Class in Water-color. New York: Watson-Guptill, 1975. Although the title says "water-color," the book is really about the two major watermedia: watercolor and acrylic. Many of the paintings in the book are acrylics, and the author's wonderful instructional writing will inspire acrylic painters. This is an advanced book about the creative process in painting—and one of the best art instruction books ever.

Blake, Wendon, Acrylic Watercolor Painting. New York: Watson-Guptill, 1970. Although many watercolorists actually paint "watercolors" in acrylic, this is the only book on the subject. The text covers all the essential watercolor techniques and explains how to do them in acrylic. Illustrations were contributed by leading watercolorists and reveal a wide range of styles and methods.

Blake, Wendon, Complete Guide to Acrylic Painting. New York: Watson-Guptill, 1971. This is a comprehensive survey of acrylic painting techniques from the basic opaque and transparent methods to more advanced methods like underpainting and overpainting, the tempera technique, mixed media, textural painting, and collage. Illustra-

tions are by many leading acrylic painters, working in varied styles and with many different techniques.

De Reyna, Rudy, Painting in Opaque Watercolor. New York: Watson-Guptill, 1969. Although this is really about the techniques of painting in opaque watercolor (or gouache), the techniques are so similar to acrylic that this book can be very helpful to readers who are learning to handle acrylic colors. It's an old book and may look a bit dated, but the instruction is as sound as ever.

De Reyna, Rudy, Realist Techniques in Water Media. New York: Watson-Guptill, 1987. De Reyna wrote a number of books on "magic realist" painting methods, with excellent step-by-step demonstrations in acrylic and other watermedia. This is a distillation of the instruction originally published in those books. All the techniques in this inexpensive paperback are useful for acrylic painters.

Gutiérrez, José, and Roukes, Nicholas, *Painting with Acrylics*. New York: Watson-Guptill, 1965. An early book that describes the first acrylic colors and how to use them, this lively volume is filled with interesting facts about the techniques of leading artists. You can skip the outdated data about the chemistry of acrylics, but the book is worth tracking down for its stimulating ideas about painting techniques.

Hollerbach, Serge, Composing in Acrylics. New York: Watson-Guptill, 1988. This new book explains the basics of acrylic painting, but is most significant for its emphasis on how to use acrylic to experiment with pictorial design—an essential subject that most books neglect.

Pellew, John C., Acrylic Landscape Painting, New York: Watson-Guptill, 1970. For readers who wanted to paint landscapes, seascapes, and still lifes in acrylic, this was the best early book on the subject. The book is notable for its step-by-step demonstrations of various acrylic techniques by the author, a master of outdoor painting.

Rodwell, Jenny, *Painting with Acrylics*. Cincinnati: North Light, 1986. Beginning with the basic materials, tools, and techniques of acrylic painting, this lively book then focuses on the versatility of the medium in twenty-seven painting projects. The projects are stimulating because they survey varied subjects—landscape, still life, portrait, figure—and show how to paint them in many different styles and techniques.

Roukes, Nicholas, Acrylics Bold and New. New York: Watson-Guptill, 1986. This is a lively "idea book" that reproduces work by leading contemporary artists who work in acrylic—showing innovative ways to use the medium for various styles and technical effects.

Taubes, Frederic, Acrylic Painting for the Beginner. New York: Watson-Guptill, 1981. The author wrote a famous series of books on oil painting methods, based on old-master techniques, and his book on acrylic painting is interesting because it follows the same approach—explaining how to use this twentieth-century medium for classical techniques.

Woody, Russell O., Jr., Painting with Synthetic Media. New York: Reinhold, 1965. One of the first books on acrylics and other synthetic art materials, this is still one of the most interesting. Although artists' materials have changed a lot since the book was published, the text and illustrations (by a variety of distinguished artists) are full of stimulating ideas.

INDEX

A Asymmetrical design, 18 B Brushes, 3, 9 care of, 10, 19 Brushwork, 37-39, 53, 100, 127, 149 C Center of interest, 18, 116 Colors blending by scumbling, 32-33 brilliant and quiet, 105 contrast of, 18 of distant objects, 17 mediums for, 2 mixing, 10, 71-73, 117-119 muddy, 10, 11, 92 of nearby objects, 17 optical mixtures of, 10 selecting, 2 thinning, 10 Composition, 18, 81, 140	L Landscapes, 37 of autumn, 51-55 with clouds, 107-110 of desert, 95-99 with evergreens, 79-82 with forests and trees, 13-14, 46-50, 51-55, 72, 73, 74-78, 83-87 of hills, 72, 92-94 with mist, 72 mountains in, 11-12, 72, 88-91 selecting subjects for, 70 skies in, 73, 88 with snow, 73, 103-107 with streams, 73, 100-101 of summer, 46-50 of sunsets, 111-114 of winter, 56-59 Layout of work area, 9 Light, 16, 116, 144 of moon, 129-132 on snow, 103-107 in sunsets, 113	of beach, 138-141 colors for, 117-119 with dunes, 142-145 with foam, 118 with fog, 133-137 light in, 120-124 moonlight in, 129-132 selecting subjects for, 116 skies in, 119 rocks in, 148 of surf, 125-128 of tide pools, 119, 146-150 with waves, 118 Shadows, 16, 26, 27, 41 Silhouettes, 16 Spatial planes, 17 Still lifes of flowers, 43-45 of fruit, 32-34, 40-42 household objects, 35-36 T Techniques
D Distance, 17, 49 Drawing board, 4, 9 Drawings for portraits, 66 preliminary, 26, 85 for subject study, 74, 123 Drybrush, 30-31 Drying time, slowing, 2 F Flower arrangements, 44 Foreground, 17, 49	in sunsets, 113 M Mat board, 24 Mediums, 2 Middle ground, 17, 49 Modeling form, 26-29, 40-42 P Painting locations for, 46, 94, 116 steps for, 42, 102 surfaces for, 5-8, 9 Paintings	combining, 15 opaque painting, 11-12 transparent painting, 13 Textures of beach, 138-141 drybrush for, 30-31 granulation, 63 of painting surfaces, 5-8 tools for creating, 20-21 of trees, 74-78 Three-dimensional shape, 26-29 Tools basic painting, 3, 4 care and storage of, 19 miscellaneous, 9
G Gesso, 6 Glaze, 10, 47 Glazing, 35-36, 64 Graded wash, 79 Grisaille, 35 H Horizon, 18 I Impasto, 39, 75	correcting, 22-23, 61, 62, 147 preserving, 24 Palette, 3, 4, 9 cleaning, 19 with limited colors, 105 location of colors on, 9 Perspective, aerial, 17, 89 in seascapes, 139 Portrait, 64-68 S Scumbling, 10, 65, 68, 97 Seascapes, 38, 39, 60-63	unusual painting, 20-21 Transparent subjects, 43, 44-45, 117 U Underpainting, 35-36, 64 V Viewfinder, 70 W Watercolor paper, 7 Wet blending, 40-41 Wet-in-wet, 38, 60

		į.						X.
	•							
		,						
							Ta.	
	,							
	•							
	1							
						. •		
	¥							
Y ₁ - 1								
			A Company of the Comp					